Teaching the Arts behind Bars

Teaching the
Arts
behind Bars

Rachel Marie-Crane Williams
with a Foreword by Buzz Alexander

NORTHEASTERN UNIVERSITY PRESS • *Boston*

Northeastern University Press

Copyright 2003 by Rachel Marie-Crane Williams

Library of Congress Cataloging-in-Publication Data

Williams, Rachel Marie-Crane, 1972–
 Teaching the arts behind bars / by Rachel Marie-Crane Williams ; with a foreword by Buzz Alexander.
 p. cm.
 ISBN 1–55553–568–2 (pbk. : alk. paper)—
ISBN 1–55553–569–0 (alk. paper)
 1. Arts—Study and teaching. 2. Prisoners—Education. I. Title.
 NX282 .W55 2003
 700'.71—dc21 2002015416

Designed by Gary Gore

Composed in Meridien by Coghill Composition in Richmond, Virginia. Printed and bound by Maple Press in York, Pennsylvania. The paper is Sebago Antique, an acid-free sheet.

MANUFACTURED IN THE UNITED STATES OF AMERICA
07 06 05 04 03 5 4 3 2 1

For Jack J. Williams, the first person who told me I could paint

Contents

Foreword

When those of us who have done cultural work in prisons and youth facilities gather, we are full of talk, of stories, of outrage and laughter and confusion, of the need to share with others who have left "America" or "the world" to enter these foreign places. We know that the obscene policy of over-incarceration we have seen close up must be reversed. We can talk far into the night. In the essays in this volume we hear each other talking, and as always the talk resonates and provokes. These essays are for us.

The essays are also for those who are beginning or thinking of beginning a workshop or class in a prison. You spring up everywhere on your own initiative. You are in new territory and feel isolated. Here you find colleagues who know the people you are coming to know. Here you find instruction, ideas, reflections, illustrations, and hauntings, as well as stories of oppression and resistance, of denial and growth, of creation, of witness.

And so these essays are for you, also, who seek knowledge of the human condition and who seek your brothers and sisters who have disappeared from our communities.

As I close these pages, I am most haunted by James Thompson's description of the dark Loire Valley dungeon cell where a long time ago an artist, perhaps self-taught, kept his spirit lit with religious images, countryside landscapes, fantastical animals, a self-portrait. That story about the transformation of prison space is at the heart of this book. It is about what we in the Prison Creative Arts Project call the "clearing of space," about what Carol Becker, in the epigraph to Rachel Williams's first essay, calls "a demilitarized zone, a place of safety." It is about what is at stake.

Thompson's essay pulls up so many memories—Hollis-El, for instance, a hulking fierce man who could play a great comic drunk, telling us that in the yard he is like "this" (a clenched fist), that in the theater workshop he is like "this" (he opens a tiny space between thumb and forefinger, the other fingers still closed), and then back in the yard he is again the clenched fist.

Or Dell, a Native American adopted into an abusive Polish family, now a Michigan lifer, who told us that as a youth he loved walking the California beaches and redwood forests and that the theater workshops are "like that." Or Terrye, who joined the Sisters Within Theater Troupe because she heard that we laughed, or Danny, who stays alive because of our annual art exhibition, or the anonymous artist who writes about the "spark" the exhibition "lit in me." It reminds me what happens when the visual artists, writers, dancers, singers, musicians, storytellers, and actors in prison—for they are artists before we get there, as James Thompson insists—risk art. It reminds me what becomes possible when we enter from outside and make spaces that, as Jimmy Baca told my students, enable the incarcerated to keep their lights from going out, from crossing the invisible line into numbness.

In the Poet's Corner at the Southern Michigan Correctional Facility, we give each other assignments. Knowing about my years of prison work, Mike challenged me to write about what the workshops mean to me. I wrote about Hollis-El and Dell, then remembered a moment in English 319, my course that trains students to facilitate prison workshops:

III
At the university
a circle of stiff classroom chairs
which we unbend with our minds
"The men at Ryan and I
come to the workshop," Chris says,
"for the same reason:
something is missing in our lives,
and we come there to find it."

IV
Antonio comes to extend what he knows of love
* and anger*
Gucci comes seeking new families through finding
* his old,*
Chi comes to find the stories and voice that will let him
* pass wisdom on*
Co-Pilot comes to tame his whirling thoughts into
* powerful renderings of his time*
Mike, you come to find rhymes for your hard past
* and for the discipline and insight that motivate you now*

Sarah comes for the composite person and comes to delight and surprise us
 with her lyrical twists, her quick laugh
Phil comes out of a commitment to us and to himself

And I come, like you all, to find justice

V
I find it in our unusual laughter
I find it in our challenges and risks
I find it in the gasps I hear when someone reads a powerful poem
 or finds a right line
I find it in the safety of our space and in our liking for each other
I find it in our generosity
 in our forgiveness for what we have not done well
 in the voices we discover as they lift up out of us,
 like smoke and fire,
 singing
I find it in our attempts to understand why we are here
 in our anger when it rises
I find it in Co-Pilot's desire to write poetry like cutting quick right
 for a jump-shot and passing off, spontaneous,
I find it in Chi's assignment not to revise
 in Gucci's photographs
 in Phil's mantra
 in Sarah's many names
 in Antonio's family and Co-Pilot's cohesiveness
 in the insistence of the podium
And Mike, I find it in your direct, penetrating questions
 and in our answers

VI
Prisons are about no, the workshops are yes
Prisons are limits, blocks, barriers,
 workshops
 are openings, doors, dances, breakings through

Prisons are about poverty and poor opportunity,
 boarded houses and rotting schools,
 a system that leaves so many children out,

Workshops are a piece of the reply,
* they are about the strength of our stories,*
* about our voices, our songs, our laughter, our resistance,*
* about our families*
* our neighborhoods,*
* our communities,*
* ourselves,*
* about what might and may be.*

This book is about yes. It is about refusing to join those who say no, who stereotype, punish, isolate, humiliate, ignore, exploit, and incarcerate. It is about being present, *being* yes, being alert, tough, and vulnerable— venturing, as Jane Ellen Ibur says, "into deep woods where you've never been before." It is about bearing witness and about respect. These authors are so full of respect for the men and women with whom they create, so respectful of the staff who facilitate their entrances. This book is about affirming and acting on the possible, about refusing, as Leslie Neal says, to offer simple formulas. The authors contribute as examples their experiences and methods, but insist on leaving prison arts open to the inventiveness of participants and the circumstances of each setting. This book is for honesty and against pretension; it's about knowing that we are guests in the prisons and that we are gone if we are arrogant or incautious or disrespectful to authorities. We must recognize that our expectations and needs may not be those of the "subjects" with whom we work, and must realize that the "wreck" is always, as Grady Hillman says, "waiting around the bend."

This book is about saying yes to the complex, uneasy, sometimes dangerous, beautiful, creative people we engage with, knowing what to demand from them and ourselves, and knowing when to disengage. It is about saying *yes* to the ethical complexities that James Thompson broaches. It is about crying, as Judith Tannenbaum does, when the prisoners are forbidden to write back to the child poets who have responded to their poems, and about embracing sadly what she had to acknowledge:

But already, my time at San Quentin had taught me that my heart, though wholly right in its sight, saw only part of the picture. Already, my time had taught me to remember that some men whom I knew as kind and caring had also caused great harm to other people. Already, my time had taught me I didn't know everything.

In the unambiguous world of my heart's sight, I could always respond with moral assurance. In the more ambiguous world of San Quentin, there was always another point of view. In the ambiguous world of San Quentin, I believed in my heart's sight and, simultaneously, was forced to acknowledge all I didn't know. In the ambiguous world of San Quentin, I received dozens of lessons weekly from Paradox, the great teacher.

This book is about saying *yes* to our own healing, growth, and rehabilitation because in a nation that has incarcerated two million of its citizens and devastated those dependent upon them, we all need rehabilitation. It is about listening to ourselves and our partners on those significant rides to and from the prisons; it is about listening to the conversations that flow in and out and around the workshops, because in these spaces we are seeking ourselves and each other.

These authors know that something very basic is at stake. They know that every human being, no matter what has been done to them, no matter what they have done, has the right to grow beyond their worst moment and become more fully human. They know that we need to save our souls, define our lives, discover the resources of our imaginations and of our fellow beings, and rehearse and prepare for what comes next. They know that this isn't easy and that not everyone wishes to grow, that some are merciless and perhaps hopelessly hostile. In a sentencing circle in a Canadian aboriginal community, the elders apologize to a youth whose sentence they will determine: we did, they say, something wrong in raising you, or you would not be before us. They explain to him that he is before them because they need him in the community.[1] This book is about the right of human beings to seek wholeness and about the need of communities to have whole human beings.

This morning, the Sisters Within Theater Troupe has struggled over the fate of Big Daddy, drug kingpin and destroyer of family and community. What we do with Big Daddy will be what we are telling our audience in our new play, "The Leap With Faith." We reject a simplistic conversion (suggested title: "A Change of Heart"), a life-ending bullet, isolation in prison. No, we realize, his soul must be in contention as he begins the difficult task of growing beyond what he has been. The other characters, Page, Nicole, Helene, Mark, Baby Sug, Star Lite, Francesca, and Faith, must determine their relation to him at the end as they seek their own growth, seek relation, family, and community. The resolution must be difficult, honest, guardedly hopeful.

Yesterday, members of the Poet's Corner fought over whether the yard, their masculine culture, their sharing with others only on a "need-to-know" basis, would allow us to enter into the deep woods where we've never been and to have a worthwhile workshop.

At stake in these challenges is how well we will be with ourselves, with each other, and, in the end, with everyone in our lives. The civilization of incarcerating America does not favor our success. Our colleagues in this book, authors and prisoners, artists all, give us much heart.

Buzz Alexander

Acknowledgments

This book is a product of friendship and support. I would first like to thank all of the contributors. I want to thank Grady Hillman for his encouragement and for being a sounding board; James Thompson for helping to send me to London and for his two fabulous books; Judith Tannenbaum for coming to Iowa, for being generous, and for recommending Northeastern University Press; Leslie Neal for dancing at Jefferson and inspiring me to explore the touchy-feely side of teaching in prison; Pat MacEnulty for being courageous, making our summer collaboration wonderful, and filling the world with good writing; Susan Hill for having a great sense of humor, telling stories, and taking me under her wing; Jane Ellen Ibur for trusting me with her story and for sending me great e-mails; William Cleveland for writing the wonderful book that helped me write my dissertation; Terry Karson and Sara Mast for being allies at the University of Iowa; and Buzz Alexander for being so patient and helpful, for doing so much work, and for providing a role model of prison arts and academia combined.

I also want to thank my family. Little Marie pushed me to finish this project in a way that no one else could. Sean Kelley, my husband, stayed up late, especially on prison nights, listened, and helped me edit. The women in my family, Sharon, Ree, Moms, Jeanne, and Sara, deserve an especially big thank you for teaching me that working to help others is rewarding in spite of the challenges involved. I thank my dad for teaching me to be a rebel and be critical of authority, my brother for teaching me how to stretch a dollar and walk to the beat of your own drum, and Tim for demonstrating the value of tinkering with things until they are right.

I have been lucky to have three *incredible* mentors in academia, Melvin Stanforth, Dr. Sally McRorie, and Dr. Steve Thunder-McGuire. Mel is my fairy godfather; Sally and Steve have encouraged me to focus my research on things I love. Liz Voss has helped me to look professional and be organized even when I am not. She has also listened to me bitch and moan. I

appreciate Dr. Tom Walz for helping me to put together a proposal, and Dr. James Marshall for explaining how to put together an anthology and for telling me the truth, "It will be hell!" The University of Iowa was kind enough to support this endeavor with their generous award of an Old Gold Fellowship. I want to thank Northeastern University Press for being patient beyond politeness and encouraging this entire project; Sarah Rowley, Emily McKeigue, Julia Smith, and Kathryn Watterson are goddesses. Anthony Pappa deserves my thanks for lending his artistry to this effort. Jane Parsons, Evelyn Ploumis-Devick, Lydia Keith, Janice Billie, Janette Taylor, Mickey Eliason, and the women who work and live at Jefferson Correctional Institution, the Iowa Correctional Institution for Women, and Taycheedah Correctional Institution, have all been incredible, and without them my path would be different.

Teaching the Arts behind Bars

Rachel Marie-Crane Williams

Introduction

While compiling this book, I have looked for the gaps in my knowledge and library. There is a great deal of information available about arts-in-corrections, but finding it took extensive work and research. The main reason I want to publish this book is because I feel it will be beneficial to young practitioners in arts-in-corrections.

When I first began to work as an artist with women in prison I felt a sense of isolation. Over the years I have drawn support from an informal network comprised of artists, writers, poets, dancers, musicians, and actors who work in correctional settings. Our experiences have strengthened our dedication to incarcerated populations. From this network of people I have gathered advice both theoretical and practical.

The Benefits of Arts-in-corrections Programs for Participants and the Institution

Correctional facilities are traditionally devoid of programs that contribute to individual, emotional expression, which is essential to our humanity.[1] The culture within correctional institutions facilitates punishment, control, order, and correctional rehabilitation. Yet in an environment where individual expression is not encouraged, the arts result in therapeutic benefits for students. Many of the inmates I have researched during program evaluations say that making art or participating in arts activities has helped them cope with prison life and given them a sense of confidence that they never possessed before. These kinds of activities help many inmates manage their high levels of stress by making them feel productive, normal, and human.

Since the 1970s, incarceration rates in the United States have continued

to rise dramatically. As of December 2000 there were 1,383,892 adults on probation, in jail, or in prison.[2] As of June 2000, the Bureau of Justice Statistics (BJS) concluded that in the United States the prison population is growing by 1,585 inmates per week; in the decade between 1990 and 2000 the number of inmates in state prisons grew by 27,953 and, "the rate of incarceration increased from 1 in every 218 residents to 1 in every 142."[3]

Fewer than half of all state prison inmates are sentenced to prison for committing a violent crime, according to the BJS.[4] This means that our society is locking up individuals who easily could be sentenced to community alternatives, situations in which they can work, pay taxes, and maintain their families rather than go to prison. The impact on their children alone is tremendous. In 1999 it was estimated that 721,500 inmates were parents to over 1,498,800 children.[5]

Many prisoners come from families in which they were sexually and physically abused, and many have had drug and alcohol problems; in fact, one-fifth of all inmates in state prisons are sentenced for drug offenses. These people would benefit from treatment programs, parenting classes, probation, and supervision instead of imprisonment. Educational and vocational training opportunities combined with life skills and, in some cases, drug treatment might offer them a way to overcome their current circumstances, including poverty.

This growing incarcerated population lives a life grounded in a dystopic narrative of oppression, punishment, and deprivation. For most, prison means living for many hours each day in a small space the size of a modest household bathroom, enduring exile from family and friends, possessing a meager collection of necessary objects, and being treated almost like a child. Within this culture of control there are few outlets for expression, stress, memory, and creativity, and little relief from boredom. There are also limited options for making contact with the outside culture or for exploring self-worth and identity.

Progressive correctional institutions seek ways to meet the needs of their prisoners, reduce violence and levels of harmful stress, and provide creative opportunities for residents that will add to their education, instill positive habits, and boost self-esteem. According to Jan Gibbons, an arts practitioner, for inmates, producing art cleanses the pain, grief, anxiety, and loss associated with prison.[6] While the arts, especially the visual and literary arts, are widespread and highly valued within prison culture, few formal opportunities exist for residents to learn these disciplines. In recent decades many artists and arts agencies have aided correctional institutions by establishing

arts programs. Volunteers create and facilitate some of these programs, while larger collaborative partnerships between arts agencies, public and private organizations, artists, and the criminal justice system produce others. These workshops and programs benefit not only participants but also institutions.

According to Eric Schlosser, a journalist, almost 1,000 prisons have been built during the past twenty years.[7] Logically, one would assume that overcrowding would diminish as space is made available. However, overcrowding has become even worse. At the end of 2000, state prisons were operating at or over their capacity by 15 percent, while federal prisons were operating at 31 percent over capacity.[8] Although violent crime has diminished, more prisons have been built, and the population of inmates continues to increase each year. The good news is that in 2000 the state prison population began to decline for the first time since 1972.[9] Research has linked overcrowding to "higher rates of stress-induced mental disorders, higher rates of aggression, and higher rates of violence."[10]

According to Lawrence Brewster, a researcher from California, art making within prison offers one way of reducing violent incidents and stress. Inmates who participated in the Arts-in-Corrections program in California, one of the largest and most successful programs in the country, had a much higher percentage of favorable outcomes (88%) six months after their release compared to inmates who did not participate in the Arts-in-Corrections program (72.25%). As time progressed the difference in these percentages continued to increase. After two years, over 69 percent of the Arts-in-Corrections participants had managed to keep their favorable status compared to only 42 percent of the nonparticipants. Studies such as those conducted in California by Brewster have linked a reduced rate of recidivism with inmates who participate in arts education programs.[11] In an interview with Steve Durland, coeditor of *High Performance Magazine* (1996), Grady Hillman, a poet, cites this study and points to the 60 to 90 percent decrease of incident rates. Hillman points out that this was easily documented because of the heavy surveillance and observation that most institutions employ. Hillman also states that arts programming saved money, reduced violence, and curbed recidivism. These findings are also echoed in Bill Cleveland's *Art in Other Places*.[12]

Why has the introduction of arts-based programming helped reduce recidivism? What does making art do that makes it a transformative experience for inmates? Durland states:

California did a seven-year recidivist rate study and found a dramatic drop in the recidivist rate of these inmates [who participate in arts programs] after they left prison, compared to the general prison population. These people did not commit crimes when they got back into the free world. Something really profound had happened to them in the prison setting that transformed their behavior. So you can also make the argument that you're reducing crime on the outside by bringing these programs in.[13]

The arts are an intrinsic part of culture. They are woven into the fabric of our everyday lives from the billboards we see on the side of the road, to our tennis shoes, to the music we hear on the radio. The arts influence everything around us. In prison, the arts have many obvious functions such as decoration, communication, status, therapy, recreation, and expression. But they also seem to act as invisible glue that cements people together through production and sharing. They secure individual as well as cultural identity, mark personal and cultural transitions, and establish some sort of personal control over chaos.[14] Prison is a place where deprivation is part of the culture. Inmates are deprived of outlets to express emotions, ways to identify themselves and the culture of which they were previously a part, normal communion with their families, and the material and metaphysical freedoms available to most human beings. Deprivation of such freedoms, liberties, and choices results in depression, violence, and even assault. William Cleveland explains the link between life and the arts: "For members of our society who are confined physically or emotionally, access to the creative process through the arts provides a vital link to self-expression and self-esteem; to productivity and potency. The need for art is most evident when participation in other activities in life are [sic] limited."[15] Roger Cardinal's introduction to *Cellblock Visions* eloquently states:

At first glance, the term "Prison Art" seems self-contradictory. If we at all associate art making with the unfettered flight of the creative impulse it would hardly seem likely to take off behind iron bars. Yet, for all that its manifestations have hitherto escaped public notice, creativity within the prison population is as much a potentiality as within any other; and the artistic output of the physically and spiritually confined, achieved almost entirely against the grain of circumstance, forms both a substantial corpus and an admirable proof of the tenacity of the human urge to expression.[16]

In order to provide a more productive environment where self-esteem is built, emotions are dealt with, past histories of abuse and addiction are over-

come, and the future is approached with a productive plan based on positive actions and attitudes, the culture itself must change to include greater outlets for positive individual emotional expression, interaction, and recognition.[17]

Many people involved in the business of corrections realize that such a paradigm shift is necessary. Some states have directly addressed the need to reevaluate the role of corrections and the services available to inmates, and have sought to meet this need through their institutions. Unfortunately, many prisons have neglected to challenge their original philosophies of suffering and punishment, consequently avoiding the possibility of productive incarceration. Each institution is shaped by its individual administrative power structure's philosophy and the amount of resources it controls. A positive change in corrections could reduce recidivism, save taxpayers money, and rebuild lives wrecked by destructive actions and circumstances.

Why does one find, in the confines of prison, individuals who have not even thought about participating in the arts since elementary school, suddenly thriving on and working toward the production of something called art? Why would people who, under normal circumstances in the free world, might reject the arts suddenly turn to them?

In prison, art functions as recreation and stress relief, and it is a way for inmates to transform and move beyond their current reality. Inmates use art to overcome deprivation. They become artists to reconfigure their identity and boost their prison status. They make art because they can benefit monetarily. Some use it for body decoration; others use it for therapy. Many memorialize their loved ones and their lives through the arts. Art plays a big role in communicating with the outside world, especially through letters. Through their work, many inmates can see some continuity between their lives before prison and their current lives behind bars.[18]

Gyles Brandreth, the author of *Created in Captivity,* cites boredom as the main reason that inmates initially become involved in the arts.[19] C. Lee Harrington, a professor at Miami University in Ohio, studied the link between time and the work of inmates on death row. She states that their work's meanings are tied to the passage of time, and she draws a line between subjective time and objective time, with art as one way of aligning their dissonance. Objective time is based on the twelve-month calendar, while subjective time is tied to personal concepts of time such as the seasons or the number of days between visits from friends.[20] Some of the inmates he interviewed on death row said that before reforms in the early 1980s, they would typically spend twenty to twenty-two hours in isolation on a daily

basis. For any human being to face such isolation requires some stimulation, as well as some place or thing to which to escape. We, as a species, must *do* something. Inmates on death row or those serving long sentences sometimes use their participation in the arts as a way to awaken their imaginations and transform their time.

Harrington and Riches assert that another reason inmates engage in the arts is to produce gifts. Many inmates want a way to express their gratitude to friends, family, and lawyers who support them, and they want to continue participating in society's custom of gift giving during special times. This continuity through objects, performances, poems, letters, and images is a concrete reminder to others that they wish to express their emotions of gratitude, sympathy, happiness, love, and hope. Gifts of art provide a way for inmates to have a presence outside of prison through their work. Harrington quotes one inmate who says, "I give everything away because I want to have people to have those things long after I'm gone. That's how I want them to remember me, as doing something good, not as a monster."[21]

Monetary rewards motivate some prisoners. Producing art, poetry, or prose is one legitimate way of making money or gaining goods in prison. In prisons where it is illegal for inmates to sell or trade anything with others, there is usually a huge black market. Inmates know who sells what and who can arrange for deals to be made. Some inmates make cards and tokens for other inmates, who may be unskilled in the literary or visual arts, to give to their families as gifts.[22] People in prison find value in the attributes that mark things as skillfully handmade or written.

Prisons where inmates are allowed to sell their work to people on the outside often see positive outcomes. For some inmates, this is the first time they have earned money through a legitimate enterprise. At the Iowa Correctional Institution for Women (ICIW), inmates are allowed to sell their work. Much of what is sold is bought by officers. These transactions strengthen the respect the inmates have for staff and also give the staff a more positive view of inmates. The women at ICIW have also sold hand-painted furniture at a coffee shop in Iowa City to raise money for the art program. This program has really motivated many of the women to make art and appreciate its value to others. Some have even gotten commissions from coffee shop customers. These experiences provide inmates with skills and self-esteem that serve as a useful counterexample to their own pasts. Once released, some women have continued to create art to sell in the coffee shop. For a few of these women, this is their only source of income after prison. It is easier for the public to understand the positive effects of the art program

when they see and value the art produced by participants. Art Behind Bars (ABB) in Key West, Florida, has a similar program. Once each year former inmates are invited to sell their work as part of an inmate art auction. The proceeds are split between ABB and the artists. These former inmates are thankful for the profits from the sale of their art and feel a real sense of connection to the people who participate in the auction and bid on their pieces.

Brandreth cites attention as another reason for the popularity of the arts in prison.[23] Arts education provides not only individualized attention from a teacher but also admiration from other inmates. This attention and admiration builds self-esteem. Upon entering prison, inmates experience an erasure of the self as their personal identities are obscured behind a veil of numbers and uniforms. Offenders in large institutions become "just another inmate." Making art, according to Riches, is a way that inmates can ameliorate some of the stigma of being an inmate.[24] Thinking of themselves not just as inmates but as artists boosts inmate status within prison as well as with members of the free world.

Within the prison, many inmates are well known for making art and become teachers or critics. However, Brandreth states that as an inmate's time of release gets closer, the search for self-identity through creativity usually ebbs.[25] Inmates seem to slowly prepare for their departure through the disconnection of the self that emerged in prison and their new skills. These can often include personal artifacts and habits.

Brandreth touches on deprivation as another motivating factor for art making: "As prison is a depriving experience, attempts to ameliorate it are to be expected and the prisoner will naturally try to protect himself through his creative work, either by using the work as a counter-attack on prison itself—with aggressive, hostile painting and writing—or by using it as a means of escape from an almost unbearable situation—with idealized fantasies of every sort."[26] Engaging in the arts temporarily removes prisoners from their experience and the losses associated with imprisonment by creating a fantasy world. Often their deprivation is the catalyst for depression and anxiety, as well as hostility and anger. Art making can act as a therapeutic release for the expression of these feelings.

One inmate at Jefferson Correctional Institution (JCI) in Florida, where I used to teach painting, worked on the same square of canvas for weeks. Her children were living with their stepfather; in the past he had sexually abused them. Her moods shifted drastically each week, mostly due to her loss of control over her children's welfare. Her portrait began with a rosy

depiction of herself and three children. The following week she painted out one of the children and informed me he had died as an infant. The colors turned from pink to yellow ochre. A week later she was in better spirits, and she filled her background with azure blue, enlarged herself, and painted over the remaining two children. The next week she voluntarily placed herself in drug treatment to shorten her sentence. The drug dorm was an extremely harsh environment. During the week following her placement she came to class, began to cry, declared a psychiatric emergency, and left.

The last week of her attendance, her painting changed drastically. The background became gray; the image of herself was painted around until there was just her face left, looming in the middle of a gray void. Her children had been removed from the stepfather, who was accused of sexually abusing them again, and placed in foster care somewhere in Georgia. She said to me that she felt powerless. She provided a lesson for me as a teacher about grief, anxiety, and emotion presented through art.

Gyles Brandreth states, "Captivity stimulates creativity because the mind seeks the freedom denied to the body. I think it natural for the prisoner to seek sublimation in the imagination. Compared to the civilian population almost everything else is denied him anyway."[27] Inmates use their creativity to find ways to fill needs and desires denied to them because of their status as prisoners.

This anthology draws from the narratives, experiences, and philosophies of artists who have worked in correctional facilities in the United States. Their essays provide insight into the various regional cultures of corrections, the anecdotal differences encountered between male and female inmates and between adults and youth, and the opportunities for expression and creativity provided by the visual and performing arts. All contributors are accomplished arts professionals and have grappled with a variety of issues arising from the challenging work in the unusual environment of prison. They wish to share their perspectives in hopes of broadening the field of arts-in-corrections.

I would encourage anyone who is interested in this field to investigate the available literature (see recommended reading), to talk to people about their opinions and experiences, and to engage in their work with an open mind, enthusiasm, and caution.

The Contributors and Contents of This Book

This book is organic in its structure. I asked the authors to think about what they would have liked to have read before they began working in cor-

rectional settings. I also asked them to write about their experiences. Each contributor has responded differently. Some have written essays; others have responded with interview transcriptions, poetic reflections, and deeply personal stories.

Terry Karson, a visual artist, responded by transcribing a radio broadcast. Amy Roach, the Arts and Humanities Director for Yellowstone Public Radio, created a story based on interviews with Terry Karson and Sara Mast, the two artists who coordinated the Glass Walls Project at the Montana Women's Prison. Roach also includes the voices of the women involved. Between transcription segments, Karson interjects detailed descriptions of the setting, the project, and his thoughts about the experience.

Jane Ellen Ibur's chapter details her story of working with men at the St. Louis County Adult Correctional Facility. She writes about using a no-nonsense approach with her students to help them reach out and develop literacy skills through creative writing. Pat MacEnulty, a professor and writer in Charlotte, North Carolina, also uses creative writing as a tool to promote self-esteem and literacy with incarcerated women. Like Ibur, she mixes her story with bits of useful advice and bittersweet anecdotes about the people with whom she worked. She also provides a guide to understanding and developing attainable program goals.

When I asked Judith Tannenbaum to write about her experience, I learned that she had just finished *Disguised as a Poem: My Years of Teaching Poetry at San Quentin*. I choose chapter 5 from her book because it describes the complexity of teaching poetry in prison and coordinating a community outreach program; and it recounts uncomfortable personal discussions and situations with inmates and the outside world, and the personal anxiety that these interactions can generate. *Disguised as a Poem: My Years of Teaching Poetry at San Quentin* is one of my favorite personal library additions. It is deeply moving, motivating, and gritty.

Other contributors sent chapters filled with straightforward practical advice. William (Bill) Cleveland, author of *Art in Other Places*, and director and founder of the Center for the Study of Art and Community, based in Minneapolis, details a commonsense set of survival skills for artists working in corrections. He describes how teachers can use their artistic sensibilities to see the environment and community with renewed vision. He also covers the process of site selection and assessment, and discusses designing and implementing a successful curriculum and teaching strategies. Finally, he stresses the importance of rest, recovery, and making art.

Grady Hillman traces his involvement as a leading figure in arts-in-cor-

rections from his humble beginnings as a poet in residence in Huntsville, Texas, to his work as a highly sought consultant for the National Endowment for the Arts and the Office of Juvenile Justice and Delinquency Prevention. Hillman, an anthropologist and artist, focuses his observations on some of the nearly one hundred American adult and juvenile institutions he has visited, but he also uses his extensive experience in Ireland, England, and Peru to further describe the "system" as experienced and understood by inmates, staff, and the public. Hillman writes candidly about the lessons that he learned during his career in hopes that readers might avoid some of his pitfalls.

James Thompson, a theater artist, professor, and the founder of the Theatre in Prisons and Probation Center (TIPP) in the United Kingdom, outlines ten principles of practice. He offers these principles but warns the reader to be skeptical and open to the nuances of working within different contexts. He adds depth to his chapter by telling stories related to his international work in Brazil and Sri Lanka. He has worked extensively in the United States and the United Kingdom.

When people think of corrections they often overlook the number of people that enter the judicial system as juvenile offenders. Susan Hill has written about her work with the California Youth Authority and the Artsreach program of the University of California Los Angeles. She addresses issues of multiculturalism, collaboration, and self-determination that have arisen in her work with youth over two decades. Her story centers around a student who was both difficult and rewarding.

Buzz Alexander, a professor of English language and literature at the University of Michigan, writes about his experience, the Prison Creative Arts Project (PCAP), and the Michigan prisons. He is a well-known figure in the world of arts-in-corrections and political prison reform. He sensitively discusses collaboration, prayer, various influences, and people important to the development and success of PCAP. Evident in this chapter are Alexander's incredible experience and interests in literature, pedagogical empowerment, community-based learning, and prison theater.

Leslie Neal, the founder of ArtSpring, and an associate professor of dance at Florida International University, tells a moving story of her work in the women's prisons of Florida. As a dancer she shares a unique perspective about the reciprocal exchange and gratification she has discovered through her work over the past decade.

My contributions to this anthology include the final chapter dedicated to program evaluation and the story of my experience with one project at

the Iowa Correctional Institution for Women. The final chapter is dedicated to program evaluation because accountability, documentation, and outcome evaluations are growing concerns among state agencies, foundations, and private agencies that offer funding in the arts. This chapter describes a summative model of evaluation based on qualitative and quantitative practices.

I hope the narratives in this book contribute to the proliferation of more arts-in-corrections programming. As artists it is imperative that we carry our work beyond the walls of our studios, universities, theaters, and galleries. Working in prisons has been one of the most rewarding experiences in my life. This work stokes my passion for art and teaching. While at times prison work is difficult, it reminds me to be forgiving, to be comfortable with ambiguity, and never to take my life or lifestyle for granted.

Each contributor to this book has a vision for arts-in-corrections. Each one has offered a way for incarcerated people to reinvent themselves as artists, dancers, actors, or writers.

Grady Hillman

The Mythology of the
Corrections Community

I begin writing this essay just after the twentieth anniversary of my first arts-in-corrections residency, a three-year stint as poet-in-the-schools (beginning in the fall of 1980) for the prison school system of the Texas Department of Corrections (TDC). That experience opened up to me a new world, which has swept me along on its course to over seventy correctional facilities in four countries (five depending on how you want to configure Northern Ireland). During these years, I've felt compelled to chronicle my experiences and research in articles and book chapters, screenplays and training manuals, but even that record reminds me that I've forgotten much more than I remember. This work is a struggle; its support or lack thereof is constantly vulnerable to shifts in societal emotion and impulses of political convenience. I've seen wonderful programs, and some that are best described as ill conceived, appear and disappear without regard to quality. This work is fraught with unforeseen crevasses. Sometimes we are faced with traps set by those who don't want to see us succeed or those who would exploit our presence for personal motives; sometimes we set traps for ourselves. Those of us who endeavor to bring arts experiences into correctional settings must be constantly present or looking forward. Rarely are we afforded the luxury of looking back. In TDC parlance, there's always a wreck waiting around the bend.

My commitment to arts-in-corrections contributed to a divorce, to new romances, and to the discovery of a tribe of fellow fools and prophets who

believe in the arts and work in prisons and alternative settings. Like any strangers entering a foreign land, we have come to understand ourselves better, learned where our edges are, discovered the differences between a Freeworlder and a Lockedup.[1] Most remarkably, if we are attentive, our students teach us the power of the tools we use in our art.

It seems appropriate at this time, twenty years later, that I look back and attempt to outline my arts-in-corrections experience—and that is all it can be, just a silhouette of the real thing. Some of it will be wrong, but I hope it's all true.

I was working as a poet-in-the-schools in Huntsville, Texas, when I was invited to perform the same function for the Texas prison school system. What seemed to be serendipity or coincidence accompanied the inception of this new project; I think this sense reflected my early romantic associations with both poetry and prisons, and a natural youthful assumption that I was in some way unique. I've since learned that art and the criminal justice system are more ubiquitous than anyone realizes. At current rates of incarceration, nearly 2 percent of our population is behind bars at any given moment.[2]

Twenty years ago our prisons did not incarcerate so many of us. Texas had what was then considered to be a huge system, some 25,000 inmates, the third largest system in the nation, if memory serves. Now it and California are the largest systems in the nation, maybe the world, with over 150,000 adult inmates. Much has changed since 1980. Back then Texas ran what was discovered to be an unconstitutional correctional program, one that employed inmate guards. Being an initiate, I simply assumed all prisons had "building tenders," convicts who carried keys, controlled the cell doors and corridors, and directed traffic in these mini-cities. Now, corrections officers are one of the largest workforces in the state and in other states such as California and Florida, which are more amenable to labor organizing. Correctional officers' unions are the largest labor groups, carrying enormous political clout. Back then, privatization of prisons was hardly a decent topic of conversation; the notion that we would turn over the wheels of justice to business concerns somehow was demeaning to the authority and gravity of our system of law. Now, I work in two states with privatized juvenile facilities, companies whose growth stocks can be traded on NASDAQ.

I was invited into the Texas prison system by Bob Pierce, a man who worked as Assistant Director of Personnel for the Windham School System of the Texas Department of Corrections. Bob had a Ph.D. in Folklore from the University of Nebraska and was a member of the Huntsville Arts Coun-

cil, the organization that contracted me to provide a creative writing residency in the public schools. Bob was into prison culture big time; he'd done graduate work on Ledbelly and later taught graduate courses at Sam Houston State University on prison literature.[3] Windham was a nongeographic school district created by the Texas legislature to provide GED and competency-based high school diploma programs as well as coordinate the vocational and college programs. There were about twenty-five prisons then, and every one of them had a school. Bob's rationale was that if Windham was a school system, receiving state money based on ADA (average daily attendance) just like any other school system, why couldn't it apply for and receive artist-in-education grants from the Texas Commission on the Arts (TCA). After some head scratching and advocating by Marilyn Schieferdecker, who ran TCA's Arts in Education (AIE) program, it was determined that it could. We were pretty sure that this was the first ever state-funded arts-in-education prison residency.

I conducted two ten-month creative writing residencies for Windham before joining staff for about six months and going off grant. During that time I provided workshops for eighteen prisons through the schools, correlating my creative writing exercises to core elements of the language arts curriculum. That wasn't hard. What was challenging was trying to create expressive writing exercises for men and women who were functionally illiterate, operating at or well below a fifth grade level. Out of my three years at Windham came the beginnings of the curriculum I use to this day, an experience-based curriculum emphasizing descriptions of immediate sensory perception, memory, and dreams—universal imagistic experiences that are not age specific but that definitely relate to the genres of poetry, fiction, and scriptwriting. I also taught professional writing workshops at three prisons—my five hours a week of community time under the AIE grant. Most of these men (and these professional workshop students were all male) managed to get published during the three years we worked together. Almost all of them had high school diplomas and some had college degrees. My selection of participants was based on demonstrated talent, and my three years with the TDC and Windham produced one anthology, *Writers Block,* and a film, *Lions, Parakeets and Other Prisoners.*[4] I also managed to bring in about a dozen guest artists.

While the residency had some unique characteristics, it came in at the end of a wave of prison arts programming that had been going on for four or five years. Then, prisons still had as part of their missions a rehabilitative agenda. Now, rehabilitation is no longer even given lip service. The Texas

Department of Corrections went so far as to change its name to the Texas Department of Criminal Justice, revealing in semantic terms a more punitive philosophy. The Federal Bureau of Prisons had a well-developed national prison arts program, and some states, such as Oklahoma and California, had been providing artist residencies to all the prisons in their systems for some time. The Committee of Small Magazine Editors and Publishers (COSMEP) coordinated a prison arts project that provided boxes of small press literature free to prison creative writing projects, and they had a magazine that regularly published inmate writing and artwork. Many publications around the country actively solicited the work of inmates inspired by the efforts of Eldridge Cleaver, Malcolm Braley, Michael Hogan, Ricardo Sanchez, Etheridge Knight, and many others.[5]

One of the first lessons I learned is that there are many working artists in prison—men and women who have already determined that the creation of personal or cultural expressions helps them to do their time and may actually be something they can do when they get out. Even the system in Texas supported this activity to some extent. Almost every facility had a "piddlin' shop," a space where inmates could do arts and crafts. Supplies weren't provided but could be purchased through education and recreation funds, the same money, typically provided by families, that enabled inmates to buy cigarettes or cans of tuna at the commissary. Every year, the TDC organized an inmate art festival, which was held in conjunction with the prison rodeo, and inmates could sell their work and receive compensation. Guards and staff purchased much of the work. The TDC also had a recording studio and maintained three inmate bands that regularly performed at prison functions.

To the best of my knowledge, that is all gone now. Many fine programs still exist to support fine arts programs for adult inmate populations, but they are definitely on the wane compared to the extent of programming and organized support that existed in 1980. The reasons are many and complex. Fundamentally, I believe we began to incarcerate more people than the system could handle, and all treatment programs—education, job training, drug treatment—suffered with the massive buildup of what has been rightly termed "the prison industrial complex." Those institutions without beds began to ship inmates across state lines where there was space. County jails began receiving state inmates for a price. Suddenly, prisons were all about bed space, and correctional institutions, which had never been overly concerned about recidivism rates, began to look upon bed space as a financial resource and locating prisoners as a commodity market.

That's not what ended my presence at Windham. I made the mistake of joining the staff. After two years of working under grants, Windham encouraged me to join the faculty. It was a disaster from the beginning. The students I could serve changed—no more professional workshops, only GED students. Oversight on book publications became an arduous chain-of-command process that lasted months. My freedom to respond to teacher requests and perceived student needs was slowed incredibly. I was even asked to help the prison superintendent write speeches. (I refused.) I was so low on the totem pole that the ground came to eye level. I had originally thought that institutionalizing the arts program was the best outcome I could hope for, but I learned that collaboration between correctional institutions and arts organizations (such as the Texas Commission on the Arts) is a much better route to go.

Contracts protect all parties and clearly define roles and responsibilities. They serve the artists and the prisons. Rather than absorb arts programs into institutional hierarchies, correctional institutions should be encouraged to absorb the cost but continue to operate with arts organizations and artists on a contract basis. In recent years, I have seen the wonderful California Arts-in-Corrections program struggle with this issue to its detriment. Battles with the William James Association, the arts provider for the northern half of the state, and UCLA ArtsReach, the southern provider, instigated by the California Department of Corrections to gain greater control have driven away both providers and left the program in disarray. California developed a system of hiring some artists as facilitators, making them civil servants and requiring them to coordinate activities at their prisons. But prisons are remote, and facilitators cannot take care of the hiring, the invoicing, and the training of resident artists. This difficulty was created by the program's demonstrated success—it was proven to reduce recidivism and incidents of inmate misbehavior, and it has actually saved its host institutions significant amounts of money.[6] When success happens, association with or control over a program becomes attractive, and power struggles can ensue.

Adult penal institutions are traditionally organized around a military-style hierarchy with highly defined chains of command. Like the military, control of information to the outside is of great concern. Departments of corrections operate in highly charged political environments. Without clear missions, public perceptions of what prisons do or are supposed to do range from assumptions that corrections should rehabilitate to assumptions that they should punish. Arts programs, by their nature, get the words and images out. Most curricula are organized around producing culminating

events—performances, exhibitions, and publications. As programs become more successful and the successes and talents of the inmate participants become more evident, the penal hierarchy recognizes that these are not frivolous activities and adjusts to frame them in the context of public and political perception. A highly favorable newspaper article can result in the artist being asked to gain approval before granting any further interviews with the media. Sometimes the oversight is reasonable, and sometimes it is oppressive.

As I was preparing *Writers Block,* the administration wanted to review the contents prior to their publication, which delayed progress. Then they imposed a new system of release forms, which required that I secure permission from each contributor even though all contributions were submitted with a form that granted publication rights. Many of the contributors had been released, and I had to try to track them down on the outside. This extra paperwork was a result of the administration's perceived need to protect itself from inmate lawsuits. All in all, it was a miserable though eye-opening experience. (I've discussed this with many other artists in this work who have felt like they were punished for doing well.) Even though I was no longer under contract to TCA, the publication was funded through a grant from them, which enabled me to get the book published. I was able to convince the state arts commission to apply pressure to the state department of corrections to make it happen. This experience points out the need for contracts with clear delineation of roles and responsibilities.

My parachute from the Texas arts-in-corrections program was a media development grant from the Texas Committee for the Humanities to write a screenplay about the prison years of O. Henry. That research brought me to the Ohio State Penitentiary, where William Sidney Porter transformed himself into a popular writer while doing a three-year, three-month stint for embezzlement around 1900. Back then it was a federal prison. I also became familiar with the accounts of Charles Dickens, who visited the United States twice in the mid-1800s to provide a social critique of our new institutions called penitentiaries.[7] He was not impressed. However, my research clearly revealed that prisoners have occupied themselves with making art since the notion of incarceration began. O. Henry's work was not in any way state supported, but there was an inmate band at his prison and he participated in an inmate-organized creative writing club. Dickens chronicled how convicts in the most confined segregated situations imaginable made fabric collages from bits of wool collected from looms, attempted to make musical

instruments with broken pieces from tools, or spent time writing down songs.

The screenplay was part of a strategy I had hit upon to become an advocate for arts programming in correctional settings. It seemed that many arts-in-corrections programs around the nation were running away from exposure, fearful that the public would decry such programs as contributing to the common clichéd perception that we were somehow running country clubs instead of houses of punishment. My freedom from the TDC allowed me the opportunity to provide a more realistic and historically justified advocacy without being held accountable to institutional censors. I secured another grant from the Texas Committee on the Humanities, this time from their public discussion program, to produce a touring program called *Jailin' in Texas: The Artistic and Folkloric Perspective*. This program toured scholars of prison culture like Bob Pierce and Irmtraud Feigs, who examined the careers of Ledbelly and O. Henry; Renee Jukien and Susan Stone, who worked in and documented correctional culture through film or photography; and the poets Ricardo Sanchez and Raul Salinas, who were former inmate authors. We visited seven Texas cities through programs organized by museums and public libraries, setting up exhibits that ran for weeks and framed the one- or two-day symposia. We enjoyed good audiences and even better media coverage. In each city, we tried to include and support an arts-in-corrections program if there was one. The cities were Houston, San Antonio, Dallas, El Paso, Temple, Austin, and, of course, Huntsville, the home of the TDC.

Between 1985 and 1988, I held three nine-month contracts as artist-in-residence with the San Antonio school district. Like my prison program, these were Texas Commission on the Arts grants, which supported me on a half-time twenty hour per week commitment. This allowed me to visit other programs for brief stints during the school year and conduct residencies in the summer such as the one for Bexar County Jail. A conference hosted by UCLA ArtsReach in 1986 called *Art in Other Places* brought me into contact with many other artists around the country who were conducting residencies in alternative spaces. UCLA ArtsReach and the William James Association, the two aforementioned contract arts organizations for the California Department of Corrections, brought me out to California several times as a guest artist between 1986 and 1991. During that time, I was able to visit about a dozen prisons.

If I seemed to disparage the California program earlier in this chapter, it is only because I have always held it in such high regard. It was once the most comprehensive arts program for a state's adult prison population in the

nation, probably the world. Even in decline, some twenty-five years or so after its inception, it is probably still the largest, most well-funded program anywhere. The California program arose with many notable contributors, but at its heart was the friendship between an artist who voluntarily developed an arts program on death row and a state senator who sat on the appropriations committee. The result was a line-item appropriation for arts programming to the Department of Corrections for the purpose of conducting arts residencies at every prison in the system. The program was effectively nurtured, developed, and sustained through the dedicated leadership of Susan Hill with UCLA ArtsReach and Ellen Davidson with the William James Association. The contributions of both women to the world of the arts and community continue, but I feel the California program is reduced by their absence.

An encouraging trend of the past decade has been that arts-in-corrections programs in other states have had similar beginnings. Arts-in-juvenile-justice initiatives have sprung up in Idaho, South Dakota, Alabama, and Mississippi through dialogues between individuals in state arts councils and state legislators that have resulted in significant appropriations for such programs. As I survey the contemporary landscape, I see no more promising development than the interest and leadership of state arts councils in working with legislators and other state agencies to develop programs for offender populations.

Although I had many guest visits to programs in Texas and elsewhere, my next correctional residency that lasted for more than a couple of weeks took place in the Bexar County Jail of San Antonio. This program was organized by a faith-based outreach organization. Religious organizations were allowed much greater entry into correctional facilities in the 1980s than any other type of institution. The Christian charismatic movement had gained political and social approval, and if an inmate could demonstrate convincingly to a parole board that he or she had been "born again," it could serve as grounds for parole being granted. This no longer appears to be true. Mandatory sentences have reduced greatly the issuance of parole, and it became clear by the end of the decade that those who pretended or actually experienced a religious transformation were just as likely to re-offend as those who did not. It should be noted, however, that many prison ministries currently account for the need of a social net to support ex-felons when they leave prison, and they have generated after-care models that truly attempt to restore criminals to communities. This effort is sorely lacking in the criminal justice system as well as in the development of arts programs in correctional

settings. Arts organizations that undertake correctional work are in a wonderful position to connect the adults and youth in their programs with outside cultural resources that could sustain the arts experience when inmates leave correctional settings, but they rarely do except in very informal ways.

The organization I contracted with in San Antonio was called United Ministries and was very liberal in nature. Its mission seemed to be to make the experience of incarceration less damaging and as humane as possible. I conducted a ten-week residency under the guidance of lead artist Nivea Gonzales. The greatest accomplishment of this residency was that Nivea and I managed to put together an exhibit on inmate art for the Institute of Texan Cultures. We focused on inmate jail graffiti, tattoos, and panosart, a traditional use of handkerchiefs as canvases for spiritual and artistic expression. An important lesson here was that inmate correctional culture supports its own indigenous art forms in much greater complexity than the generally recognized relationship between the blues and prison field songs. California, with its long history of prison arts programs, was the first to raise the level of debate about whether the arts traditions of the West, which were the mainstay of arts residencies, might represent a sort of cultural imperialism. We were pushing mainstream and elite models when there was an already active and vital arts vocabulary at work in prisons that was invisible to the public. Judith Tannenbaum comes to mind as the most articulate spokesperson for this issue. I tried to make my curriculum as open as possible and to instruct rigorously in how to use the tools of creative writing, leaving the specific end product up to the workshop participants. I did not guide them into therapeutic or prosocial domains. Nor did I look for social critiques. I did try to use the workshop environment to encourage an appreciation of audience, an understanding that readers had needs and expectations. Whether the students chose to accept or subvert those expectations was entirely up to them, but I felt I owed them the perspective of professionals rather than simply providing them an opportunity to journal.

My travels in the late 1980s took me to other programs around the country. One of the most notable was a bibliotherapy program in Colorado at the Buena Vista Correctional facility. In the 1970s and early 1980s, prison librarians often developed programs that employed the arts. However, with the massive expansion of prisons and prison populations, one of the original principles of the penitentiary system as devised by the Quakers—that of quiet contemplation, reflection, and penitence supported by reading—has been abandoned. Prison librarians are becoming more and more scarce, and their previous role as cultural programmers has been radically diminished.

Another institution, the community college, once held great promise for supporting arts programs in prisons. When I entered the Texas prison system, regional community colleges provided academic courses to inmates. Some, like Lee College in Baytown, had more students behind bars than in the free world. The prospect was there for community colleges to offer courses in studio art, music, or any of the art curricula existing in their course catalogs if enough students enrolled. But 1980 saw the election of Ronald Reagan, whose administration saw to the termination of educational Pell Grants for inmates. Attitudes to offender populations continued to harden, as evidenced by George Bush's highly successful Willie Horton commercial campaign employed against Michael Dukakis. Suddenly, arts programs for prisons began to die out. Sensational cases such as the murder committed by inmate author Jack Abbott after his release were used to indict arts-in-corrections programs even though Abbott had never been associated with such a program. All prison systems were stressed by the massive influx of inmates in the late 1980s and the rise of the prison gang as a competitive force of prison control. Basically, prison systems were hearing from the public and politicians that we needed to hurt inmates not help them. Good time and parole were removed as behavior management tools, making the job of prison administration much more difficult. Prisons were forced to redirect their energies and resources to increased security and guard staffing. An arts program—or any of the educational, vocational, or counseling programs— might be readily dismissed for unrelated systemic conflicts. The arts program in New Mexico was abandoned after a riot even though arts programs were proven to reduce inmate misbehavior. Texas abandoned its arts programs after the federal government took over the system because of overcrowding and the use of inmate guards. Leadership from Washington retreated as the Federal Bureau of Prisons starved its arts programs to death. The fact that any arts-in-corrections programs for adults survived the 1980s is a testament to their effectiveness as something that inmates wanted and that enlightened prison systems realized they could hold out as incentives.

My most long-lived relationship with a correctional facility, one that continues to the present, began in 1985 with the Corsicana State Home, a Texas Youth Commission facility for juvenile felons who are emotionally disturbed. This former state orphanage about an hour from Dallas had been converted into a long-term residential facility for youth who, basically, were as dangerous to themselves as they were to others. Many had been diagnosed as schizophrenic or manic-depressive. Most were on medication and were being supervised for suicidal tendencies. This residency came about as

a local partnership between the state facility's volunteer coordinator, Lucy Humbert, and Sylvia Bonin, the director of the local art agency, the Navarro Arts Council. Sylvia was one of the more active arts providers for schools in the local counties, and in the mid-1980s she began bringing those artists into the State Home as part of their residencies. Lucy had access to the Wende Funds, an account that had been set up to serve the kids in the facility by orphans who had grown up there. Humbert and Bonin integrated the arts into their spring and summer curricula, bringing highly regarded artists from North America and Europe through the facility. Because of my previous work in the prisons, I was trusted and brought in every year to partner with new artists for a few days. That relationship extends into the present.

This model program is notable for two very special reasons that make it replicable in contemporary times. It represents a partnership between a state juvenile correctional facility and a local arts agency (LAA), which provides arts services to youth across school district lines and sometimes in several counties. The LAAs, as they are called, can be found across the country, and through the leadership of the National Assembly of Local Arts Agencies, now Americans for the Arts, they have been encouraged to employ artists and provide guidance in utilizing best practices to serve all populations in their domain. They are natural partners for correctional facilities, which have traditionally been located in highly remote rural areas.

The second attribute of this program is that the State Home, now renamed the Corsicana State School, is a school within a school. The Texas juvenile justice system perceives its facilities to be training schools, and within these "training" facilities, TYC also runs its own academic school system and hires its own teachers, just like the Windham School System of the TDC. These schools provide GED and high school diploma programs, and many of the facilities have art teachers. Some state systems are designed like Texas's. Other state juvenile systems contract with neighboring school districts to provide the same academic services as free-world kids receive. Because these youth may be incarcerated for years, there are state and federal guidelines requiring they have access to educational opportunities. These schools can be ready-made partners for arts programming; many training schools struggle to meet state requirements in arts instruction and therefore welcome arts partnerships. This model has proven to be a survivor of the past two decades.

Soon after my residency in the Bexar County Jail, I had my first experience with what would become the next big trend in arts-in-corrections. In

1989, I conducted a ten-week residency in the Bexar County Juvenile Detention Facility. This was an eye-opener. In the TDC, I worked extensively with members of prison gangs; the Mexican Mafia, Texas Syndicate, Aryan Brotherhood, and others all had significant representation in my creative writing classes. I'd learned that there was a sort of patriarchal code that discouraged the participation of youth. These gangs were for men and women, not kids. However, with the rise of the highly addictive and highly lucrative drug crack in the late 1980s came the tidal wave of Bloods and Crips, which then fragmented into a multitude of youth gangs all armed with the nine millimeters so easily obtained in our free-world society. Juvenile crime was on the rise, and the public lived in terror of drive-bys. These were not the kids from Corsicana, who would never have been able to function in a gang environment. I discovered that these kids often had parents behind bars and that for them life behind bars was more familiar than successful mainstream life. They knew the Texas prison system almost as well as I did, though their perceptions were tinged with a sort of romanticism that I knew to be false.

Beginning in the late 1980s, incarceration of youth paralleled the massive increases in the adult system. The strategy of certifying youths as adults so that they could be judged by the adult system became a common practice, though they served their sentences in overextended juvenile facilities until they reached the age that allowed transfer into the adult system. One interesting phenomenon that accompanied this influx was that child-care workers in the facilities noted the arts interest and talent of the youth under their supervision and began requesting some type of arts instruction for youth. Rather than the outside-in process of the 1980s in which artists and arts organizations took the lead in developing programs behind bars, the beginning of the 1990s saw an inside-out movement, with county and municipal juvenile systems actively seeking partnerships with arts providers.

In 1989–90, I spent a year in Peru on a Fulbright Research Grant that allowed me to collect and study Andean folklore. While there, I managed to work with a theater project for women incarcerated in a Lima prison, a wonderful program, which was supported by U.S. drug intervention money. I won't comment much on that here except to say that it was my first international experience, one that I was able to extend to Ireland, Northern Ireland, and England later in the decade.

While in Peru, I carried on a correspondence with Dianne Logan, the public information officer of the Harris County Juvenile Probation Department. Logan was attempting to build an arts program for the massive Houston juvenile justice system, the third largest in the nation. Harris County

JPD operated three county residential facilities for youth: a five-story deten-
tion center, a long-term residential facility, and a residential halfway house.
In 1990, when I returned from Peru, they also managed ten field service
units—offices that worked with youth and families in the community. The
probation department enjoyed a friendly relationship with a member of the
Brown family who sat on the board of the Brown Foundation (the same
Brown that one finds in the oil company Brown & Root). Other grants were
secured as well, and the probation department contracted with five Houston
arts providers to create their program. The providers were the Art League of
Houston for visual arts, Southwest Alternate Media Project (SWAMP) for
video instruction, Writers in the Schools (WITS) for creative writing, Shake-
speare Outreach of the University of Houston for theater, and Chrysalis
Dance Company for dance. To the best of my knowledge, ten years later the
only provider continuing is Chrysalis, but in 1992 this program operated
with an annual budget of more than $250,000 and provided residencies for
some thirty-five artists of all genres. That same year StreetSmART, as the
program was called, was recognized by the National Council of Family Court
and Juvenile Judges as "The Most Unique and Innovative Juvenile Justice
Program in the Nation."

StreetSmART was a victim of big city politics. The chief of the Juvenile
Justice Department, John Cocoros, retired and took Dianne Logan with him.
(Later, we three created the Southwest Correctional Arts Network [SCAN],
a nonprofit organization, which supports arts-in-corrections work.) They felt
the art program would be in good hands with their successor, who was not
only a supporter of arts-in-juvenile justice but also a favorite of the Brown
Foundation. However, the new chief ran afoul of the probation department
board. There was an acrimonious struggle, and she left. The Brown Founda-
tion support went with her. In the year 2000, I find that there are many
foundations willing to support arts-in-corrections programs, but personal
contact seems to be a critical element of maintaining support. Often, ready
access and a friendly face are more important than a twenty-page program-
matic blueprint with assurances of effectiveness in dealing with some juve-
nile justice problem.

StreetSmART was remarkable for several reasons, but its most notable
accomplishment was that it provided a prevention, intervention, and after-
care program—a total wraparound—without really meaning to do so. The
department felt that young offenders needed the arts and tried to provide as
much as possible. Youth were not formally referred from one program to
another, and we did not track as well as contemporary programs do, but

StreetSmART had programs for youth on probation in the community and for youth who were incarcerated in the county system either as residents, as short-term detainees, or in transition. The artists and arts organizations also referred youths to community arts organizations so they could continue their arts experience. Dianne Logan was a wizard at creating exhibits and working the media. She wore a button every day that read "Have I told you about StreetSmART?" when her primary role was that of spokesperson for the juvenile justice system in the third largest city in the nation. Dianne is the kind of visionary juvenile justice professional who not only gets why arts-in-corrections is so important but can make the criminal justice system and staff adapt to benefit from such programs.

By the 1990s, I found myself no longer in demand so much as a community artist but as a consultant who helped develop and implement arts-in-corrections programs. Another great need of the arts-in-corrections field in the early and mid-1990s was advocacy support. Arts organizations had their own constituencies, which might or might not be supportive of developing programs for juvenile and adult offenders. The criminal justice system was also trying to become coherent and accountable and was willing to support programs if they were data based. While my time with a specific program was not nearly as long as some others who have worked in this field, I seemed to have the big picture, and that gave many programs around the country the necessary sense of security that they weren't going too far out on a limb but were actually at or near the cutting edge of the fields of community arts and corrections. I became somewhat of a vagabond, an arts-in-corrections mercenary. (In actuality, I was putting my degree in anthropology to work.)

In this essay, I have tried to identify trends and model programs, but I hope I also have been able to relate them to the culture of the times. What I tried to do was not implement some scheme of an ideal program in all the different sites I visited but rather determine what wanted to happen in any given situation. I became a matchmaker for corrections and the arts, recognizing that every relationship was unique and had its own assemblage of personalities, cultures, and wants. Sometimes I translated. Sometimes I sealed the deal. Sometimes I taught. Sometimes I just listened so that the real practitioners could articulate their thoughts and figure out where they wanted to go. I bring this up because I am a consultant who is not a big advocate of consultants. We can help with many of the chores and sometimes transform obstacles into opportunities, but every program should look first to its own community for resources and expertise, cultivating its own leadership and autonomy.

William Cleveland

Common Sense and Common Ground

Survival Skills for Artists Working in Correctional Institutions

Common Ground

One of the first points I make to artists considering work in detention centers, prisons, mental hospitals, and other locked social institutions is that no two sites are alike. I tell them that it's dangerous to generalize about communities or institutions or to assume that the way things work in one place will apply to any other. I warn them that they will encounter a different reality in each place they work.

Nevertheless, when you converse with artists who have worked in these institutions, as I did when writing *Art in Other Places,* you can't help but become aware that there is a common ground that they all occupy, regardless of their particular constituency.[1] That common ground is the subject of this chapter. The shared territory I describe here is a unique sensibility—a sensitivity even—that appears to allow artists to function successfully in the most tentative and unpredictable environments. It is a way of working whose basic ingredients are a commitment to excellence and plain old common sense.

The best way for me to share this information is to assume that you, the reader and the institutional or community site you are approaching, are virgins. That is, neither have had a prior institutional arts experience. I will take you through the experience chronologically and introduce useful information when appropriate. My focus here will be on "inside" skills that might be characterized as diplomatic or bureaucratic rather than artistic. Other important areas such as funding and external political strategies are not ad-

dressed here but should be considered central to the success of these endeavors.

The Visit

Of the many paths that lead artists to work in "other places," this is probably the most common. I often recommend a visit as a painless way for artists to satisfy their curiosity and, more importantly, to check out their own reactions to what is often a very alien environment.

By suggesting a visit, I don't mean just showing up and assuming someone is going to be able to show you around. The best way to find out what is going on inside a hospital or prison or a community corrections program is to call or write, asking for a tour. Most will be more than happy to accommodate you.

Some people experience a strong, negative reaction to institutional environments. That is to be expected. There are many discomforting things to be found in these places. One of the purposes of your visit is to measure your expectations against reality and, quite simply, to find out if you can handle it. Most of these places are not horrible and depressing. They will, though, be very different from what you are accustomed to, and there is often an intensity that can seem overwhelming. There are some institutions that are in bad shape. It is best to find out how you are going to react to these conditions before you consider further involvement.

When you visit, use your artist's eyes and ears to filter and evaluate your impressions. What do you see? What do you feel from the place? Is it open or closed physically, emotionally, spiritually? How does the staff interact? Do they take the time to speak to you? How do they communicate to the clients? Are they tired, hassled, burned out? Are they alive, energetic, friendly? Consider the facilities. Are they clean? Do they seem efficient, controlled? What about the prisoners or patients? Are they healthy, alive, active? These and many more observations should be made. This may seem a lot to ask of a simple, often closely supervised jaunt around a facility. It can and should be done, though, if not on this visit, then on subsequent ones.

The Approach

Okay, you have made your visits, and you have decided to introduce yourself formally to the site you have your eye on. You feel you've learned enough about the facility, staff, and clients to begin talking to the powers-

that-be about doing an incredible project. You shove your portfolio or tapes and resume under your arm and put your hat on and away you go. Right? Wrong. You have quite a few questions to answer and lot of work to do before you are ready for that.

To begin with, who is it you are going to see? Do you have an appointment? How much time have you got? Most importantly, what are you going to tell them? Specifically, what is it you are asking them to let you do? Who are you? Are you qualified? Finally, how do you look? Here are a few more basic things to consider before you charge out the door.

Prepare: The questions above and more should be considered before you find yourself sitting in a busy program administrator's waiting room, waiting and waiting. Although it may not turn out to be the case, you should anticipate sitting across the table from a middle-aged, overworked, under-paid, burned out, one-time idealist bureaucrat who has a latent fear of artists and art. You should be prepared to convince him or her that it would be in their self-interest to commit a portion of the facility's already overburdened resources to you and your project. Thus prepared, you will have a less than fifty-fifty chance of making your case successfully. Without some groundwork, you probably won't even last five minutes.

Research: Through your site visit and from other sources—the library or a university or a friend or even this book—you should have learned something about the history and current status of the site you are approaching. The most valuable piece of information you can take with you on your interview is a sense of place. What are its problems, achievements, and needs? With this information you can develop a program that is responsive to the institution's point of view.

Self-Interest: Keep in mind that self-interest drives the bureaucracy. Bring a brief narrative description and an outline of your project that simply and clearly states what it is you want to do and how it can contribute to the administrator's mission. Notice I say "administrator's mission" and not necessarily the overall mission of the facility. You hope these are one and the same, but this may not be the case. Also, make sure that whatever you have proposed is in keeping with your goals as well.

Impressions: If self-interest is the number-one driving force of the administrative life of a program site, impression is a close second. By impression, I

mean the way things appear, rather than the more objective and seemingly reliable "way things are." While it is true that administrators and program staff generally communicate in bottom-line, concrete terms about their work and the services they provide, many institutional decisions and attitudes have their basis in subjective impression. Some say that in bureaucracy impression is reality. While that statement is subject for debate, I say assume that it is true and you have a better chance of making a good first impression.

To do that, it is important that the artist recognize that many people have a very narrow, stereotypical idea of what an "artist" is. The image of the sloppy, wild-eyed, undisciplined, bohemian artist still lives in the minds of many. Some artists and the media help to feed this impression. To the average person, this image is considered romantic or comical. To the administrator or program director responsible for clients who are "crazy," "incontinent," or "violence prone," whose universe is dominated by federal and state rules and regulations, lawsuits, and union negotiations, there is a distinct possibility that you will be seen as a nuisance or a threat. Add to this the real anger some hold toward the high-profile, elitist art world, and you can see that artists have their work cut out for them.

This situation, of course, will not always be the case, but it is best to be prepared. To mediate a possibly negative reaction, use common sense. Dress conservatively. Be yourself, but try to stay away from the "image." Communicate clearly and succinctly. Don't edit out your passion, but temper it with the concrete. Show examples of your work. Show your knowledge of your field and of the administrator's field. Ask questions. You are talking professional-to-professional. Command respect. If you are sent packing, so be it. If you generate interest, you have begun on the right foot. If you feel these few suggestions may cramp your style, then maybe this type of work is not for you.

Being There

I'm going to jump forward now and assume that your proposal has been accepted and you are ready to begin establishing your program. Ideally, you have been able to build to this point in stages. By that, I mean that both you and the site have had the opportunity to establish a relationship through increasing increments of commitment, beginning with a one-time workshop or a short residency and building to a project lasting a year or more. Unfortunately, this does not often happen. Regardless of how you start out, here

are a few things you can do that will help you build a solid base for your program.

Introductions: Some advise starting at the top and working down when making introductions. I say, start at the bottom, and you will learn more on your way up. Begin with the bottom-line program and maintenance staff. In many institutions these people are called "line staff." Tell the line staff who you are and what you're going to be doing. Introduce yourself as a newcomer and inquire if you can ask their advice when you have questions. Then let them tell you something about what they do. Listen hard. Assume that some time in the near future the success or failure of your project will depend upon their cooperation and skill. This may sound dramatic, but it will probably prove true.

As you meet your fellow workers, try to imagine what it's like for them in their jobs. Get an organizational chart and a description of the various jobs and responsibilities. Compare what you read with what you are hearing. Once again, call upon your artist's sensibilities to construct a picture of the formal and informal relationships that hold the site together or threaten to tear it apart.

Listen: In these first few days you will probably hear many stories. Once again, listen hard. You are hearing the institutional memory. Many of these stories will contain snatches of what I call the "prevailing winds." In the wind, you may hear something about staff morale, the director's expectations, or an impending crisis. Listen, and you will learn something about the prevailing work ethic and program philosophy. Over time, the stories you gather will tell you much of what you need to know in order to survive in your new home.

It's important for you to recognize that during your introductory tour your fellow workers are meeting you, too! Think of this as your second round of interviews. The very fact that you are taking the time to talk and not asking for something is a plus. For many of those you are talking to, though, their bottom line will be quite simple: Can you be trusted and how much extra work is your program going to mean?

Generate Trust: Opinions about your trustworthiness will be formed as a result of the way you operate in the early going. The hard part for you will be to realize that your professionalism and years of training will not legitimize you. Most people have no idea what an artist does. If they do know, in

the context of their work they probably place little value on it. Your credibility will be based upon the respect you pay to their turf. For the first few months, you are the student, and your fellow staff members are your teachers. The more questions you ask of your co-workers, the more you validate their knowledge and the more they will learn to trust you. If they perceive that you are going off half-cocked, they will bury you.

Face Reality: Any new program means more work for others. The staff will know this. They also know that you need them more than they need you. I have always felt the best approach in this situation is to meet it head on. Speak to the people whose services you will be using the most. Try to learn what works, and more importantly, what ticks them off about their jobs. At some point, communicate your awareness of what it means for a new program to be coming in and indicate your willingness to do anything that will make their job easier.

Setting Up Shop

Now that you have set the stage, it's time for you to begin doing what you came to do. As I said before, you have been the student. By this time you are probably itching to move into familiar subject matter and establish your own identity in this unfamiliar place. As with earlier pioneers, you are feeling your territorial imperative. That's good! Insecurity is a powerful motivating force. It would be helpful to remember, though, that the valley you have moved into has already been settled. At this point you are a squatter. Here are a few things to keep in mind while you are setting up shop in your new neighborhood.

Perspective: You and your students are cogs in the institutional wheel. You can't get where you want to go unless you learn to work the wheel. Your students know that. They want you to know it as well. Your goal is to end up in a classroom with your students, unencumbered, so that you can teach. The folks who are in charge of the machinery that turns the wheel grant you that privilege, not your students. This is a hard perspective to keep, but try.

Often, with visions of organization charts, job descriptions, and institutional protocols swimming in your head, it is hard to keep in mind why you came to this place. Don't lose your vision! At times, you may need to think like a bureaucrat, but you must learn to shed that skin once you hit the classroom. Your power comes from your art and your ability to teach. You

and your students can transcend the institutional wheel through the knowledge and skills you have come to share. For you to be successful, the passion and excellence you embody must have a forum, a place to shine. If you find yourself regularly compromising your own standards, question what you are doing.

Assessment: Now, the students. Who are they? Where are they? What do they want? What do they need? In the vernacular of the bureaucracy, it is time to do a needs assessment. Depending on the size of your potential student population there are a number of approaches. Become a cultural anthropologist. Find out what the "clients" of your facility think and know about the arts. The reactions will probably range from puzzlement to anger to "expert" criticism. Also, find out what is already going on. If you are barging in on someone else's turf, engage them as potential partners not adversaries.

Respect: Regardless of what you find, it is important to recognize that you are joining an already existing culture rather than establishing one. If you see yourself as a cultural missionary or a benevolent fixer of ravaged souls, you are probably barking up the wrong tree. Respect the people you are working with until they give you reason not to. It is crucial for you to be open and nonjudgmental about what you learn from and about your prospective students and staff. If you are not, they will know it and probably freeze you out. There is great power in neutrality. By that I do not mean being numb or uncaring. You will meet many people with strong opinions in your work. Once again, I encourage you to listen and learn.

Think Small, Slow, Less: Yes, it's true. In most institutions, small or large, it does take five to ten times longer than it should to get anything done. As an artist, you are used to being in control and setting your own pace. You will probably not have that luxury working in an institution. You must learn to be patient without losing your creative edge. This is one of the ultimate tests for a highly motivated, independent artist working in an institution. Try to think of it as another rhythm. As you learn the ropes, the beat will quicken a little. For right now, the snail's pace is to your advantage. You may be starting to feel at home, but you are not. For your own protection, you need to steel yourself to thinking "small, slow, and less." Your first class or project must be designed for success. It is your debut. If you trip over your gown, your fall may be a long one.

Design: At this point you are probably rethinking your plans. You know your subject. You know what works. If you are considering a change, don't alter the heart of what you came here to do. Your program should be geared to your needs as well as your students'. Although you are a novice and a stranger outside of your classroom, when you are in class you are in your element. Make the best of it. Any modifications you make should relate to pace or schedule, not content or quality. These are your standards, your credentials. Don't compromise them.

Educate: Once you start, you may feel some pressure for quick results or "large numbers" (i.e., art shows, concerts, large class sizes). Resist with all your might. A way to avoid this is to present your program design ahead of time as a plan or curriculum. If you are lucky, the powers-that-be will buy into it right off. It will help to remind them that you are not a baby-sitter, therapist, English teacher, or custodian. Later, when you are being pressed to build a booth for the county fair or produce a mural in the next two weeks, your approved plan may help you avoid being dumped on or taken advantage of. If this does happen and it takes you by surprise, it shouldn't. Remember, most of the people you are working with will have only the vaguest idea of what you are doing there. Keep in mind that your definition of quality will probably not be shared by many of the people who have invited you here. It would be unreasonable on your part to expect otherwise. Your requests for adequate preparation time or proper materials may in fact give rise to resentment. It is up to you to educate your co-workers as well as your students.

Communication

Once you have established your program as a regular and consistent activity, its survival and growth are almost totally dependent on how well you communicate. There are many methods of communication used in institutional and community environments. The following are some traditional and nontraditional modes of communication common to organizations.

Conversation: Understandably, information, reliable and otherwise, is most often shared through informal conversation. As I mentioned before, you can learn a lot from the stories and complaints of workers and clients. Taken with a grain of salt, lunchroom or coffee break chatter will probably be one of your best sources of information. Join in. Conversation is a good

way to turn the "art person" into a human being and inform people about your program. These informal situations can also be good places to ask questions or test the water with new ideas.

Rumor: Rumors are an integral part of community and institutional life. For staff and clients who are far removed from the place where decisions are made, they can be both informative and entertaining. They can also be dangerous. There is usually some element of truth in every rumor. Good management will be aware of the current story making the rounds and will act to quell or clarify. Poor managers will be oblivious or ignore what is often a good indicator of problems, real or perceived. The source and nature of rumors will also tell you a lot about the morale of the place where you are working. Most importantly, when you hear a rumor that involves or impacts you or your program, don't panic. Quietly go to those you trust, and try to find out what is really going on.

Meetings: If you are asked to attend a meeting, you may be beginning to make your presence felt. Being invited to meetings is a sign of bureaucratic recognition. The best meetings are short and informative. The worst go on forever. If you can, try to avoid the latter. Meetings are often very good places to learn what is going on in the institutional world surrounding your classroom. Once again, listen and learn. As you do, pay attention to the way people relate during the meeting. You can learn a lot watching the interpersonal dynamics among the participants. Before you decide to take an active role in a discussion, have some idea what it is you want to accomplish by doing so. If you have a problem, be prepared to offer a solution. If you have a new idea or a possible solution to someone else's problem, be prepared to invest some of your time and energy.

Memos: As alien and distasteful as it may seem to some, the memorandum is often the most effective way to pass on information in an organizational setting. Judiciously used, memos can be a particularly useful tool for "outsiders" or "program types" who are assumed to be bureaucratically unsophisticated. Memos are often used to reiterate or clarify an agreement made in a meeting or informal conversation. A written reminder can come in handy when you find your verbal requests being ignored. Memos catch the attention of the reader and provide a record of your efforts. Memos can also be used to keep higher-ups informed about the progress of your pro-

gram, or to point out future problems and recommended solutions. Finally, when you receive a memo, don't trash it. Read it; then, follow up.

Events: For various reasons, institutions often want to create a product or event of some sort. Conferences, community meetings, publications, videos, staff retreats, and holiday celebrations are significant because they are visible and leave a lasting impression. There is nothing that you can do that holds a greater potential for positive payoff or devastating failure than participation in a special project of this type. Think long and hard before you accept a major role in a high-profile institutional event. If you do, try to make sure you have some degree of control over your part of the project and do a good job. Remember, because you are an artist you will be expected to perform miracles.

The best event to undertake is your own. Nothing promotes the value of an artist's work better than an artist's work. In the often-difficult institutional environment, artistic events or products created by your program can provide a breath of fresh air. They will also leave a clear and lasting impression of what your program is all about. For many who live and work in your site, your art program will not exist until they can touch or see it. An exhibition, production, or publication may be the only means available to truly communicate how the arts address the community's needs. Once you have established yourself "inside," these activities can also be used to provide a unique bridge between the site and the greater community.

People

Much of what I have shared in this chapter has been about developing good working relationships with clients and fellow staff members. Whether you are a visual artist, a performer, or a writer, the success or failure of your project or workshop will depend almost entirely upon your ability to earn the trust and respect of these people. As you work to gain acceptance for your program, there are some people who will be particularly important. These are individuals who have the ability to help or hinder your progress.

Line Staff: Line staff, of course, is not a person but rather a category of worker. In a prison the line staff are the uniformed correctional officers. In a mental hospital they might be called psychiatric technicians. Nurses and nurses' aides fill the line staff role in hospitals and convalescent facilities. The vast majority of social service and community agency managers will tell

you that their line staff are their most important workers. Their work is often referred to as "being in the trenches." These are the people who are responsible for the majority of the ongoing activity taking place in your site. They will bear the largest portion of the extra work that will be generated by your program, and you will need their cooperation the most. It is vitally important to cultivate a good working relationship with them.

Your Supervisor: You will probably have no say over who supervises you. Actually, if there is someone assigned to look after you, you are ahead of the game. Often, particularly at smaller sites, the supervision of the resident artist is not a major priority. If you do find yourself playing the "lone ranger," you may end up isolated and uninformed. In some instances this can be a blessing, but having a supervisor in the chain of command is usually preferable.

Ideally, a good supervisor will act as your organizational guide and will advocate your interests with the powers-that-be. In order to do this effectively, he or she must know what you are doing and why you are doing it. When you have a problem or a need, present your supervisor with all the relevant information and suggest a solution if you have one. Most importantly, your supervisor must feel that it is in his or her self-interest to go to bat for you. Your job will be to convince them of that.

The Benevolent Expert: Within institutions large and small, there are basic administrative activities that require specialized knowledge and training such as finance, procurement, maintenance, personnel, and contract management. If you are very lucky, it will be someone else's job to make the bureaucracy respond in your moment of crisis. This seldom happens, though, and left to your own devices, the administrative jungles can be very confusing.

Often the only way to make sense of it all is to enlist the help of a benevolent expert or two. This is someone who knows his or her way around the bureaucracy and can get things done fast. These people are so important that you should be cultivating them from the first day you arrive. Don't make the mistake of asking for their help at the last minute.

The Arch Enemy: No matter how hard you work or how cooperative you are, there is the possibility that someone in your facility will resent your presence enough to try to disrupt your work. At first there will be a number of people on site who feel that your program is a waste of time. This is to be

expected, given the often-difficult living and working conditions that exist in many facilities. In time, most will come to appreciate your contribution. Occasionally, though, there will be people who will go out of their way to make life difficult for you. Regardless of how prepared you are for this, it will probably come as a shock. Don't panic, and more importantly, don't take it personally. Feedback from others you trust will help you learn to recognize the difference between staff or clients who are incompetent or overworked and those who are truly out to get you. If the going gets rough, it is even more important not to try to go it alone. No matter how bad it gets, don't be tempted to respond in kind to your arch enemy. The last laugh will probably not be yours if you do.

The Guardian Angel: One of the best ways to avoid getting in trouble is to have someone on staff who will go out of their way to help and protect you and your program. The ideal guardian angels are veteran senior staff members who really know the ropes and are willing to share their knowledge and use their influence on your behalf—those to whom you can go with the most difficult and sensitive problems. Needless to say, a guardian angel is invaluable. If you are lucky enough to find one, be careful not to abuse his or her generosity or take him or her for granted.

This chapter is meant only as a primer and can in no way adequately prepare you for work in a social institution or community site. Hopefully, if you are working or are considering work in a social institution or community site, there are those in your community who are experienced in this work and with whom you can talk. If this resource is not readily available, *A Manual for Artists Working in Community and Social Institutions* (available from the Center for the Study of Art and Community) includes a national directory of artists and organizations doing institutional work.[2] Good luck!

James Thompson

Doubtful Principles in Arts in Prisons

First, three examples from my experience of arts in prisons.

One from somewhere near the beginning . . .

Origins: A Cell in the Loire

A number of years ago I was on holiday with my family in the Loire valley of France exploring the countryside and the range of impressive historical buildings. One huge stately house offered up not only beautiful gardens but also the chance to freely roam the dungeons. For someone who works in prisons any chance of seeing the incarceration systems of old is always met with ethically suspect glee. So I immediately descended. Literally and metaphorically, as we climbed down steps, I weaved historically doubtful stories for my intrigued young daughter. We wound our way through endless caverns and dark rooms, up circular staircases, and imagined the horrors faced by the long dead incumbents of these grim cells. Each one dark, dank, and full of shadowed half-light in which I imagined possible stories of religious persecution and terrible suffering. I almost convinced myself that the smell of lingering sweat was a remnant of centuries of oppression rather than the natural odors of my fellow tourists on this hot French summer's day.

Halfway up one narrow stone spiral stairway was a larger than average cell, which, according to the guidebook, had housed a particularly famous

prisoner. My daughter careened in, ran around, and then left, shouting *next!* I went in and looked around in the semidarkness that was only lit through the narrow slot in the stairwell beyond the door. What I saw astounded me. On the far wall was a series of religious images painted onto the stone. On the near side wall, to my left, was a large image of a man, which my brochure informed me was a self-portrait of the artist, the prisoner. On the wall to my right there were images of the countryside. Fields and hills were adorned with people and animals. The paint was dull and peeling in many places, but on closer inspection I noted that the images of animals were often slightly and clearly deliberately wrong or mythical. There were horses with bulls' heads, and sheep with human heads. Minotaurs and unicorns were playing in what were once green fields; now they were sadly faded.

This cell in the Loire valley had been transformed by the prisoner into an artist's studio. What I caught a glimpse of there were the remains of his collection, often painted on and over each other, now sadly flaking, ageing, and barely visible. It seemed he had used his artwork to express his beliefs. The religious images must have in some way acted to maintain the convictions for which he had undoubtedly been imprisoned. He had also used his art to create an image of himself—a permanent, perfect, and ageless image, which I doubt looked much like he did after years in that room. Finally, he had created a vision of what lay beyond his cell. He had remembered the countryside on his walls, at the same time playing with that memory by adding the fantastical and the imaginary. The art played many different roles in that room. There seemed to be no one reason why he had painted. I crept out of this cell realizing that here were the arts in prison, leaving a story far richer than any of the others that I had been telling my daughter on our vicarious tour.

One from somewhere in the middle . . .

Dilemmas: A Church in Brazil

In 1997 I paid my first visit to Carandiru prison in São Paulo, Brazil—a prison that with 7,000 prisoners holds the record for being the biggest (in terms of number of inmates) in Latin America. With my British and Brazilian colleagues, I was there to run a pilot program of theater-based AIDS/HIV education workshops.

Our venue was the Salão Nobre—a huge cavern of a hall, with a high balcony at one end and a stage at the other. It was like an opera hall without the seats. The evangelical prisoners were working on the balcony, and there

were various inscriptions on the walls quoting the Bible. There was confusion about whether the space functioned as a theater or a church. Whichever it was, the ambiguity was an appropriate frame for the confusion of meanings and interactions that took place on that day. Outsiders came to work inside, gringo with Brazilian, white with black, and the free with the captive. Prisoners who taught other prisoners wanted to learn to take back materials to their classrooms. We wanted to learn about the situation in order that the programs could be developed. Someone somewhere expected *us* to teach *them* what they should know about AIDS.

After the initial introductions the workshop took off. Thirty prisoners (approximately), two British theater workers, two Brazilian theater students, and two prison officials were involved in two hours of participatory theater on AIDS, HIV, and sexually transmitted diseases. Still, images were created by the prisoners out of the bodies of their peers. Images of illness, dying, and mourning. Images of drug use, conflict, and desperation. Images of friendship and hope. Images of the complex life of the prison, which I might read one way while the group read them another. The tableaux were changed to reveal desires for the future. The group members challenged each other and argued over how stories were told and what should be represented.

AIDS education is usually about behavioral change. One of the assumptions about theater work in prisons was that because it dealt with explorations and re-creations of human behavior, it could be part of programs that sought out that change. In the context of the United Kingdom, where most of our programs had been devised in the past, we had allowed ourselves to slip into a prison rehabilitation framework that insisted on setting that agenda. Programs had been premised on a clear statement of which changes were needed and what model or appropriate behavior should be learned. This workshop in the Salão reminded me that however much we had tried to maintain a distance from this approach to prison work, we had incorporated some of its assumptions into our practice. The workshop reminded me that we can never know what is possible behavior for another group. AIDS education seeks a simple change in behavior: Get people to use condoms. Here they demonstrated that even that edict was an imposition.

Use a condom. We don't have any.

Use a condom. They are prohibitively expensive for our partners who come to the prison for conjugal visits.

Use a condom. Wives are sold on conjugal visits to other prisoners to pay off debts, and you can't control the condom use of your debtor.

Use a condom. I'll die from violence long before I die from AIDS.

Use a condom. Most of us are already HIV positive.

Theater in prisons is not about changing people's behavior because that implies a preknowledge of what change is required. Between the gringos and the Brazilians, the white and the black, the free and the captive, the only clarity that theater could give on this day was that the lines of certainty must be blurred.

And one from somewhere near the end . . .

Ethics: A Shed in Sri Lanka

In a long tin shed with flapping corrugated windows.
On top of a hill. On top of the world according to one boy.
The cracking and smacking of the glassless air holes played an unrhythmic backing to the whole day.
The room trying to take off.
At one end the Hindu Kovil, in one corner the Buddhist shrine, and at the end, around the corner, a Christian altar.

Instructors few and trainees many, young, and young, and younger.
The amputees were involved in the games—better at some.

All played with the same youthful exuberance that any group would.
Slowly, they created images that by the end of the day were sharp, crisp, rich, and detailed.
Is there a responsibility to tell their stories, tell this story, or tell no story?
Ethically my tattered wings were (are) flapping.
I am responsible—I have searched out this work.
Perhaps this place is where it ends.
In searching for prison theater's heart, of where it can logically go, of the darkness it can possibly face, I find boys, young men playing cricket.

The wire, the little wire there is, is threaded with colored creepers.
Garlands for the green corrugated halls, flapping their windows, trying to fly.
Seeing them safely off, or wrapping them safely in.
The young men slip off their slipoffable shoes and enter the triple holy place.
Good morning, I have come with my friends to do two days of theater.

Theater in the places to stop the dinner party cutlery mid mousse.
Theater in prisons, done that darling, but with child soldiers—ooh and aagh.

My ethics clink and clank with the forks and the knives.
Failing to fly from the top of this mountain,
and thinking about staggering to that hill I think is Just Over the Next Ridge.
Child soldiers—done that—what is for dessert?

There is a logic to my theater work—adolescents, captives, crisis, violence, rehabili-
tation. This group presented a joyful mixture of reticence, delight, disruption, and
creative freedom.

In a micro micro project I deliberately steer around their trauma, finding mo-
ments of lightness; tangential stories,
opportunities for talking and reading and telling that tug at the hems of the
Reason They Are Really There.
But never wear the full dress.
Threads snagged by games that weave around their trauma—garlanding it.
Seeing it safely away, or wrapping it safely in?

Ethical minefield is a trivializing metaphor when three have lost their legs in
mines.

The final image series showed the emotions of hope, fear, and joy translated into
stories of father-son relations, weddings, lovers' conflicts, and cricket.
Of course, cricket.

In applying theater, I creep into the discourse that I am working within so that
the work can translate, adapt, and grow from the understanding of those for whom I
am working.
I struggled here for two days.
I flapped and flipped between clarity and total confusion because I could not find
the discursive home or homes that constructed this place.
What was happening here, for what reason?
Rehabilitation for what, to what?
Child protection?
Counterterrorism?
Vocational training?
Helping child soldiers?
Containment of surrendees?
Not knowing was fine. But suddenly being here made us all vulnerable to which-
ever discourse any group chose to frame our work. In the absence of us claiming an
interpretative zone for this work, we were in danger of succumbing to the categoriza-

tion of others. And in a Conflict Situation that is dangerous. Young people deserve to
have programs of work—wherever, whenever. But . . .
 Maybe this is the top of a mountain where we should have said "no."

I am used to finding uneasy compromises to make theater work happen. Prisons
forced our hands here—but we found places of comfort within prison regimes that
could provide a theoretical home for the practice.
 In a war zone, neutrality is not a place you can easily occupy.
 All territory is contested.
 Even tops of mountains
 Seeing me safely, wrapping me in
 Perhaps this place is where it ends.

Doubtful Principles

As the examples above demonstrate, the arts in prison have no origina-
tor, no one agenda, and are ethically profoundly complex. Prisoners have
used different art forms for centuries for varying and sometimes contradic-
tory reasons; they have done so in different continents and contexts, and
practice the arts today with a rich mix of justifications and principles. It is
difficult to outline a history of this field because that would give a status to
spaces, places, and moments of practice that have had their own sets of
inspirations and precursors. It would be equally problematic to set an agenda
for the field because that would automatically exclude other equally legiti-
mate justifications of practice. An attempt to establish an overarching mis-
sion for arts in prisons could marginalize and erase practices in its necessary
generalizations. Finally, it is hard to set out ethical principles because ethics
are best carved out of the contexts of specific practices. Ethical guidelines for
my work will not simply be translatable to the practices of others. Working
with imprisoned child soldiers in a government-run camp during a civil war
in Sri Lanka makes me the last person who can lecture others on ethics.

There is no consensus about how arts in prisons should be discussed or
debated. I have deliberately used a variety of writing forms to counter my
own use of the discourse of certain forms of psychology that I have in the
past constructed around prison arts practice.[1] I now believe it is too restric-
tive to think of the arts in prison in only one way and to try to develop a
coherent approach to theorizing about it. The practice is too diverse to be
distilled into neat theoretical positions. I have interviewed practitioners of
prison-based puppet theater in South Africa, witnessed rehearsals of a play

by an international cast in a prison in Tenerife, seen the videos of epic professionally directed prison theater in Milan, seen psychodrama with capital offenders in Texas, and designed drama-based anger management programs for the probation service in the UK. It would be a difficult task to find a critical coherence in work that is devised and directed for hugely different reasons and in response to greatly different demands. So, what is this chapter doing then?

I aim here to offer ten *doubted* principles or questions about arts-in-corrections around which many of the debates that I have encountered in the field have coalesced. These principles have been useful to question my own work, to pull myself back from certain projects, and to help develop my own language on the field. I use each of the principles to question the experiences I have described above and to examine other areas of arts in prison with which I am familiar. I do not claim that this list is in any way conclusive or foolproof. This is not the coherence that I have stated would be hard to find. Rather, I hope these ideas inspire new lists or new ways of thinking about arts-in-corrections rather than an acceptance that this is any kind of artificial standard. Each principle is stated, examined, deliberately doubted, and then left open.

A Doubtful Principle List

There Are None—Beware Those That Talk of Principles
I had to start with this. But ultimately it must be true. At the foundation of arts in prisons, there is no foundation. There is no single base upon which all groups, individuals, artists, and prisoners have constructed years of work. My work and that of the Theatre in Prisons and Probation (TIPP) Center started by offering theater workshops to regional prison and probation services. We went on to develop particular offense-focused programs and workshops on issues such as offending behavior, drugs, and anger management. Many of the principles I am outlining here are based in some way on reflections on that practice. However, we built this practice around a particular situation and the specific demands of our criminal justice partners. If there was any foundation to our practice, it was peculiar to the 1990s and the UK. The foundation was a moment that I would be wrong to assume existed elsewhere.

Artists Are Not Special People (They Often Think They Are)
In 1995, I was working with a dance company that was commissioned to run one week of workshops with prisoners in a Young Offender Institu-

tion near Manchester, England. The idea was that at the end of the week they would perform with the young people for an audience of delegates from the European Conference on Theatre and Prisons. The dancers were taken on a tour of the prison the week before their work was due to start. They had been chosen because, according to our research, they were a company that sought to make dance accessible to excluded audiences, particularly young men.

They were ushered up to the second floor of the 1960s concrete education block to be shown the room in which they would be working. My colleagues and I had worked in that very room many times. They walked in and looked around the square classroom. One of them started jumping up and down, banging his feet on the floor. "We can't possibly work in here," he said, "the floor, it's not sprung." A sprung floor, in a prison?

Arts in prisons are a minor part of the life of the institution. Guards have many more important things on their minds, prison directors are not going to be impressed by our demands, and prisoners are occupied by a multitude of concerns. We are a guest in these institutions, and however much we might disapprove of various practices, we need to conduct ourselves as visitors in someone else's house. We are not particularly significant and cannot expect sprung floors. We must adapt our work to fit the possibilities and limitations of the space in which we find ourselves. We must not expect them to adapt to us. Artists are often cursed with a certain preciousness and feeling of self-importance. Only by insisting, in the first instance, that the work is not of great significance is it at all likely, in the end, to become just that.

Art Is a Verb Not a Noun

There is much debate in arts-in-prison work over conceptions of art as verb or noun. Art either *is* something or it *does* something. This is expressed in terms of both the projects and the people running them.

Under the United Nations Basic Principles for the Treatment of Prisoners adopted in 1990, all prisoners have a right to take part in cultural activities. When we designed the prison theater projects in Brazil and developed a subsequent theater and human rights initiative, we did not argue for them under this principle. We did not frame theater work as a right, but we made the case for what it did. We depicted it as an action that could achieve certain objectives. The theater and human rights initiative in Brazil is thus framed as a program that uses participatory theater to raise awareness and debate issues of human rights in the Brazilian prison system. It is a verb

project not a noun project. Interestingly, in the wake of the theater and AIDS projects in São Paulo, several prisons have established new cultural projects and theater groups. These programs have been portrayed as evidence that the system is respecting the prisoners' rights to cultural activities. The arts are defined in these cases as a right in themselves, not for what objective they might meet.

These two traditions are constantly played out between and sometimes within projects. One side would argue that theater in prisons is valuable for what it does. In this formulation, participation in theater has certain effects. It has an impact that somehow changes individuals or institutions. When writing a proposal, therefore, the aim of the project could never be to do theater; the aim must be what happens because of the theater. This does not mean that aesthetic and creative issues are marginalized, but rather they are only necessary objectives to be met if the overall aim is to be accomplished. Those arguing from this tradition would ask: If you only had aesthetic and creative goals, why would you choose to work in a prison in the first place? There must be another reason that relates to the relevance of the arts to prisoners. The arts are thus actions—they do things.

The counterstatement to this way of seeing the work would argue that the aim should be only to run a theater program or put on a high-quality performance. The project is done for the art form, not for what the art form does. The effects of that program are strong but incidental; they are the necessary components of a successful art process. This framework would argue that being specific about the effect or function of the art form has a damaging effect on the process. It is the open-ended and surprising outcomes that are art's power. By concentrating on the function, we would lose our expertise in the execution of the art itself.

One of my colleagues who helped me run the child soldiers workshops in Sri Lanka was a psychiatric social worker from southern India. He was responsible for setting up the Tamil language social work training for Sri Lanka in a context of war-inflicted individual, family, and community trauma. The workshops I was running had to be framed for the government agency in charge of the staff as a therapeutic intervention, and for the army running the camp as simple drama workshops. I wanted to do two days of workshops that would not have any direct therapeutic intent because to raise or tackle major issues in two days would have been highly irresponsible. After running the workshops, my social worker colleague commented how in terms of microlevel skills in group work and personal communica-

tion, the workshop had touched on everything that he would be trying to achieve through very different techniques. The work had clearly functioned within the objective of the discipline of my colleague. However, whereas in the past I have tended to be very verb or function oriented—the work is being done in order to achieve this—here I had been wary of using this framework because of circumstance. Yet another person identified the functions for me. Although theater people can, on occasion, hold on to the luxury of explaining their work for what it is and not what it does, every time we enter a social institution that is not a theater, our work will be interpreted for effect. We can choose to engage directly with this or abstain. Sometimes it is useful to do the former; at others it might be vital to do the latter.

The final point to make on the verb/noun division is that it is also apparent in the way that arts-in-prisons practitioners describe themselves. A noun practitioner says, "I am an artist, and I work in prisons." The verb practitioner says, "I run arts programs in prisons." Recognizing that this division is often blurred in practice, the first comes from a tradition that emphasizes *artists* in prisons, the second from one that concentrates on the *arts* in prisons. The former assumes that the presence of the artist and their practical work will inspire other prison artists. The statement "I am an artist" is a powerful counterweight to the negative associations of "I am a criminal" or "I am a prisoner." Without doubting that this noun statement is valid, I believe that the practice of stating "I am" perhaps means "I would like to be." The statement is perhaps an action that in being made has the effect of changing the status of the person who makes it.

The second tradition here is based more on the belief that it is the facilitating of an artistic process that is important. Ultimately this tradition would hold that it does not have to be an artist that runs the program. What is important is what you do and how you do it, not who you are. The best artist can be the worst teacher. Also, this tradition would question how a program can be sustained and reach the necessary thousands of prisoners, if it relies on the services of people who are lucky enough to be able to label themselves "artists." Perhaps the ability to refer to himself as an artist was what gave the Loire prisoner sustenance through his long sentence. The Brazil AIDS project running in over forty prisons would, however, not be possible if the original artistic team had not trained educators from every prison to run the program. In insisting that anyone can be an artist, this project also insisted that anyone could run theater workshops. What they did was the priority not who they were.

Prisoners Should Be Subjects Not Objects

In all examples of arts in prisons, I would maintain that it is vital that prisoners are the subjects of the process and not the objects of it. The arts process is never done to them. This is especially a concern with arts projects that combine with therapeutic interventions that have as a stated aim the desire to change the prisoner. It is also of concern because the whole prison system is something that is done to people. The state of being a prisoner is one in which you are the object of a process that seeks to inflict punishment on you and perhaps release you reformed into the community.

The early projects of the TIPP Center too rapidly accepted the logic of therapeutic rehabilitation programs and came close to being theater workshops done to people to change them. I say they came close only because I have seen "theater-based" programs that do go over this boundary and drag people through a regime to make them "face up to" what they have done. One example was a program in the UK that brought young offenders and victims of crime on stage together in front of a public audience. This only resulted in the young people being objectified, displayed, and made to look guilty for the pain they had caused. It is wrong to assume that art is somehow automatically a force for good in the prison system. The discipline and control that are often needed can just as easily be turned to make the art form part of the punishing agenda of the institution.

The situation in the Brazilian project is one where this principle was etched out in practice. The project is funded to educate prisoners about AIDS/HIV, with the assumption that this education boils down to one standard prescription: Encourage the inmates to use condoms. Doing didactic message-based plays *to* audiences of prisoners might have been an option, but to adopt the principle that prisoners should be subjects of the artistic process rather than objects, they had to be drawn in to setting the objectives and priorities for the program. They complicated the behavioral message and demonstrated, as directors of the process, that simplistic answers could not be given.

Prisoners Should Be Participants Not Observers

The artist in the cell in the Loire was not a consumer of art but a creator. He did not sit and watch in awe as another artist demonstrated his or her skill. The prisoners in Brazil and the young men in Sri Lanka all took part in the process. They were engaged in using the art—in this case creating theater. Arts in prisons should not be about giving the prisoners the opportunity to consume art. This does not mean that touring companies should not take

their work into prisons, but they should develop mechanisms to encourage participation, and occasional performances should not be an alternative to more sustained arts activity.

In Tenerife, there is a prison with a lively arts program primarily directed by the prisoners, who edit their own prison magazine and have created a stunning theater company. In 1997, I sat and watched the company rehearse their new show. In this piece, there were women and men prisoners from a range of different countries. Just off the coast of Africa, Tenerife's position as a major winter sun destination for northern Europeans made the cast one of the most multilingual I have seen in a prison. Their play was a complicated story and a complicated piece of staging, designed as it was to include as many of those interested as possible. All involved, from the actors and directors to those taking on technical positions, were prisoners. Their participation was a remarkable antidote to the familiar object status of prisoners where the right to make decisions, take choices, and be responsible for your own actions is minimal.

In concentrating the process of arts in prisons on the prisoner as participant in a project rather than passive audience, it is vital that the diversity of art forms and prisoner interests is taken into account. Arts in prisons are about providing relevant programs to the whole prison community. This means that women prisoners and young prisoners must have access to programs in the same way that their adult male counterparts might. It means that the existing cultural traditions of prisoners should be encouraged and developed. On the last day of the project that I ran with the young men in Sri Lanka, the group performed a rich array of sketches, songs, and dances based on and adapted from a range of Tamil and Sri Lankan cultural forms. Their show demonstrated that they were already active participants in cultural work. Artists entering prisons too often forget that prisoner-initiated art is already a rich part of prison life. Our work must extend this and provide links for prisoners to new cultural experiences.

A respect for different cultural traditions and interests within a prison does not mean that each group should have only art programs that meet their cultural needs or expectations. Introducing various art forms to a range of individuals can encourage a respect for difference. In 1996, I witnessed a Cuban drumming workshop in a prison in California. The participants were African, Hispanic, and white Americans. As participants in a process that engaged them physically and mentally, they were demonstrating a respect for each other and the art form they were studying. A prison official told me that this particular class was the first instance of men from the three main

groups in the prison working together since a fatal riot between African and Hispanic Americans a few months earlier. Participation provides the possibility of communication through an action that implies and demonstrates respect for different traditions. Being a passive observer will ensure that fear of difference is maintained and sustained.

We Should Respect Other Languages of Practice

Each space in which we practice our art form will have certain discursive practices and norms governing and describing the work that people do. In prisons there are competing discourses relating to punishment, security, rehabilitation, and personal change. Arts workers need to decide how and in what way we relate to and perhaps use those languages. We can discuss or describe our art form in almost any way we chose, but in order to enter the prison we will be required at times to explain the practice in terms with which others are familiar.

The history of my practice has been one in which I quickly encountered a rehabilitation discourse that could be adapted to explain the work we sought to do. The style of group work in the UK Probation and Prison Services is predominantly modeled on a form of cognitive behavioral therapy where offenders are challenged to examine their thinking about their crimes and then practice new strategies for avoiding those moments in the future. It is a form of rehabilitation that places the thinking of the offender at its center and challenges the way they justify and minimize their past actions. In the UK, much of this work was practiced with groups of offenders seated and running through exercises printed on sheets or written on flip chart paper. Our immediate intervention was to accept the logic of the program but to offer a more dynamic and participative method for delivering the material. We thus learned a particular way of seeing prison work and then explained our practice within this framework. In learning to operate within this discourse, we could much more easily develop projects within community justice and prison establishments.

This led to projects that combined participative theater workshop techniques with approaches to offending behavior, anger management, and drug education. These programs always sought to take the learning objectives of existing programs and make them more engaging and responsive to the varying learning styles of the participants. You could not expect people to sit and read if they had struggled in traditional educational settings. These projects have gone on to become standard practice in a number of prisons and probation service areas. For example, Greater Manchester Probation Service

in the northwest of England uses the anger-management program we devised as the main court-ordered program for violent offenders in the region.

Many projects in the UK are now adapting their practices to fit new priorities. For example, an education department directive on developing an increased emphasis on certain essential skills for prisoners has led to a number of arts organizations developing projects that teach those skills through various art forms. A government-wide priority on training sections of the community who have suffered from high unemployment rates (including ex-prisoners) has led to a number of projects that seek to teach groups "skills for employment," again through a variety of art forms.

Though I would commend much of this work because it is pragmatically making art tackle and apply itself to difficult social objectives, I also have a concern. This was most notably realized in the execution and development of the projects with which I was involved in the TIPP Center. In learning a way of explaining or describing your art practice so that it is understood by nonartist prison governors, probation officers, and guards, you can start to develop your arts work with that framework as the guiding creative force. I feel now that we often forgot that it was a way of explaining, not the way of creating the work. When devising the anger-management program, we at times became lost in the minutiae of anger-control procedures and struggled to create the workshops. It was only when we consciously decided to put aside our newly researched information about anger and remember our understanding of the theater that we rediscovered the impetus for developing the program. Once we constructed the metaphors and techniques that we wanted to use, we realized that we could then reapply the interpretative framework of anger management. We discovered through this process that a drama workshop, an artistic process, only becomes a confidence-building exercise, an anger-control technique, or a conflict-resolution workshop at the moment and in the context of its execution. Describing our work in a way that appeals to a particular criminal justice audience is legitimate because we know that if carefully designed the work can meet a range of different objectives. However, we must remember that this is a useful description of what the process will do when executed in a certain way and not a description of what the art form will always be.

In the end, the confidence we had in the TIPP Center and in the various models of rehabilitation actually hindered our program development—the creative process behind new projects—but greatly aided the acceptance of our programs within criminal justice agencies. My experience in Brazil and Sri Lanka also reminds me that the language learned in one place will have

no automatic resonance in a different context. In Brazil, the language of cognitive behavioral group work did not ease our transition into the system. There the overarching concern was the fact that the people in prison came from a situation of such extreme poverty that individual change was not a priority. The discourses surrounding the prison system were ones of citizenship and human rights. It is in the spaces that these debates open up that the work in Brazil has been developed.

Similarly in Sri Lanka there was not a clear dominant form of "prison speak" that explained what sort of programs should be done with the young child soldiers. I explain above that this was the key ethical problem with this project. Discourses should not be adopted opportunistically. What they can do is offer a space for practice and for that practice to be discussed or explained. The lack of clear frameworks for the work in the camp made it very difficult to understand our own practice and to comfortably advocate for it. Clearly, the highly contested situation of a civil war meant that any work that touched upon areas of that conflict would be grasped and defined for different groups' purposes. The principle here is that we should respect other languages of practice. The situation in Sri Lanka meant that we had to find a language of practice that did not implicate us in a war. At times there are perhaps no "languages of practice" in which we can carve a space; perhaps these are the moments when, as I say above and explain further below, we should say *no*.

Sustainability Is Key

There are many different reasons why some projects are sustained and others disappear quickly. Principle number seven is that we should do all in our power to ensure that projects can sustain themselves for as long as is appropriate and is desired by the participants in the initiative. The difficulty in offering clear guidelines here is perhaps best illustrated by the fact that the prisoner in the Loire dungeon sustained his art project for many years with, I assume, little outside support or encouragement. Maybe the continual supply of paints was the single sustaining influence, but I also assume that it was the strong need, desire, or will of the man to continue the work. Without that desire, that need, or that hunger for the work no amount of planning will sustain a project.

The important question around which debates about sustainability are focused is whether we should concern ourselves with services or projects. The principle of the Brazilian AIDS/HIV program was that we wanted to reach as many prisoners as possible. When the initiative was started, it was

formed as a series of projects in four or five prisons. We relied on a commit-
ted group of theater artists and students to sustain the work. After the initial
stage, however, we shifted the emphasis to developing the program as a
service. To do this we trained prison teachers and prisoner monitors to exe-
cute the program in their prisons. Now the program reaches over forty pris-
ons in the state and is structured into the delivery of education in each es-
tablishment. It has become a service not a project. As a service, it will
continue as part of the work of those prisons without being reliant on special
funding that in the Brazilian context was very hard to obtain.

In Sri Lanka, there is a similar desire to develop services rather than
projects. All my work in that country has involved training a variety of staff
who work with prisoners, traumatized young people, displaced people, or
child soldiers to run theater programs. In this context, it is felt that the
outside specialist should develop a way to make him- or herself not continu-
ally necessary. The child soldiers project described above, however, did not
fit into that pattern; it was clearly a project not a service. Though I did run a
training course for staff at the center after the project, I felt it important to
run a program directly with the young men, even if it was very short. To
train staff in generic theater skills, I still needed more of the specifics of their
situation. So I ran a project, and in doing so I began to doubt some of my
certainties about the importance of service development rather than project
provision.

The first doubt is linked to the principle of verb or noun projects. If you
only train nonarts staff to deliver projects, you will be relying totally on what
the art form can do as a method. There will be a danger of the purely me-
chanical and functional aspects of what the art does being prioritized over
the aesthetic and creative questions. I have already hinted that this division
is perhaps false, but I believe the process is more powerful when there is
respect for the process of engaging in the art form per se as well as a clear
understanding of its function.

The second doubt is one of quality control. I will always believe that
nonartists can run arts programs, but there will inevitably be a range of
ability and quality in what they deliver. This is true not only of their basic
understanding of the processes involved but also of people's understanding
of the pedagogical principles attached to much arts education. A probation
officer or guard who has become used to insisting on right answers and
encouraging prisoners to make the *right* decisions, might find it hard to
adapt to a program that insists on accepting multiple interpretations and
allowing students to experiment with different possibilities. This rigidity cer-

tainly has been a problem in the past when I have trained prison officers to run a TIPP-created offending behavior workshop, or prison educators in Brazil. It was also a tension that arose between the project in Sri Lanka and the subsequent service development course.

The importance of the outsider coming in is the final point to counter my basic assertion that a services rather than a projects approach will sustain prison arts programs. I believe the major factor in the success of the child soldiers program was that we were not the staff and that we came from elsewhere. Our very presence indicated to that group of young people that beyond their hill there were others that valued them, and far from being isolated, they could connect with a group of artists from the rest of the island. Part of the impact of the arts process is that it runs counter to familiar patterns of time in prisons. It can have a profound impact because it is not part of the routine but in many positive ways changes, challenges, and disrupts that routine. A project approach ensures that the arts keep their place as an alternative to the often numbing routine of the rest of the prison. In the few days of running drama workshops with the child soldiers in a sweaty tin room in Sri Lanka, a whole new time and space was created that bore no relation to the rigid time zones of their usual life. Playing with time and changing space is linked to acts of escapism and liberation. Although we cannot aim to release people physically from their situations, by breaking the routine a powerful, positive change can be possible. If the arts are part of the routine and are there as a service, perhaps it will be difficult for them to act as a counter to it.

Avoid or Counter the Performance of Punishment

In many ways punishment has always been performed. Whether it attracted large crowds to the gallows outside the city walls of many an English town, or drew marketgoers to launch their rotten produce at local criminals trussed up in the stocks, it was about entertaining or warning an audience more than changing the person of the offender. Being tougher than the next politician, parading victims to demonstrate your credentials, or supporting "deterrence" (punishment directly used to impress an audience) are a few of the many modern ways that punishment is constructed for modern audiences. If punishment is performed, we need to ask ourselves carefully what artists are doing in places of punishment—particularly those artists who use forms of performance as part of their art. In creating a play that is to be performed to other inmates or an invited audience of the public, in what way are we playing a part in a performance of punishment?

This question has become significant in the current climate, where it is the performance of punishment and the impact of the punishment on its audience that is often more important than really trying to control crime. I believe that this tendency, though always part of criminal justice, is currently seriously undermining its credibility. Concentrating on your audience leads to lack of focus on the real needs of the offenders and the victims of crime, in turn promoting a system that does not see huge rises in prison numbers as a problem and puts little emphasis on positive attempts at rehabilitation. We need to examine how our performances relate to other performances of punishment and check that they do not display prisoners to the further delight and voyeuristic pleasure of the crowd. They should, in fact, be seeking to disrupt the assumptions within the performance of punishment rather than contributing to it. The project mentioned above in which young offenders were paraded on a stage in the UK did not do that. It assumed that because it was an arts project it was positive and humane. However, it played into the process that displays prisoners as a warning to the presumably well-behaved audience. The prisoners were objects of punishment not subjects in an arts process. To be hard, this theater-in-prisons project was perhaps no better than the stocks.

To challenge these performances of punishment, many of the principles that I have outlined need to be in place. Prisoners must be in control of the process; they must be participants and creators not objects of the art. The work must be careful not to exist as a simplistic one-way statement about their offending; rather it should open up questions and doubts in both the prisoners' and the audiences' minds. The public that consumes the art form displayed must be involved in a process that avoids the vicarious pleasure people get from seeing pain and suffering. Theater and many art forms can be instrumental in this because they can be part of a process that promotes the offender as a creative, active person with a potential beyond the assumed role of criminal. Performances, art displays, and music concerts can shift and undermine expectations because they play with an audience that has certain assumptions about how punishment is performed and what role the characters play in it. Without an explicit intent to do this, displays of prisoners and their work can easily become further punishing spectacles that benefit only the jailers.

One of my concerns about the Sri Lankan project, as I have already touched upon, was that we were not in control of how the project was projected beyond the moment of its execution. You can never have total control of the reception of a performance, but often by being clear as to the objec-

tives and framework in which you are working, you can align the work to certain positive movements or approaches. I have stated that it is important for us to be familiar with the discourses of the different professional groupings that operate in the criminal justice system. The ethical dilemma in Sri Lanka was the gradual realization that the only reason we had been allowed to run this project was that it would be used as evidence of the progressiveness of one side and the inhumanity of another in the civil war. Our work was in danger of being used in performances that we were not actively engaged in seeking to control.

Sometimes We Must Say No

All the principles that I have outlined are in some way about the ethics of theater or arts work in prisons. They are principles that I have deliberately doubted and debated in my explanation of them. They were not formulated prior to my work on prison theater projects but in my execution of them. Similarly, therefore, new principles will be formed as others work in these areas, and these principles will be challenged or changed as different groups have different experiences. However, perhaps we do need to look at a penultimate principle that asks when should we say *no* to a project or when should we say *no* to an aspect of a program. In working in a realm of complex moral or ethical judgment, where people have committed acts that have often inflicted terrible pain and who are now having legitimized "pain" inflicted upon them, we need to have a limit. I say in my description of the Sri Lankan project above that young people deserve to have projects wherever and whenever, but then I also say that perhaps this was the place where we should have said *no*. My final point is to ask exactly when we must say *no*.

When I was first asked to work in a prison in the UK, I said *no*. I thought simplistically that by working in a prison you were no better than the hangman. By being there, you were complicit in a system of punishment that I thought was unnecessary and inhumane. I had not formulated this view out of thin air; I had just finished six months of work in a Sri Lankan prison (teaching English not theater in 1985) where I had felt compromised by the system. There I had seen blatant human rights abuses, frightening conditions, and terrible suffering, coupled with a degree of humanity from my prisoner students that was inspiring and astounding. I am also the son of a prisoner of war who spent time in the notorious Changi prison in Singapore before spending over two years building the railroad in Burma. Prison comes to me with intensely negative associations. The suggestion of working in a prison in Manchester, England, was thus easily dismissed.

However, I changed my mind . . . and then became convinced that rewarding and powerful work could be done inside the criminal justice system. Rather than being an oppressive monolith, it was a place in which many people struggled daily to change themselves, change each other, and create a better future. There were possibilities for progressive programs in the spaces that many people inside the system have spent long years creating and defending. While some still abuse their roles and while prisons, I continue to maintain, make little contribution to making our communities safer, in those places positive work can take place. So when do we say *no*? When the principles outlined above are broken, it is easy to consider saying *no*. But . . .

The closest I have been to saying *no* recently—Sri Lanka—made me want to do the project even more. I even want to go back because in that extreme situation there were some very young men who were inspiring in the way they grasped the material we brought. I still doubt the ethics of working with what were prisoners of war, but in the middle of a drama workshop with people dancing with delight through various theater exercises, you believe your heart and eyes before listening to your judgment.

So perhaps my answer is that there is no clear line that can be drawn theoretically, because the rational can be overridden by the impact of the emotive. We must therefore seek the place where we say *no* at that point when we *feel* that it is wrong to do otherwise. When our gut notices that somehow the work will step over a boundary, we should not proceed. My gut will tell me that I should not work in situations where my work contributes directly to people's continued incarceration, where it is used to justify abuses in human rights, when the action compromises the safety of participants, artists, or any other person. My gut wrenches when the performance titillates, when the display objectifies or the process pacifies. My gut wrenches when a theater exercise drags out stories of pain from a participant under the premise that this confrontation will help them come to terms with their past. My gut wrenches when people are battered by the unobtainable expertise of another. My heart leaps, however, when . . .

To go on to my final principle . . .

It Don't Mean a Thing If It Ain't Got That Swing

We should also have a principle of when we say *yes*! This too could be easily answered with a nod to the principles already outlined. When the first eight are understood, then the project should move ahead. However, we need to remember that all these are meaningless unless we recall what in-

spired us to be involved in the arts in the first place. By spending too long on principles of practice, we will lose that swing that enables us to be arts practitioners, teachers, or facilitators. This is not to say that the arts have some essential quality—as I have already said, they can do as much harm as good. Yet there is a changing, specific, creative heart to different arts processes of which we must never lose sight. That heart is not the same for each art form, in each circumstance that it occurs, or across cultural groups or communities. However, there are indefinable parts of theater and the arts. They defy definition because the arts process is about enacting something that is beyond mere word, mere marks on a page, mere vocal tricks. It is a combination of the physical, emotional, and intellectual that is richer, more complex, and more meaningful than the pale shadows that words can create. Art is done when words alone are not enough. In prison, often words are not enough. We speak in an arts process that at times we should refuse to translate back into the restricted semantics from which it is seeking to escape. The point of arts work in prison is often that it is giving those that have struggled to find words a new language to speak in and through.

We should say *yes* when it is that strength that is prioritized and those who aim to speak are at the center of the process. *Yes* is when the swing of the work, that indefinable changing part of the process, is placed at its heart. The artwork is only meaningful when it starts from this position; it will only mean a thing when it has that swing.

Conclusion

The cell art in the Loire is still there, paint peeling even more, but I am sure it continues to intrigue passing tourists. The Salão Nobre is definitely peeling, and there are even hints that Carandiru prison is to be closed and the prisoners displaced. Nevertheless, projects still take place there, and the AIDS project continues across the state. The young men in Sri Lanka might soon be going home, and more will have arrived.[2] The war in Sri Lanka continues.

I hope my ten principles will prompt more questioning and perhaps more practice in this field. Writing from the UK, I am sitting in a country with the highest ratio of prisoners to population in Europe, looking across to my friends in the United States, where there is the highest prisoner per capita population rate in the world. We perhaps should not be proud that our field is growing in response to a highly problematic, politically and ethically dubious response to crime. However, the arts do offer a powerful antidote to

much of the negative assumptions that surround the work of prisons and the people in them. They do offer an opportunity to create spaces that can counter the personally destructive routines and habits of prison life. To continue to respond to these challenges, we must continue to create principles for the work. We must take positions so that the potential of the arts-in-prisons field can be realized. These new principles and new positions must continually be created, however *doubtfully* they are stated.

Pat MacEnulty

Arts Programs in Recovery— Finding Out the Why

So, you want to do an arts program for folks in recovery. The first thing you have to figure out is not how but why. Whether you're writing a grant for funding or convincing administrators to let you try out a program in their facility, an explanation of benefits will be in order. Not only that, the proposed recipients of the arts program will want to know what's in it for them. Artists sometimes take it for granted that the arts are good for you. It's something they know by intuition. It's another matter altogether to turn on the left brain and actually state goals, objectives, and purposes. Doing this not only satisfies funders, administrators, and participants, it helps you as the facilitator clarify your goals and purpose, and makes the day-to-day planning of your program easier and more straightforward.

The first arts program that I ever facilitated was a creative writing program at Jefferson Correctional Institution (JCI) for women in Monticello, Florida. I was contacted by Dr. Evelyn Ploumis-Devick, who was working at the Florida Department of Corrections and who had received a grant from the state to institute a pilot program for arts-in-corrections. The Communications Bridge Project was a three-part program. I would be facilitating creative writing at Jefferson, Leslie Neal would run a dance program at a maximum-security women's prison in South Florida, and Dean Newman would lead a writing/literature program at a men's institution in North Florida.

At the time, I was a doctoral candidate in the creative writing program at Florida State University. That year I had received a University Fellowship

to write my creative dissertation, a novel about women in prison. The novel was based on my own experiences as an inmate in a women's correctional facility in 1980. Evelyn didn't know this when she contacted me. She had simply heard through one of her colleagues, who was active in the creative writing community, that I might be a good person to help design and facilitate her program.

Although I had been in prison and although I was a creative writer, I had a lot to learn about facilitating arts programs. For one thing, I needed to grasp the concept of "facilitating" as opposed to teaching. I'd been teaching writing to undergraduates for several years. I gave assignments, corrected their work for organization, style, and grammar, and ran workshops designed to identify the writer's goals, motivations, and the meaning of the work itself. I had also been a participant in creative writing workshops for more than a decade. The methodology of those workshops had been for a group of individuals to closely examine and critique a piece of writing, poking and prodding in search of weaknesses. Afterward in conference, the teacher would help the writer figure out how to salvage what was left of the piece, not to mention what was left of the writer's ego. I believed that I would go into my prison workshop and use the same sort of technique—in a more nurturing way but with the same purpose—to discover and nourish the seeds of good writing and help make the writing better. Wrong!

It didn't take long to establish that one of the participants, a former alcoholic, had a strong facility with language and that she had fascinating life experiences to draw upon. One evening she brought in a particularly moving piece about the death of her much-loved father and the subsequent sexual escapades of her mother. All of the workshop participants were deeply touched by the evocation of a young girl's sense of grief and betrayal. But I had trained myself not to get involved with the personal aspect of a piece of writing. Instead, I saw the raw material for a fabulous short story, and I began to suggest ways to improve the piece, to heighten the dramatic potential, and to deepen the characterization. Like pioneers under siege on the Oregon Trail, the rest of the participants formed a protective circle around the writer. They insisted that the story was perfect as it was and that the writer shouldn't change a thing. I tried to convince them that good writing required manipulation and revision. I wanted them to look at their experiences objectively in order to be able to turn these events into the stuff of fiction or memoir. Fortunately, I had established a rapport with these women, and the writer whose work was in question and I were "homies." Otherwise, I would have lost that group.

Participant Goals

It took me a while, but I finally realized that the goals of the women in my creative writing workshop were different from my own goals as a writer. I wrote with the aim of being published. I often used personal experiences, but for me, once the words went down on paper, the person I was writing about was no longer me but a character whom I could manipulate and change at will. The events that I based my fiction upon could be rearranged, tensions heightened, and results and dialogue fictionalized.

The goals of the women in the workshop, however, were different; they were deeper. For them, writing was a way to save their lives. If somehow they wrote a story or poem that someone somewhere would publish, that was fine. But what writing did for them was to offer a way to look at themselves, to see who they were, to find that which was valuable and meaningful in themselves, and to share pieces of their lives and experiences with others who would understand them and validate their worth as human beings. All the public they needed was right there in that little room. Of course, part of their validation did come in the form of publication. We created a book of their work that they were allowed to keep. They also were able to perform selected pieces of their writing at a reading that we gave at the end of the workshop. In this manner and through the workshop itself, they achieved their goals. They had developed lasting bonds with each other, and they had achieved recognition from within the institution, from family members who saw the final publication, and from the community members who came as guests to the workshop and the performance. They had regained a sense of themselves as worthwhile, creative women who had something to offer the world.

I learned from my first experience facilitating an arts program that the purpose of the program needs to mesh with the goals of the participants. That is one reason I always identify myself as a facilitator rather than a teacher. When we embark upon an arts program in a corrections facility, school, or treatment center, we are facilitating discovery of the creativity within each individual. Although we will impart skills and techniques to the participants, our main purpose is to acknowledge and honor that which they choose to share with us.

Goals among participants may vary, but generally people in recovery come to arts programs for stress reduction, self-expression, and self-betterment. Needless to say, the situations of the participants are often extremely stressful. They may be suffering from separation from their families. If they

are awaiting sentencing or are under court supervision, they may be uncertain about their futures. They are undoubtedly having to learn how to live without the crutch of substance abuse. Coming to an arts program gives the participants a chance to escape their problems for a while. The arts program provides a "mental-health" break—a chance to laugh, to let down their guards, and to allow their "natural" child out.

Bomante, one of the participants in a poetry workshop at the Mecklenberg County Jail in North Carolina, expressed this idea in a short poem he wrote:

coming to class, feeling tense
and uncomfortable. After
observing, I begin to feel
relaxed and expressive,
wanting to participate,
falling into place I begin
thinking & writing,
writing and thinking . . .

Not only is incarceration or treatment a stressful time for many participants, conditions in corrections or treatment facilities may be dehumanizing. The women at JCI were addressed as "Inmate Jones" or whatever their last name was and were required to walk single file down a narrow strip on the side of a wide paved road. If they stepped over the painted yellow line, an officer would write a disciplinary report. Officers and guests, however, could walk anywhere on the road they chose. Treatment centers and schools are less restrictive, of course, but any institution has a plethora of rules that tend to take responsibility and choice away from the residents or clients. Thus, the chance to express individuality becomes a valued opportunity. In an arts program, they are able to break some rules safely. They can also be someone other than the label that has been attached to them. The very fact that the facilitator chooses to treat the participants as artists, writers, or performers helps them shed other roles of victim, perpetrator, failure, or addict.

While the participants in an arts program may not be exactly sure how the program will make them "better people," most of them will take it on faith that some life skills will be imparted to them over the course of the program. I have found that an effective way to clarify the ways that the program will help them is to ask them rather than tell them. It's a trick the court jester uses in James Thurber's story "Many Moons."[1] The princess in

the story says she wants the moon, but all the king's advisors tell him it is impossible because it is too big and made out of green cheese or asbestos. The court jester, however, goes directly to the princess and asks her how big the moon is and what it is made of. The little girl tells him it is made of gold and is no bigger than her thumbnail. This technique is useful when you aren't exactly sure what benefits the program might provide. The participants themselves will figure it out and tell you.

When I first met with a group of women at JCI for a drama program, I asked them what aspects of drama they thought would be useful for them later when they got out of prison. Among other things, they said it would teach them things to do with their children, it would give them self-confidence when going to a job interview or when speaking in front of others, and it would help identify skills and talents that they might use on the outside. Some of them also figured that there might even be career opportunities for them in the arts.

The participants who sign up for an arts program are usually ready to make a change in their lives. They may not have all the skills to accomplish this yet, but they are open-minded to what the facilitator has to offer them. The ones who are not ready or for whom arts programs are not a viable solution to their problems will identify themselves in short order and will drop out of the program. There should be no pressure on them to continue if they decide to drop out. No matter how talented they may be, if they are not ready to make the emotional commitment that an arts program requires, then they won't get anything out of it anyway. Let them go with your blessing.

Program Purpose

The purpose of any arts program is to facilitate the goals of the participants and the institution, school, or treatment center through the arts. For instance, the purpose of a particular program may be described as follows: "to foster mental health and develop coping skills in participants while reducing tensions in the facility." Yet the program may serve other purposes, of which no one is aware until sometime later. One particularly vivid example occurred with the women at JCI.

After that first creative writing program, I found that later workshops that revolved around disciplines in which I consider myself to be more of a novice were even more successful than those in which I had achieved a degree of success because my goals didn't get in the way of the program's

purpose. For instance, my next workshop was a drama workshop, which was operated in conjunction with a visual arts program facilitated by Rachel Williams in the summer of 1997. I knew quite a bit about theater and had written a couple of children's plays, but I'd had very little formal training in recent years and had certainly never done anything on a professional level. I discovered that I had fewer control issues, and the result was that I easily flowed with a more organic process. I gave guidance and direction to the women as they developed their skits and monologues for a final performance, but the work they produced was truly their own.

With the drama program at Jefferson Correctional Institution, an unintended purpose became apparent months after the program was complete. After several weeks of drama, improvisation, and writing exercises, we began to formulate a theme for the final production. I had hoped the participants might choose a theme such as freedom, passion, or family, topics we had worked on in writing exercises, but they decided that the theme of their final production would revolve around death. It seemed an odd choice at the time, but I was determined to allow the participants to steer the direction of this workshop.

Not all of the skits were about death, but it was obviously a predominant theme. The women created a short play about a woman dying of AIDS who was fearful of the rejection of her friends; another skit concerned two older women looking back on their lives as they were sewing while Death watched and decided which of the two women to take; in two different monologues, the main character faced the prospect of suicide; and in one scene Death actually spoke to the audience. In the visual art workshop, they created a costume for Death from a yellow T-shirt and black leggings as well as costumes for the other players. Since my beloved cat of 14 years had died that summer, my heart, at least, was in agreement with the theme, even if my head felt the administration might not fully approve. My head was right.

We scheduled two performances—one in the afternoon for staff and one in the evening for inmates. After seeing the performance, the assistant superintendent and the head of security conferred. They both agreed: the skits were too morbid. They told me that the tone of the performance would have to change in order for us to get permission to perform that night for the general population. I consulted with the participants, and we decided that in the suicide skits, both characters would decide to choose life. We also added a dance, a celebration of life, at the end of the performance. We left the two other skits untouched, and Death was still a major character throughout the program.

The performance was an enormous hit with the general population. I have never been in an audience that was so receptive, so involved, and so much an actual part of the production. I had invited several guests from the community, and they all concurred that it was a stunning and quite wonderful event. Later, I met with the women, tied up some loose ends, had them write their evaluations of the program, and said my good-byes. I moved on to other projects.

About four months later, a van transporting some JCI inmates to another facility was involved in a car crash. Seven women were killed. It was a terrible blow to the compound. A tragedy like that has an enormous psychological effect on a closed population. But when I got a chance to speak to women on the compound, they said that they felt the performance that summer had prepared them in a way. It had made them think about life and death and their own mortality. I was glad the group had gone with the theme that the women had chosen; otherwise, this strange purpose would never have been accomplished.

Though the purpose of your arts program is to facilitate the participants' goals, you also need to satisfy the goals of the institution or treatment center where the program is taking place.

Institutional Goals

For schools, corrections facilities, and drug treatment centers, arts programs offer a variety of low-cost benefits. One of the most obvious is that of establishing links and partnerships with the community. Even if the arts program is facilitated by a staff member of the institution, artists from the community and from nearby universities or colleges can (and should, if possible) be brought in on a guest-artist basis. This contact between artists and the participants of the program offers the participants a glimpse into the life of a creative individual. One thing that people in recovery and artists have in common is that they are often looked upon as outsiders by the larger world. Artists have managed to use their outsider status constructively, and they make good role models for people in recovery. A psychological connection is made in the mind of the program participant—"It's okay to be an outsider. I'm okay."

Partnerships have another advantage in that they can divide costs for programs between various partners. For instance, a university may provide

a faculty member and graduate students to help facilitate an arts program while the institution pays for the individual lead facilitator and for supplies.

An important factor in any arts program is that those participating should be offered the choice to be or not to be in the program. While incentives such as gain time (time taken off sentences) for taking programs in general might be offered, the main motivation should be internal rather than external to avoid a confusion of goals. When a program is voluntary rather than mandatory, the participants will generally have similar goals. This does not mean that attendance is voluntary. Once a participant has chosen to be in a program, then certain guidelines must be stipulated. For instance, many facilitators require that the participants attend at least three-fourths of all workshops offered in order to receive a certificate. This means that in a twelve-session program, they cannot miss more than three workshops in order to receive a certificate. They can still participate in the class, but most of them will want to receive the certificate.

Arts programs can make the atmosphere less tense for both participants and staff. Arts programs have been proven to reduce tension by providing constructive outlets for creativity, reducing stress, giving the participants something productive to do with their time, and replacing destructive thoughts, habits, and images with self-affirming creative expressions.

In corrections, arts programs have reduced recidivism by providing opportunities for productive change, providing skills that are useful on the job market, and encouraging problem solving through the arts experience model. A California Department of Corrections synopsis on parole outcomes reported in 1987 that after two years only 31 percent of arts-in-corrections inmates returned as opposed to a 58 percent overall return.[2]

Institutions, treatment centers, and schools also have logistical goals that arts programs are designed to fulfill. If an artist is brought in from the outside, it gives the staff members a chance to be relieved of their duties for a while. The ideal situation is when staff members join in the group and participate as artists. This helps to establish a rapport between staff members and participants, which is critical to successful treatment. Often, however, the staff will leave the artists and the participants to their own devices.

Fran Barber, the former assistant superintendent of Jefferson Correctional Institution, stressed that arts programs helped improve security in the institution because the positive atmosphere established in the context of the program often spread to the rest of the compound.

Program Goals

The program goals are those qualities that help accomplish the program purpose. Goals will be particularized for each program, but they may generally be:
 (1) to raise self-esteem among the participants;
 (2) to develop critical thinking, cooperative skills, and literacy;
 (3) to lower behavioral-incident rates among participants;
 (4) to form a link with the community through publication or performance.

All of these goals serve the main purpose of the program, but the primary goal of most arts programs is to raise self-esteem among the participants. This is achieved by honoring, respecting, and recognizing the contribution of each participant. The value of self-esteem has been viewed with some deserved mistrust by a number of authorities. Sometimes we seem to be concerned with self-esteem at the expense of real achievement.

My brother used to teach chess in a public school in an impoverished district in New York City. His school's chess team garnered extraordinary successes on both the state and national levels, offering stiff competition to much better-funded programs. Soon the team began bringing back numerous trophies as a result of their accomplishments. But some of the parents didn't want other students to feel bad, and so they organized a group to purchase trophies for every single student in the school—for doing absolutely nothing. One somehow doubts that the trophies for accomplishing nothing were actually worth much in the eyes of the children who received them. This is an example of meaningless self-esteem building.

The arts provide opportunities for meaningful self-esteem. You can't cheat at creativity; therefore, what is produced in arts programs will be a direct reflection of each individual participant. It takes courage to expose those inner thoughts and feelings. That courage in itself is worthy of admiration and respect.

Blanche, a participant in a creative writing program, wrote:

> Writing is a risk because it exposes that which is so desperately trying to escape. I use the term escape because it is a passion that yearns to be freed. How and why I have kept it captive sometimes eludes me. I think it is because I know it will bring about exposure, and with exposure comes judgment, with judgment comes heartache. That is what I have always

associated with writing. Lately I've been thinking, maybe I will grant my creativity a furlough—yes, I think so, and now is a good time.

Arts programs will also uncover hidden talents. People who may not be very good writers might turn out to be excellent performers or visual artists. Or they may demonstrate leadership qualities. Or, given a little guidance, they may blossom in ways they had never imagined. In a poetry workshop, one of the participants called himself "Stumped" because he didn't know how to write poetry, but within two weeks, he had begun to rivet the rest of the group with his simple, evocative poems. Every single one of the participants will do at least one original and stunning piece of work, even if it's only one line in a poem or one movement in a dance—it is simply inevitable if the program is designed well.

Other program goals usually involve the development of certain skills, such as critical thinking, cooperation, and literacy. Arts programs develop critical thinking by allowing participants the freedom to interpret their own work and the work of others. For instance, in a visual arts exercise of drawing on the right brain, participants may use their nondominant hand to create a shape, and then use their left brain to decide what the shape means and how to create a symbol out of the shape. Or, when given certain formal exercises in poetry or dance, they must problem-solve to figure out how to express themselves within a particular form.

Arts programs are cooperative. They are not competitive. Each individual is afforded an equal opportunity for self-expression and recognized for what he or she produces. Participants encourage each other, make suggestions, and learn how to listen. The world in which they have lived has often been a world of lack rather than abundance. They have had to compete for attention, money, love, drugs, and affection. The world from which they come has never had enough for everyone. In that world, a few were winners, and everyone else was the loser. In an arts program, there are no losers, and there is enough time and attention for everyone in the group.

Literacy is a by-product of many arts programs. This is obvious in poetry and creative writing programs. As participants endeavor to express themselves, they become more adept at using language and more comfortable in reading and writing. I have seen the vocabularies of nonnative speakers increase as they searched for the right words in English to convey their meaning. In addition, they learn terms associated with creative writing. However, literacy is not confined to writing programs. The facilitators of dance programs can include journaling as a way to analyze the participants' work

and explore feelings they want to recreate in dance. Visual artists may also incorporate writing into their programs as they use books to learn about great works of art, or they may create text in the actual production of the work. Utilizing more than one art form helps participants learn how to verbalize, visualize, and embody their expressiveness.

The aforementioned goals are all directly related to the participants. Another goal of many arts programs, however, is related to how society views marginalized populations. Too often, alcoholics, drug addicts, offenders, and at-risk teens are dismissed by society as hopeless—and worthless. These stereotypes contribute to a waste of human resources. What arts programs do is to allow others outside the system to view those within the system as individuals rather than statistics. This goal can be achieved by bringing in guest artists, giving public readings of participants' written work, displaying their visual work in public spaces, publishing their poems and pictures and using the Internet to display their work.

Dave Hickey, a professor at the University of Nevada, Las Vegas, wrote an essay which stated, "One of the things that art can do and that urgently needs doing—one of the things that art has done in the past and does no longer—is to civilize us a little."[3] I believe that when we take art into prisons, treatment centers, schools, and other venues where it has not previously been fully utilized, we are helping to civilize not just those who participate in the programs but those who have tried to hide these "untouchables" from our sight. Hickey writes that he understands art "to be a necessary accouterment of urban life, a democratic social field of sublimated anxiety and contentious civility." In other words, the arts provide a safe and civil place in which to deal with anxiety, to learn from our conflicts, and even to value them.

Facilitator Goals

Arts programs provide a wonderful opportunity for artists to ply their trade in a manner that is meaningful to society, nurtures their own creativity, and provides ways to make a living while still being artists. Make no mistake, artists are professionals and should be paid for facilitating or guest-facilitating arts programs. Facilitators who are not artists by profession also gain by developing their latent talents and by establishing rapport with their clients. There is no more personal way to get to know someone than through their art.

In my programs, I have an additional goal. With every arts program that

I facilitate, I train an artist or mental health professional, as well as one of the participants, to also be a facilitator. I believe so strongly in the value of these programs to the participants and the rewards to facilitators that I am eager for others to jump on the bus. Arts programs don't have to be difficult. However, it is necessary to go in with adequate knowledge and resources. On-site training helps accomplish this.

Artists will never become millionaires by facilitating arts programs for people in corrections and/or recovery. However, they will find that it is one of the most rewarding aspects of their lives. The appreciation of their efforts and the abundance of talent is far greater than that which will be found in almost any other setting. Mental health professionals who add arts programs to their treatment methods will discover that work can also be play and that they will get to know their clients on a more intimate basis than through counseling alone.

When people ask me what it's like to work with women in a prison substance-abuse program, at-risk kids in a shelter, or men in a jail, I have difficulty describing it. They can't comprehend the immense pleasures in this sort of work unless they go in and find out for themselves.

Leslie Neal

The Sacred Circle

If someone with clairvoyant skills had told me ten years ago that I would soon be going to prison each week (indeed three or four prisons each week), I would have laughed out loud. Never in my wildest dreams would I have thought I would drive so many miles and cross so many razor-wired thresholds with a dedication and a desire that is so unyielding. No, I was on the road to great stardom as a choreographer. I was going to be famous. I was somewhat sidetracked by a full-time university job, but not hindered. My creative dance theater work was going to change lives. Now, seven years later, as I reflect on where I was then and where I am now, I realize that the life that has been most significantly changed is my own.

These changes have been part of an extraordinary journey. Seven years ago, I didn't know what I was doing. Back then, I was set on following the formula of what I thought was success. I was driven by an ambitious self that sought recognition and reward, companioned with a frightened, insecure self hiding in the back seat. Incarceration meant nothing to me. I never gave any thought to sentencing guidelines, the prison industrial complex, the battered women's clemency laws, statistics on the ever-increasing prison population, parole boards, the appellate process, or the death penalty. Since then, my priorities have certainly changed. I have a whole bookshelf dedicated to prison topics and at least a hundred videos of performances of the work of the female inmates in the Inside Out class I teach. I travel to other states and tour and teach in prisons. I have toured death row for women in

Florida, written letters to governors, met and cried with families after visiting a loved one inside, rejoiced at seeing a friend walk out those gates and into freedom, written thousands of letters, received innumerable collect phone calls from inmates, and defended what I do over and over again. Each time the road gets rocky, a clearing always opens. I have been supported, loved, and guided. The light always turns green, and I continue to stumble ahead along this unexpected path.

I go to three different facilities a week—two maximum-security prisons for women and a brand-new minimum-security work release center. The Florida Department of Corrections is very supportive of my volunteer program. They have found that it allows a positive release of emotions and builds community. I go to Broward Correctional, where I started the Inside Out program seven years ago, every Saturday. Saturdays are visiting days, and each week I walk past the lines of family members, husbands, children, and boyfriends waiting for hours to get in. We have that in common now—waiting to get into a place most people would never want to go. We do so because we care about those who live there—those waiting for us on the other side. Eyes shadowed, hair sprayed, lips outlined, uniforms ironed, they are waiting to hear their names called out over the compound loudspeaker as if they are at some strange beauty contest. They are anxiously waiting for their connection to the free world.

I no longer have to wait. I sweep by the impatient families with gentle smiles and good-morning greetings. I walk right through the visiting park with the pacing officers, the clutching hands, the inmate mothers desperately holding and breathing in the smells of their children, and the occasional kissers in the corner.

Whether I go in on a weekday or during visitation on Saturdays, once I'm on the compound the rhythm of doing time is always the same. Upon entering that world, I become a part of it. As an artist, I approach community work as an opportunity to share with others a healing process that has helped me. I do not go in with a preconceived notion or a judgmental determination that these folks need to be fixed. In retrospect, I think I'm the one that needed fixing. I am the Inside Out lady, and I walk through the compound meeting and greeting like a campaigning candidate, responding and waving as my name is screamed out across the yard. Everyone knows me, from the staff to the inmates. I am famous in certain circles. I always wanted to be famous.

Once I'm in the room where we meet for class, free of officers and supervisors, a circle must be made. At Broward our circle of chairs has been pre-

pared by the "elder" group of women I have known or worked with for seven years. If I am at another compound, I enter alone and set up. My job is to make that circle, to show up and allow this space for participants. The circle must always be made.

Over the years, I would say that more than 300 women have been involved in the Inside Out class, women whose lives have been filled with such pain and hardship. Women who are still surviving and willing to come to this class each week and take huge risks to trust me and each other as we create and touch upon our issues within our creative work. Women who share the fact that their survival is about finding meaning in their lives. They come and write poems, tell their stories, and create dances that express their feelings—the shame they carry as victims of abuse, the pain of losing their children, the hopelessness of seeing the cycle continue in their families, the fear of dying inside, the anger at a system that demoralizes and dehumanizes them, the sadness of their inability to have a new chance to try again.

Once they arrive, there's the usual catching up, chatter, and mulling about of any women at a social gathering, and then we settle into our circle. First is always our meditation, our sacred focusing inside. I start with images of breath and body consciousness, and then one or another member of the class takes us on our journey of guided meditation. They evoke images of hot water bubble baths, flying, smells of food and babies, fields of flowers, the beach, strawberries, waterfalls—always sensual, natural, and always feminine. Then we sit quietly in that muted time between inside and out and acknowledge the shining eyes of those who have come to the circle that day. We pause to recognize the amazing fact that our various and diverse lives have somehow brought us here in this moment together. Then we speak our names, the names of our mothers, our grandmothers, our great-grandmothers, our children, and we bring our essence for that day to our circle. Our essences define who we are and where we are that day. We form a circle of women where each voice is valid, and each one is heard. It is a feminine construct, a womb for our own rebirthing. It is here that our individual and collective power forms. We form our circle of trust.

It is within this circle that some of the most profound experiences I have ever had in prison have occurred. For our circle truly is the metaphor for community and who we are, who we would like to become and how we may choose to restructure our world. It is how we deal with conflict that always amazes me. Anger, resentment, hurt feelings, performance anxieties, frustration with the group and ourselves inevitably arise, as they would in any social/familiar interaction. But when they do, rather than repressing or ig-

noring or abandoning or denying these places of conflict, each of us returns to the circle with a willingness to pass the "talking stick" and say what's on our minds. I have never experienced a healthy way of dealing with conflict within groups I know in the free world, but here within the walls and gates, the bars and barriers of prison, we deal with it. We confront it and then stay with it until a resolution is found and the conflict passes.

Then we always dance together. Even when the energy is low or their medication is off. We'll create our own circle dances, or I'll bring in scarves or we'll begin to move together in unison. We dance out our anger and frustration with strong directed motion, and the years of suppression and blocking off of the emotions of the body are released. We laugh, breathe, stretch, and speak in the beautiful language of movement. Then we move on.

I am confident that all of us who work in arts-in-corrections continually ask the same core question: Why? Why am I doing this? Why do I travel so many miles and wait for hours to get in a place that no one ever wants to be? Why are they letting me in? Why is it such a strong priority in my life? I honestly don't know, but on some level, I think I'm beginning to understand.

Perhaps it is a calling. Maybe that's what it was for me, one of those strange psychic events that our Western minds don't want to own, much less talk about with others, but a calling, nonetheless. Mine was not a quiet, deep soft inner voice nudging my awareness. No. Mine was more like a scream, so loud that it jerked me up out of a deep sleep. Or perhaps you could say it was more like an uncomfortable belch that bellowed up through me and came out saying "You are going to work in prison."

Not real eloquent, I know. Not the type of wisdom that speaks in parables with a lot of pregnant pauses and magical meanings. No, my calling wasn't a pretty moment. It did not feel great. It just was. It felt more like a sprouting that initiates a growing process that is unfolding and unraveling, ongoing and transforming, unpredictable and challenging. At that time, I had no idea how to begin or what to do.

Now, seven years later, I still constantly question what I'm doing. I know that's not what you want to hear, and in all honesty, I really don't like admitting it. How lovely if I could candidly and fluently provide you with a step-by-step method on teaching arts inside. How I wish I could create a simple formula and teach others in three days or less. But it's just not that simple. At least, it hasn't been for me. There is no yellow brick road to follow here. This work is definitely off the beaten path. There's no string to mark

where you've been, no map in place to trace a trail. You just go and make a space.

It is the women inside who come to that circle each week that always guide me. They are the teachers, and I have been forced to be the student. They have challenged me to go within myself as I have asked the same of them. They become my mythic companions in my own journey of reflection on my inner imprisonment. It has always felt safer for me to travel through my fears alone, but they have gently shone the light on my internal issues that incarcerate me. For I cannot ask them to go there if I will not. I have had to arrive face-to-face with my own insecurities, fears, shame, and sadness. Now, when I find myself once again caught up in the private prison walls of my own making, I think of those I see each week who are literally locked up inside—physically imprisoned, no choices, no privacy, no peace and quiet, no darkness, no place to hide. What would they do? I know what they would not do. They would not and do not choose to sit alone trapped in a corner. Not if they could get out. I know how they would be embracing and loving their freedom. They would eat strawberries and take bubble baths. They would run through open fields and dance in the rain. They would eat pizza and watch movies.

They stay in our workshop. For at least two hours each week, we form a circle, and within that sacred space, they find freedom. I know from sharing that circle with them that I have found freedom, too. They have taught me that all I must really do is simply go and allow a space for creative healing to emerge.

The beauty of the process of shared art making and creative expression is that it can be such a powerful metaphor for how we approach our lives. All the patterns and baggage, negative beliefs and fears that we drag around with us show up. Our circle becomes a delightful laboratory in which to notice, realize, and feel safe enough to practice a new change with a little bit less baggage. I guess, over the years, what I have been doing is consistently showing up—properly attired according to the rules—with a boom box, a bag of CDs, tapes, pastels, colored pencils, a plan that will immediately dissolve, several approved memos, a naiveté that borders on gullibility, an air of purpose, and a willingness to make a sacred space in a restrictive environment for all of us who have been called to enter.

After seven years of teaching Inside Out, I still struggle with why I do it and what I should be doing. How, as my program grows and needs to expand, do I train other artists with a similar calling to cast off on this incredible journey, recognizing that their path must and will be their own? How do

I tell them not to teach but to be willing to show up and learn? Should I tell them that there is no formula except to simply go and make a space? That sometimes it feels like you have entered a vast desert full of emotional landmines and the more landmines you set off, the more pieces of yourself you have to keep finding, picking up, mending, reevaluating, reshaping, replacing, reorganizing, and recreating until your scar tissue has made you bigger than you thought you were.

For me, teaching and sharing art making in prison has not been about serving others. It has not been a choice. It has been about an exquisite mystical rite of exploration—from the inside, out. It has become a weekly embodiment of metaphor and my own private drama of sacred myths. A calling? Yes. Teaching arts in prison has given me the chance to create a space for a divine healing to come forward from within, and my life has been transformed from an ordinary life into an extraordinary life.

Judith Tannenbaum

"Like a Poet"

ot dog!" Jim exclaimed as he hung up the receiver, picked up the cloth beanbags always on his desk, and began juggling. The call was from Jan Jonson, Jim announced, a theater director in Sweden.

Jan told Jim that he'd just completed work on a production of Samuel Beckett's *Waiting for Godot* with maximum security prisoners at Sweden's Kumla Prison. Jim and his family had visited Sweden the previous summer; Jim had even been to Kumla and met its warden, Lenart Wilson.

Beckett had heard of Jan's Kumla production and wrote letting Jan know that such work was exactly what he wished for *Godot*. The playwright wanted more details about the project and eventually asked Jan to come meet with him in Paris.

At that meeting, Jan discussed his observation that from its first line—"Nothing to be done"—*Godot* echoed prisoners' lives with their endless waiting for what may never come. Jan talked to Beckett about his desire for a theater created not by actors, but out of the forces and truths of real people's lives. Jan felt that maximum security prisoners playing *Godot* was such theater.

Beckett agreed and mentioned the play's historic connection with San Quentin. The first West Coast production of Godot was given by the San

Previously published in 2000 by Northeastern University Press as chapter 5 in *Disguised as a Poem: My Years of Teaching Poetry at San Quentin*.

Francisco Actors' Workshop. This group performed the play in San Francisco, of course, but also at San Quentin in November 1957. As the drama critic Martin Esslin wrote of this performance, "what had bewildered the sophisticated audiences of Paris, London, and New York was immediately grasped by an audience of convicts." "Godot at San Quentin" became a major chapter in Esslin's classic, *The Theatre of the Absurd*.

The *San Quentin News* wrote at the time:

> It was an expression, symbolic in order to avoid all personal error, by an author who expected each member of his audience to draw his own conclusions, making his own errors. It asked nothing in point, it forced no dramatized moral on the viewer, it held out no specific hope. . . . We're still waiting for Godot, and shall continue to wait. When the scenery gets too drab and the action too slow, we'll call each other names and swear to part forever—but then, there's no place to go!

One inmate who watched that 1957 production was so moved by the play, he went on to form a prison drama workshop. Rick Cluchey gained a pardon and established the San Quentin Players on the outside. He also became a lifelong friend of Beckett's.

Jan wanted to continue working with *Godot* in prison; Beckett was interested in the play's San Quentin connection; Lenart Wilson had recently met Jim. These three facts informed the phone call Jim had just received and resulted in plans for Jan to visit San Quentin in February.

Jim went to see our warden, for gaining his approval was the necessary first step to any potential production. After getting the go-ahead, Jim spent January recruiting prisoners to read for parts in the play. Gabriel was interested, and we'd talked Spoon into at least showing up. Ralph, the new student the others dubbed "Santa Claus," loved *Godot*, saw himself as Estragon, and signed up his friend Mike to read for Vladimir. James also said he'd be there.

James was another man new to my class, but not new to the rest of my students. James was famous. He had been out at court my whole first year at San Quentin, appealing his case. And he'd won. He returned to San Quentin no longer a lifer, but instead with less than two years left to serve. James was a San Quentin hero.

Before I met James, I had seen him. In 1985, the visual artist Jonathan Borofsky and the video artist Gary Glassman made *Prisoners*, a video about

prison life. The two artists interviewed thirty-two prisoners at three California prisons. James was one of those interviewed at San Quentin.

I'd watched the video quite a few times; now I saw James in person. James didn't swagger. Maybe his victory in court protected him from the need to swagger, or maybe his age helped. James was in his midthirties, while most men at San Quentin appeared to be close to a decade younger.

Gary Glassman had been so compelled by prison during the making of *Prisoners* with Borofsky that he applied for, and received, his own California Arts Council residency grant at the California Institution for Men near Los Angeles. One of Jim's January tasks was to call Gary and arrange for him to come to San Quentin to videotape the *Godot* readings. Jan would then take these tapes to Beckett, enabling the two men to decide if, from their point of view, a San Quentin production of the play should occur.

For two February evenings Gabriel, Spoon, Ralph, Mike, James, Jim, and I sat in the studio of SQTV, just down the hall from our classroom, listening to Jan's stories. Everyone's favorite was the one in which Jan and his Kumla cast received permission to take *Godot* on the road. The prisoners were free for a few hours to walk around Gothenburg. But when the clock showed barely an hour until curtain and only one of the five men had arrived at the theater, everyone began to worry.

An excited audience had filled the Gothenburg theater. They waited five minutes past opening time; then ten minutes; then fifteen. Jan walked through the curtains at that point and straight to center stage, where he talked about the play and its history at Kumla. Finally, even Jan—raconteur extraordinaire—had to stop telling stories and admit the bald fact: Four-fifths of his cast had escaped!

Every time Jan told the story, he acted the part of a deaf old man in the audience not understanding the uproar around him. This portrayal sent Gabriel into great guffaws. Jan cupped his hand around his ear and squeaked, "What? Has something happened? What did he say?"

Gary presented his own credentials, showing us videos from his class at California Institute for Men. Gary told us, "I walked into my class one day and asked, 'Why do these guys whistle at me when I walk past the weight pit?' The men cracked up. They said, 'It's because of the way you *walk*, man. You gotta walk smooth.'" Gary showed us the videotaped lesson his students had prepared on such strutting.

My friend the poet Kate Doughtery was in the middle of her own first year of a California Arts in Corrections grant. She was teaching poetry to the

children of Point Arena Elementary School. Sara had graduated from PA Elementary, and over the years we lived in Mendocino county, I had volunteered or been hired to share poetry with almost every child in the school. Kate invited me to come back as a guest artist in the sixth- and eighth-grade classrooms. So after Jan returned to Sweden, I went up the coast; I went back home.

Point Arena is close to the westernmost edge of the continental United States; six months of rain are followed by months of high winds, then summer's dense fog. The population of the area around town is four hundred—less than the number of men housed in San Quentin's smallest cell block.

Kate asked me to talk to the sixth graders about picture poems, share Kenneth Patchen's work and Blake's, and bring in reproductions of medieval manuscripts, with their elaborate initials and borders. We thought, though, that I would talk to the eighth graders about San Quentin and read my students' work to them.

We had great fun with the sixth graders, playing with language and image. When these children discovered I'd be reading poems by men in prison to the eighth graders, they asked to be included. Jim Wesley pushed tables and chairs around in his science classroom, and a few dozen eleven-to-fourteen-year-olds filled the room.

Over the years, I have shared prisoner work in a wide variety of school settings. But my visit to Point Arena was the first such encounter, and I didn't know what to expect. Before I read the poems, I described the five tiers of a cell block, the wire mesh over bars, how a man in lockup might exercise outside three or four times each week, but would spend most of his days and nights in a cell.

These were country kids listening, kids who lived surrounded by fields and forests, who fished in the Garcia and Gualala, who surfed in the sea. For all the redwood and fir, for all the fawns and lambs on the hillsides, though, these were kids who spent the bulk of their own days inside a school. These were kids on the brink of adolescence, kids who'd seen their share of TV cops and robbers. They listened intently to the words of the men from San Quentin. They listened to Spoon—a country boy, too, though from the desert, rather than the coast—speak in "Heart of the High Desert," that poem he'd written from my transcription of the words he'd spoken during our first conference:

A wildflower takes its
first breath of air
after a generous rainfall.

They listened to Spoon describe being kept in a cell at the city jail across the street from the high school he had attended, and what he heard from that cell:

the sounds of the games
the football games I'd gone to
my whole life in that town.

They listened to Spoon tell them:

My nephew wrote me a letter
first time in the ten years I've been here.
He wrote he remembers
I taught him to drive,
to whistle.
He remembers washing my car
He wrote, "Dear Uncle Stanley."

The Point Arena kids listened to Glenn as he waited for the officer distributing mail to come by:

As he passes
my tiny cell
I know once again
I have been forgotten.

They listened to the last words of Coties's response to his girlfriend's request for a love poem, that poem he'd shown me three months before in West Block:

Baby, this is my love poem for you.
We're both trying to see through the darkness
you on the outside
me on the inside.

They listened and asked questions, and they told me stories. One girl knew a woman who had been a sergeant at San Quentin; another girl's grandfather had been a cook there. One or two kids had a relative in prison or jail.

The kids wanted to know: What jobs did the men do in prison? Did they have children? What were their crimes? Was I ever scared? Finally, a sixth grader, Noah Berlow, burst out, "Let's write them some letters!" The next day their teacher, Nancy Wagner, handed me quite a stack.

Because these kids had been listening to the prisoners' feelings shaped in poem lines, because they themselves had been writing with Kate for almost six months, mostly they wrote poems of their own. And, fresh from our lesson on the combination of words and image, many of these poems were accompanied by an illustration or set off with a fancy initial or border.

The kids wrote poems with lines like these:

Life is a cage
It scares me just thinking
about it.
 —J.J.

and:

within a block
like ice.
 —Autumn

and:

I can see light
and happiness
unlike you.
 —Hollie

and, from a girl who described herself as "a real crazy kid":

Even though I have seen
all of it on television
it didn't even cross my
mind after 10 minutes
from watching a movie
that there is a real
person in prison.
When I heard the poems
and the writing of the
prisoners, I
took a piece of their
sorrow . . .
 —Jibs

And that Thursday in February, during a furious Point Arena rainstorm, they wondered more deeply about the men's lives:

WHAT IS IT LIKE?
It was a cold
winter day
when the rain
was pouring down
and the wind
was blowing hard and fast.
The trees were breaking.
What is it like there?
Does it have floods
rainstorms? What
is it like?
 —Matthew

and about their pain:
You are like a
baby bird trapped in an
egg it is dark no freedom
no friend you can't get out
inside you crying
but you can't show it
you have to be a
man
you have to be
strong if you are
not strong you
will not survive.
 —Danny

These kids wondered what it would be like to make a mistake so big it would change your whole life:
The memories
of a prisoner
are hard to take
Your loneliness
and grief
You think of the moon
the stars and
the world around you

You think of your
loved ones
and your
unhappy life
you go back
and want to
start your
life over again.
 —Laney

It was to Spoon, especially, the kids addressed their letters and poems. Spoon—whose world included wildflowers and butterflies, as did their world. Spoon—a country kid who "was nineteen when I got busted." Spoon—who would write in a poem later that year:

Over two years ago
I knew nothing of
poetry
Of how it allows a
huge part of me to
be free.
How the truth in
it makes people feel
how it allows me
to feel love and sorrow
like a great earthquake
starting from
so deep
within

I cradled the bundle of children's poems and hurried into town to call Jim. I'm sure the river of words I poured through the phone lines flooded out all actual detail, but Jim caught my obvious joy.

"Well, you'll show me on Monday," Jim said with excitement enough to sustain me.

I stood in the phone booth, trying to avoid getting soaked in the storm, and looked across the street at Gilmore's. I remembered how three years earlier I'd stood outside that all-purpose store pinning a deckle-edged pink sheet of paper to the bulletin board. I had just printed a small poem on the thick paper, and I wanted to share Wendell Berry's words with whoever

paused to read them. The wind that had torn through town all that day had died down, and as I stood outside Gilmore's that long ago March evening, I'd laughed: thirty-seven years old and still wanting to be the Lone Ranger, riding into town in the dark night, leaving gifts.

Now, however, back in this phone booth during a February storm, I knew I no longer wanted to hide behind some Lone Ranger mask. Those post-Hikmet questions Elmo had asked me—Who was I? Why was I here?— were the questions I'd lived my life asking. When I was younger, I'd assumed I was supposed to come up with an answer. But the voice I had let myself trust on leaving my marriage told me instead to give up such willful pretense, and to live an unmasked life of surrender.

Just before this trip to Point Arena, I'd been to lockup teaching cell to cell. That day I'd taken a Rilke poem about being shaped by submission to share with the men. I stood on the tier reading the poem to Dennis:

What we choose to fight is so tiny!
What fights with us is so great!
If only we would let ourselves be dominated
as things do by some immense storm
we would become strong too, and not need names.
When we win it's with small things,
and the triumph itself makes us small.
What is extraordinary and eternal
does not want to be bent by us . . .

I continued to the poem's last lines:
This is how he grows: by being defeated, decisively,
by constantly greater beings.

I slipped the sheet through the slight space to the far left of Dennis's cell, through a tiny gap between mesh-over-bars and the concrete wall that separated his cell from the next.

Dennis looked over the poem. He hesitated in a way I took to mean he was glad for my weekly presence and support of his writing: He didn't want to offend me. But the need to speak his truth won out.

"It's a tight poem," Dennis acknowledged, "but I hate what he says. He wants god; I'm more into the devil."

The enthusiastic fast pace I relied on to get me through the pain of being in lockup slammed into the wall of Dennis's words.

"The devil?"

"Yes."

"What's the devil?" I asked.

"What's the devil?" Dennis repeated. *"I'm* the devil. I wake up in the morning and ask what is it *I* want, what do *I* want to do? Then I do it."

I'd been astonished by Dennis's precise definition and found I agreed, such selfish will *was* the devil. And I agreed, too, with Dennis's implied corollary that surrender was the devil's opposite. Yet I disagreed with Dennis's view that such letting go was weak. As I walked out of the block, I remembered the moment I first recognized submission as courage.

It had been during that long journey through Europe after leaving my marriage. One day I hitchhiked the short distance from the English Lake District to the small town of Hawes in the Yorkshire Dales. It was raining, as usual, and the hostel wouldn't open for another few hours. I walked for a while, getting thoroughly soaked, and then climbed the stairs to the town's open-three-afternoons-a-week library. When the librarian, a woman about my own age, saw me, she immediately asked for my jacket and shoes and she set these by the heater to dry. I sat down by this heater with a volume of Wordsworth I'd taken from the poetry shelf. When the day's few patrons had selected their books and departed, the librarian made us both tea and asked for my story.

She shook her head and spoke of my courage. She herself had been born in Hawes and still lived just down the road with her husband and children. She liked her life fine, but often thought of traveling, of setting out on her own. She couldn't believe I had really done what she'd let herself only dream of.

Many times on this journey, people mentioned my courage. Courage? I didn't see it. Courage seemed what was required of heroes of old. I wasn't following dreams, and I wasn't courageous; I simply felt I had no other choice. But as the afternoon wound down, and the librarian from Hawes talked of her longings, I saw that maybe that's all courage is: Doing as best as you're able what life asks you to do.

In that Point Arena phone booth, after I'd called Jim, I realized that we all choose the way we'll tell our own stories. Others might look at my life through the lens of psychological illness, white middle-class privilege, coming-of-age-in-the-1960s insistence on discarding old structures, self-centered indulgence, or—as the folks at San Quentin saw me—the ways of a "free spirit." Any of these descriptions could frame the events and emotions I'd lived through.

But I chose to see my life as a spiritual journey. That voice I listened to

sounded to me like unfolding existence, and my surrender as aligning myself with what inevitably is.

When Sara and I decided to move from Point Arena back to the city, there was a lot that I wanted: I wanted more varied teaching, I wanted more opportunities to attend poetry readings and to give them myself, I wanted to walk down streets surrounded by a variety of faces and tongues, I wanted a less inbred life than Point Arena High would give Sara. So maybe Dennis would see our move as my vote for the devil and will.

But I saw leaving Point Arena as upping the ante, as asking those Who am I? Why am I here? questions harder. Who would I be amid noise and pollution, working many more hours to pay rent on a small apartment? Asking these questions had brought me to San Quentin. And that February Thursday, one day before my fortieth birthday, San Quentin seemed exactly where I needed to be.

When I walked into the prison Monday morning, there was Spoon across the plaza, sitting in that spiral staircase. As he did most mornings, Spoon joined me as I walked to the Arts-in-Corrections office.

On this particular morning, I was so excited by what had happened in Point Arena, I hardly took time to say hello. I knew how much these poems would mean to all my students, but I knew they would mean most to Spoon. I told him how the kids had listened to the men's poems and that they decided, on their own, to write to the poets. I told him how much the kids had loved his poems in particular. Then I pulled out the stack of papers I'd brought from Point Arena.

Two years later, Spoon would write of this moment: "I hardly ever smiled or took my shades off, even on the most wonderful of days—I'd keep the wonder inside me. But, as I began to read the poems and letters, I was unable to contain the magnificence, the sheer magic, and realness jumping off the pages into my heart and soul."

I showed Spoon the kids' words but didn't give them to him; I had to get permission first. So, as Spoon went off to his prison job, I waited for Jim.

Jim was as excited as I was as he pored over the kids' poems, drawings, and ornate initials. He, too, was touched by the care, craft, and compassion of these youngsters. He, too, could see how well the children had caught not only the feelings but the tone of the men's poems. (Laney had written in her note to Spoon: "This poem is almost like your poems.") I talked of a prisoner-student poem exchange, and Jim expanded on the idea: Maybe we could videotape the guys reading their poems and send this tape around to

schools. He picked up on the words of one child: "If you ever get out of that jail place, I hope you guys will try writing more poetry. Hearing an experienced prisoner tell all about the place, people would want to hear so they won't wind up in jail."

What better way, Jim thought out loud, to let the kids see what prison is really like? Not the blood and guts glory of TV movies, but loneliness and regret and claiming one's dignity in an environment designed to deny it.

Although we went off into a chain of "we could do this, we could do that" fantasies, we still knew we were in San Quentin, a maximum security prison run on a strict system of rules. And one primary prison rule prohibits carrying any material from the outside into the institution for an inmate. These poems didn't seem to be the kind of "material" referred to, but Jim certainly wouldn't give the poems to Spoon without consulting with his supervisor.

However, Luis wasn't in his office, and we didn't know when he would arrive. As the morning progressed, Jim and I kept getting ourselves more and more worked up over the power of art and the power of honest human sharing, so that finally, Jim decided I should go ahead and give copies of the poems to Spoon. "If that's a mistake," Jim said in prison parlance, "I'll take the heat."

When Luis did arrive after his day of meetings, Jim let me rush into his office. Luis also responded to the openness of the kids' poems, but after listening to me read—after giving me free rein to ooh and aah my pleasure—he said, "I'm not sure we can give these to Spoon."

I knew Luis approved of the work Jim and all of Arts-in-Corrections was doing, so I didn't restrain myself. I questioned, held forth. Luis didn't interrupt me, but when I stopped, he asked, "What if one of the inmates in your class gets out, goes to that school, and harms one of these kids?"

Kate and I had been very careful: No addresses were given, only first names were used, and we devised a system of parental permission with Nancy Wagner for any correspondence that might take place in the future. Still, the possibility Luis described had never really entered my mind.

"Besides," Luis added, "we don't want to be setting up inmates as some kind of positive role model."

This got me going again. For although it was true that there was one girl who wrote, "It would be really neat to have a pen pal who was in prison. I would like to tell my friends what it's like and show them my letters you sent me," and a few instances of identification with the downtrodden—"I

am a fourteen-year-old convict from Point Arena Elementary Peniten-
tiary"—such comments were few and far between.

The shared theme of the children's response was: "I loved the poems.
They were great. They made me think, 'Wow, there's real people in there!' "
And this realization made the kids wonder about the lived lives of these
men: "I used to go fishing by your prison. I could hear you guys do your
exercises." Apparently the kids were capable of making distinctions, of rec-
ognizing the human beings who had written the poems and, at the same
time, of realizing that many of these men had done serious harm to other
people. The kids wrote:

Their eyes are soft and gentle
But I wonder what
they did
to deserve this place.

They pondered:

> After being there for a while, you must have thought about what you've
> done and wished you could start life all over again. The prison probably
> doesn't treat you well and there isn't much to do, but I bet the worst
> punishment of all is loneliness.

and:

> In a way, it's really sad that some of the guys have a family at home and
> their wives need them. But I guess if they would not have committed the
> crime, they would be at home, living happily ever after.

The next day, Luis told us we'd have to get the poems back from Spoon.
The official decision was that I could make photocopies available for the men
in my class to read, but neither Spoon nor any other class poet could keep
these papers, and there absolutely could not be any exchange of letters.

I had a special class set up for that afternoon, and Spoon was one of the
men on the movement sheet. Jim, willing as usual to bear the brunt of the
burden, spoke to Spoon on his way to class. When Spoon joined Coties,
Glenn, and me, his sunglasses were back on, his face again a fixed surface
he lived behind.

At home that night I cried as I told Sara what had happened; I cried on
the phone telling Kate. But Kate wasn't crying; she was confused and angry.

What was this censorship, and what had happened to me that I so easily submitted to it?

Censorship. In my heart, of course, I felt these poems—prisoner poems read to children, kids' poems written to prisoner poets—honored what was most compassionate and human in both the children and the men. In my heart, I felt a further exchange could only be for the good—for the good of Spoon Jackson and Noah Berlow, and for the good of the spirit that lives within every human being, needing only to be nourished and nurtured.

But already, my time at San Quentin had taught me that my heart, though wholly right in its sight, saw only part of the picture. Already, my time had taught me to remember that some men whom I knew as kind and caring had also caused great harm to other people. Already, my time had taught me I didn't know everything.

In the unambiguous world of my heart's sight, I could always respond with moral assurance. In the more ambiguous world of San Quentin, there was always another point of view. In the ambiguous world of San Quentin, I believed in my heart's sight and, simultaneously, was forced to acknowledge all I didn't know. In the ambiguous world of San Quentin, I received dozens of lessons weekly from Paradox, the great teacher whose spirit I'd actually summoned with all those quotes on my wall.

My tears that night were for Spoon and the kids, who met each other with such open hearts, minds, and souls, and who spoke so clearly through poetry. So this is how the questions that had moved me from Point Arena were being answered? I couldn't believe that less than one week before I'd stood across the street from Gilmore's, full of gratitude for all San Quentin was giving me.

Well, I felt no gratitude now. Instead I wanted to tear all those quotes off my wall. I wanted an unambiguous, unparadoxical world in which openness of heart, mind, and soul were enough, would by themselves cure every ill, every harm done.

Still, I knew my tears, though real, were easy. I could go home, cry on Sara's shoulder, talk with Kate, take a long walk. Spoon had only his cell, its barred gate facing the gun rail.

Of course, Spoon had something else I had let myself forget, although I was the one who had talked and talked of its value.

When I entered the prison the next day, Spoon was not on the spiral staircase, but he appeared at the office shortly after I opened the door. He said nothing, but handed me a typed piece of paper. A poem.

RIGHT NOW I CHOOSE SADNESS
 to the students at Point Arena Elementary School
 who sent me their poems and letters
She wrote me today
and asked me
Is everyone there
on death row?
At first I said no
then I began to wonder
could it be so?

I had hoped to write you all back
to share with you
and to thank you all
Your poems and letters are so real
and full of life
and greeted me with tremendous beauty.

The whole day was enhanced with such joy
I walked around smiling inside and out
I truly felt like a poet.

Thank you for taking me beyond
the walls of San Quentin.
Today your poems and letters
were taken from my hands
Still your letters and poems
lie solid within my spirit and heart.

At least I got to see them
people say
Words sometimes do not fill the space
just like one drop of water
does not make an ocean
nor a river.

As I sit in this dark cage
sad music and silence to assuage
this deep wound

in my heart
and spirit
I think of your poems and letters
and how naturally they went to my heart . . .
no detours.

Right now I choose sadness
over happiness
for I feel like a river that has been dammed
or drained.

Jane Ellen Ibur

Us and Them

When I returned to teach in the St. Louis County Department of Justice services in January 2000 with all new men, I said:

> I've just returned from five weeks on a very poor Mexican island where I could not be reached. Before that, I spent six months caring for my closest brother, who called in May to ask if he could move in with me to die. He died a week before my birthday in October. That was the easy part, so don't fuck with me.

Then I began, as usual, handing out eight by eleven pads of paper, pens, and folders, to each man, staring at him in the eye, introducing myself as Janie, asking their name, shaking hands. That physical contact is very important to me. If the handshake is weak, I repeat until the shake is firm, not aggressive but assertive, present.

Like my father, I believe that my handshake is my contract and I expect reciprocity. I tell the men:

> My assumption is you're all guilty. I'm not here to discuss or help your case. Nothing you say or write with me will be used for or against you, unless I think your writing shows you may harm yourself or others. I take responsibility looking out for you, and if your writing leads me to suspect

you may harm yourself or others, I share that with a staff member, for your benefit.

The good of the group is more important than the good of the individual, so if you act in a disrespectful way, you're out of class, permanently. Participation in class is a privilege. No profanity from you. Let's begin.

Next, I explain:

Two kinds of truth exist in writing, the actual, factual truth, and the emotional truth. We'll deal with the emotional truth, even if we have to lie to get there. You can write anything on paper, but if you act it out, you live here. Personally, I don't like anyone telling me when to get up, what to eat, what to wear. If I don't like a TV show and my friend does, I can go to another TV and watch what I want, eat soup out of the pot, stay up till 3 A.M. I like being an adult. Of course, I have bills and responsibilities, but I negotiate for my own terms. I offer evening classes, but sometimes I bend to work with an organization's availability. I don't work nine to five; normal was never a goal. I choose my work for love. Jail has been a favorite job site for over ten years that I miss when I'm not here.

After introductions, I lay down my rules and expectations: no talking while writing; no making fun or laughing at someone's work, stuttering, whatever; no judging, no negative responses. We get together to write, to share, accept, nurture.

I share my own work by reading aloud; sometimes I write with them. I take their work home and type it, correct mechanics, then return their original and copy to bump up their skills in those areas, because when they write I want them writing from inside their hearts, their guts.

I've always wanted to work in jail—there but for the grace of God. I prefer being with real people, prefer diversity, prefer teaching people who never got the opportunity to write, express themselves. Men are taught not to express feelings or be introspective.

Depending on perspective, people never in the system generalize about *them*—as if genetic disposition, race, and environment create *them*, "those animals"—with the attitude that they get what they deserve. The righteous condescend from their perches that "we" can never be *them* because we're better bred, with values, education.

We are all divided into *us* and *them*. This arrangement is very fluid. Today we may be *us*, tomorrow *them*. Jail is very much *us* and *them*. When it comes

to correctional officers (COs), the prisoners are *them*. To the prisoners, COs are *them*. And me, I'm a chameleon; with the COs or staff, I'm *them*; with the prisoners, I'm *them*. Even I am constantly fluid.

Writing is dangerous and courageous. I give exercises to avoid staring at a blank page, the point being to have a jumping-off place. Any exercise will access your stuff. There are no correct answers or responses, no wrong ones; I don't care if they stay on the subject; I even show them how to get off the topic. The importance is the writing itself.

My students read aloud after they've written. Although I give them an option: if they're careful about what they write because they know they have to read, then, I say it's more important for them to write, to allow vulnerability, to share it with just me if they choose. We listen, and we talk. In class, comments are supportive, never negative. We all had a childhood.

If I turned back time, what would I like to know up front? Nothing. I prefer to walk in unshielded, unarmed, and existing in the present moment. I still do this work because every day is new, the first day, every man the first man, every day a new adventure, a new community formed, an expansion of mind or heart. We cry and we laugh a lot.

I've taught my students that if they act out their "stuff," such as anger, frustration, hurt, or fear through violence, they will end up in jail or the penitentiary. Some have lived the life a long time, time in the pen, out, back in. To some, it's home—"three hots and a cot," time to play basketball, a life that's structured.

I always wanted to teach in jail. I taught my first creative writing class for women at a minimum-security jail. Ann H. was the director of the Writer's Voice at the YMCA, and we did this as an outreach program. One of the women was illiterate. She told her stories to Ann, who transcribed them word for word. The woman's face lit up when she heard Ann read her words aloud to the group. Her fellow inmates encouraged, cajoled, bullied her to learn to write and in the last class, she signed her name. She was thirty-five years old.

The class rocked. Here were women laughing, talking, writing, reading, unconsciously building a community among themselves, "seeing" their voices for the first time. I was hooked.

Shortly after that, women were moved from that facility, which became male prisoners only. Juveniles were segregated in two-man cells. Once they turned seventeen, they were transferred to the dorms with the other adults. These boys were being held on serious felonies, armed criminal action, murder, and robbery. They thought they were so tough, and on the streets, with

their "posse" and their guns, I'm sure they were. Inside, though, without their buddies, their drugs, their guns, they were kids. However, I never treated them as kids. I have always treated all my students, regardless of their age, with dignity and respect.

I'm remembering one of my first male students. I often met alone with him. He bragged about how he never wore the same pair of pants twice, never left his apartment with less than 300 dollars in his pocket, and had an arsenal of guns in his closet. He was thirteen years old, a skinny, white, blond-hairdo gang leader. He volunteered that he was in jail for a drive-by, where a girl was accidentally killed. "It wasn't my fault," he told me.

"Has anyone ever gone to jail saying, 'It was my fault'?"

"Yeah, well, in this case it's true. I didn't shoot that girl. Nobody even saw her standing behind the screen door. It was an accident. I didn't even shoot the gun."

"Didn't you just get through telling me that you brought the gun, you gave the gun to the kid who did the shooting?"

"Yeah, but I didn't do it."

"How is that different? If you had not brought the gun, the girl would not be dead. You're totally responsible, just as much as if you had pulled the trigger. You talk about 'the girl' as if she's some object, some theoretical thing. She was a person. What if it was your sister, your mother, your grand-mother, your daughter?" Making it personal seemed to sink in more.

THE HOLE
Suicide is a big part of my life in here.
My best friend is Jesus.
I sleep as much as I can,
but I can't sleep no more.
It's late at night.
I'm sitting in the corner.
All I hear is a whistling noise
from the fence and an old man
singing down the hall.
At this point in time,
I get to thinking about freedom,
knowing I can't have it.
It takes me back to trying
to kill myself again.
Someone sees me and calls

the guard. Now I'm tied
down. All I can do
is pray.
 —C. R.

(When I receive writing of this nature, I report it to my prison liaison. I feel it is my responsibility to make this possibility known to my supervisor. I'm an artist, a teacher. I would be irresponsible to see this as a good poem, good self-expression only. I know that more prisoners commit suicide in jail than in prison. I report even a vague suspicion. Better to be safe.)

I've been imprisoned.
No one hears me.
I do everything in this box,
but someone thinks I'm special.
Maybe it's me.
My body gets tense
because I can't stretch.
It hurts when I move.
I'm not used to this.
No one can hear me scream.
 —C. R.

Did the writing classes change this kid? I haven't the slightest idea. But I'm not just there to make my students be better writers or to help them hone their skills to pass the essay part of the GED, as many have. I am very confrontational.

One kid said to me, "Society has ruined my life."

"I am society," I responded. "I had a shitty childhood, too, and I'm not here. I didn't make you (commit the crime). I currently put a roof over your head, make sure you're fed, and have a place to sleep, so don't lay that crap on me. Frankly, taking care of you is not the way I choose to spend my hard-earned money. You should be paying your own way."

At the new county jail, juveniles are not sequestered from adults; however, no dorms exist either. "Pods" are generally two-tiered, single-celled arrangements with glass doors rather than bars for both the "cells" and the common door. Men are released to participate in class. To be eligible for class, they cannot be in lock-down. I have the power to remove anyone from

class for whatever reason. For me, the good of the class is more important than the good of the individual.

I teach writing in jail the same as I teach anyone in any class or workshop; that is, with dignity and respect, and I expect the same. I am open, honest, and vulnerable, which gives them permission to do the same, as well as intimating, "We're going into deep woods where you've never been before; you'll be surprised what you'll see; I'll go first." (I'm using the words *class, student* generically, not in a school sense.)

My biggest problem is that my population is fluid because it's mostly pretrial. I lose men to work release, discharge, and prison.

A recent student's first writing described an explicit sexual incident between two men. I felt he was testing me. He didn't come to class the next week, and while the others were writing, I stepped out of my classroom and asked the guards to specifically call him from his pod. They wanted to know why; I said I wanted to discuss something he wrote with him. Three COs offered to read it. I said no thanks, I didn't feel I needed their help, I'd been doing this work for ten years, felt I could handle it, and would discuss it with my supervisor if I felt it was necessary. They offered to put the guy in lockdown. They warned me not to be naive; maybe the guy was a rapist. When the guy did come out, he was all grinny and complimentary. I stood near the classroom in plain view of the COs, talked to the guy, and told him to knock off the crap. Last week, he handed in another writing, which I said I wouldn't type, and I reminded him I didn't want to read anything about sex again; sex is not an appropriate subject to write about in or for class. I kept the guy after class and said, "I bet you're in here on a sex-related charge."

"Why do you think that?"

"You're not the one asking the questions."

"Well, yes, but . . ."

"I'll have to think about whether I'm done with you." I was; I never allowed him to return.

None of my exercises have anything to do with sex. In ten years, the only other guy who wrote about sex was a fifteen-year-old kid who I felt was just being honest and had a crush on me. I told the juvenile it was inappropriate for him to be writing about sex in my class; we talked openly, and it never happened again. That kid ended up studying with me for fourteen months, passing the essay section of his GED.

Men are often taught to neither have nor show emotion, in other words, "Don't cry, take it like a man." When they do show their emotions through

writing, they become different than they've ever seen themselves or imagined themselves to be. I believe these men before only exposed their shadow selves, the out-of-balance child still acting out for attention. These men are from the edge and live on the edge. I invite them to connect, first with me, then to themselves through their writing, and finally to others who read their work. I offer them belonging to a whole, an adopted or foster family, for two hours of sanctuary a week. I'm saying through my presence, "I too have been isolated and alienated. Take my (figurative) hand and with the tapestry of words we create, we find a path to enter and reenter the world that once rejected, despised us. Out of silence, we find our voice."

How many people love the work they do, or, on the other hand, are able to do the work they love? I do. I do the work I love and love the work I do. I'm good at what I do, teaching creative writing to prisoners. One of the reasons I'm so good is because I really care about these men, my students. I trust them in class. I'm open and vulnerable with them, and as a result, they're vulnerable with me. I'm very invested in my work, so emotionally invested that I have to take a break from teaching a couple of times a year and get out of town to completely get away.

I'm an idealist; I have to believe I'm making a difference or I couldn't go on teaching. I know most of these guys are going to be released and reenter society. If they have nothing new in their lives and/or have learned no useful skills, no new way of dealing with their emotions, what's to keep them from staying on the same path forever? My work is to give them skills that will give them choices and help them get a new perspective and change.

I've been working with my supervisor for ten years, though I have no real supervisor, no one I answer to. Rich is the volunteer coordinator, my liaison, and that's whom I check in with. I'm paid by the Writer's Voice through the YMCA, not the jail. The jail refuses, thus far, to pay me. Two years ago, I wrote a grant with the jail to get funding from the Regional Arts Commission. The grant was accepted and would have allowed me to teach year-round at the jail. The arrangement for the grant is that the institution, the jail, had to meet the grantor fifty-fifty. They knew this when we wrote the grant, but when the grant went through, they refused, and we had to return the money to the grantors. I ran into one of the administrators from the jail staff I'd written the grant with. He shrugged, laughed, and said I could volunteer. I said, "What about when I need groceries? Do I say to the store, I volunteer my work so I'm just going to get the food I need?"

He said, "You could always steal it."

Recently, Rich asked how class went. I said, "Fine."

He said, "Have you ever had a bad class?"

"I'm afraid not," I frowned. "It's the hell I live with." That's the truth; I've never had a bad class. Some have been better than others. I've learned a lot over the years from my students; when I stop learning, I guess the jig is up.

I believe people must take responsibility for their actions, do the time. But in the majority, I think these men *are* human. Some are mentally ill and need help, some criminally insane, some so antisocial they must be confined, some psychopaths and sociopaths. I have the power to exclude anyone from class for any reason. I've done that about four times in ten years.

Still, I believe that since most of these men will be released, they need skills to change their lives. Writing is a way to think, to learn, to process feelings. For most, what they learn from expressing their feelings through writing is often shocking for them. They discover/uncover things they never knew about themselves, such as fear. Self-knowledge is the genesis of change. Many only expressed themselves through behavior that brought sought-after attention, but negative attention. My hope is for them to learn self-expression, communication skills. I watch men change and start displaying self-esteem. If you've been told your entire life you're a piece of shit and you accept that, why not behave like a piece of shit? You're living up to expectations. Suddenly, you're in a situation where someone (me) doesn't know your past, doesn't judge you for it, and is willing to listen and be vulnerable not just back to you, but first. I invite (*them*, us) into the dark, scary, thorny, tangled woods, and I'll go first, following a vague path, but mostly just forging ahead, trail blazing.

TRAIL BLAZING

I'm behind on the trail.
I pause to check
the position of the sun, stretch,
realize the hour grows late, start to worry.
There's no time to stop
or even use my senses.

I plow on, wondering when my life quit making sense,
when my grand plan dropped off the trail
and I found myself bushwhacking without stopping,
too scared to check

behind or in front, too worried.
I felt my life stretch

ahead of me and me in the last stretch
without memory, language no longer making sense,
beyond worry,
my life trailing
behind me, someone else checking
on me until my life stops.

This kind of thought has got to stop.
The trail stretches
ahead of me. I check
my canteen. Plenty of water. I sense
my friends ahead on the trail,
know joining them will end my worry.

When I was young, I never worried,
never tired, never stopped.
I'd leave a trail
of clothes stretching
from my house to the Wilhofts', not sensing
the coolness in the air until mother checked

to see where I had gone. "Check
in once in a while, so I don't worry,"
she'd say, and I'd think, "That makes sense,"
but I was having too much fun to stop.
Besides, I wanted my days to stretch
out forever, until the sun left a trail

of pink to check time against. Then I'd stop.
I'm worried I'm still that child stretching
my youth beyond sense. I focus on the trail.
 —Jane Ellen Ibur

No guarantees that we'll come out the other side, just that we'll travel together. Why do I do this? Some say I like a captive audience. Of course, I don't know what happens to my students when they're sentenced or re-

leased, whether they continue to write or not. But I've seen the way they change while they're with me. I hope somewhere they'll remember this as a good memory, something to build on, since so many think they have no good memories from the past. I also know that the writing exercises excavate other good, long-buried memories, and these memories can become the foundation to rebuild their lives. Perhaps they did not receive what they wanted, in terms of love, nurturing, and affection, but they received enough to survive. In this sense, I am completely like them.

The students and I learn places where our lives and experiences intersect, overlap, though at first glance we would never expect to. In class, we build a separate community, polymorphous, where as people leave, they become satellites in whatever world awaits them.

How do I measure success? As a writing teacher, success is getting my students to write, to open up in their writing. I can visually see the difference. The writings are short in the beginning and get longer over time, from two sentences to two pages. I copy their rough drafts, measure them against newer rough drafts, and see improvement. When I type their work each week, and they compare their originals to my correction, the changes imprint on them; it's another way of learning without directly spending time on mechanics. Also, over time, the writing becomes more open, honest. I'm very open and vulnerable, letting them know that they're safe with me. I find connections; I tell them I'm in recovery from alcohol and drugs, close to twenty-two years.

This past year, I taught for nine months continuously, the longest stretch I've spent teaching writing at the jail. Even with many students leaving, several have stayed with me, incredibly supportive the entire time over the loss of my brother, always asking how I'm doing, sharing about the losses they've had that they were never able to discuss. They recruit new students, tell them how it works. They trust me; they know I truly care about them. They truly care about me. That's what makes me truly successful—trust and care. I love my work, I believe in the power of writing, and my energy and beliefs are contagious.

To do my work I have to be a dreamer, believer, optimist, and lunatic. I balance a tightrope between being very present, very vulnerable, and keeping enough distance. When trying to define enough, I think of cooking or baking—things not of my realm. Good cooks measure with a pinch of this, a dash of that, and season to taste. I measure "enough" the same way. This year I've stepped over the line, free falling at times off the wire.

Here's to *them*. Here's to *us*.

Terry Karson

Glass Walls

Voice on the radio: Welcome to the second Annual Volunteer Appreciation Day. Thanks for coming out everybody. I was wondering before I came out here, if when you guys drove by the prison, if you ever wondered about the women within these walls.

I am looking out the passenger window. Sara is driving. We are listening to a taped radio broadcast that takes me back to where this drive began.[1] I was on my way to Helena to meet with Arni Fishbaugh, the Executive Director of the Montana Arts Council, and Jim Whaley of the State Office of Architecture and Engineering. We were going to talk about a possible artist residency at the Women's Correctional Center in Billings. I had no idea what to expect, since it hadn't been done before, or what was about to happen. Now, several years and many grants later, we are on the same, but different, road to Helena. We've just received a sizable percent-for-art grant for our program as a result of a planned new expansion to the prison, and we need to talk over the details with Arni and her staff.

Now we are passing over the Columbus hills looking up at the vast Beartooth mountain range to the south. There is so much space, so much beauty. Suddenly, a turn in the road, a reflection through the glass—if we weren't here to see this, would it still be so beautiful? Is beauty inherent in what we see, or is it brought to bear by the witness? Is it built in or added on? Is beauty both a giver and a receiver? If so, what does it seek in return for all

that it gives? Is there a hierarchy of beauty? Would everyone say these mountains are beautiful but that trash by the side of the road is not? Or is beauty beyond the discrimination of the viewer? Eighty miles an hour along the Yellowstone River, near Reed Point, the sun to the left, white snow shadows to the right. We were thinking of the women in the prison.

I don't know how many people told me they heard this broadcast on the radio back in January of 1997 while they were driving from some place in Montana to another. Driving is our state pastime; the distances are so great, and everybody is spread around. To do business, to see friends, to have fun, you drive. And you listen to the radio, if you can tune it in.

Amy Roach, then the arts and humanities director for Yellowstone Public Radio, documented that first residency at our request and produced this piece for broadcast at its conclusion. Hearing Amy's voice again reminded me how much her presence as an observer brought a noticeable sense of thoughtfulness and reflection to the inmates, their work, and the overall atmosphere of the class. This tape has come to define that project in many ways and offers insight that could not be more clearly rendered. It is one of the illuminating documents of that time, that project, those thoughts and feelings. Our memories change things, but a document like this can take you right back to ground zero. We wanted to listen to it on this drive. We wanted to remember.

Amy Roach: Volunteer Appreciation Day is an annual affair at the Women's Correctional Center in Billings. It's the day that inmates express their thanks to volunteers from the community. There are more than 200 volunteers in all. Some lead religious services at the prison. Other volunteers teach parenting skills, lead book discussion groups, and provide haircuts. There's even a pet therapy day. Every Friday a volunteer brings dogs to the prison for those inmates who crave interspecies contact. This year Volunteer Appreciation Day coincided with an art opening at the prison. The opening was the culmination of an eight-week art class. At the opening four inmate artists unveiled their work.

My name is Amy Roach. Tonight I'll tell you the story of that art class, a story that testifies to the transformative, healing power of art. The class was taught by Billings artist Terry Karson and his wife Sara Mast, who teaches art at Billings West High School. Terry and Sara invited me to sit in on the class and bring my tape recorder along. On the first day of class Terry Karson showed slides as he explained how the project came about.

Terry Karson: So what I'm going to do is . . . we'll start with showing the slides. You new people, have you become aware of what the project is?

Inmate Voices: No. No. No.

I squint in the glare of the ice on the highway. Big Timber is nearing, and the Crazy Mountains loom in high contrast ahead of us. They are buried deep in white on the peaks, and purple-black on the crevices and ridges. As I look through the windshield, the valley floor is monochrome, golden-tan wheat and dead grass. The Crazies stand alone, separate from the other ranges. Isolated. Apart. A symbol.

How could we bring in this bold, dramatic mountain and all it represents to the flat gray life of the prison, I wondered back then. Most of the inmates are from this wild, untamed country; so somewhere in each of them is an innate sense of the vast beauty and freedom of this place called Montana. How do we find this place that is everywhere around us?

The slides we showed that first class, all black and white images of nature, we took from dozens of books: Japanese paper cutouts, European and American folk art, Mexican tinwork, Native American pottery, sea shells, images of snowy scenes, and frost on glass, trees, leaves, flowers, and feathers. What culture the art came from was difficult to determine when it was taken out of context and mixed in with everything else. The cultural guessing game we played with the women during our first meeting helped to point out the prominence of nature in art around the world and its ability to cross cultural boundaries with a rich variety of personal expression.

Terry Karson: Okay. At the end of each of the cell block halls there are the windows, there's the steel door and the windows. Well, it got to the state architect's office that you needed security windows in there and something to block the people from looking in, because you can stand on the street now and look right down your hallway.

Amy Roach: So an inmate at the prison wrote a grant to the Montana Arts Council to hire Terry to teach an art class. The class was charged with making four glass window panels, each approximately three and one-half feet by six and one-half feet, to install at the end of the four cellblocks. Terry explained that the glass panels would be black to keep people from seeing in, but into each panel a design would be etched, and where the etchings were made light would shine through.

Terry Karson: It's black and it's sandblasted, and so the sandblasting turns white, and so we're going to have a black and white image. So this black and white image has to have a very strong graphic feeling to it. It can't be wimpy. During the course of this sixteen-class course we are going to develop your skills to that end. I think you'll be amazed at the talent that you already have inside of you that you may not even know is there or that you've never had the opportunity to mine out of you. So, our job is to try to draw these skills out of you. And I can tell you that art is something that is so amazing that you could be locked up in a three by three by three-foot block of space and if you had a pencil and paper you'd be pretty happy because that's how rich it is. You can create your own world on a piece of paper. And within that world is whatever can come out of your imagination and that's what we're here to do is to try to inspire you to find your own voice. So from there, something really fun, signatures.

Amy Roach: While they practiced writing their signatures in different styles, one of the inmates joked that Lori, who has had some experience with forgery, ought to be pretty good at this one. She joked back, "Obviously I wasn't as good as I thought I was or I wouldn't be here." I didn't know I held so many preconceptions about prisoners until I was hit with the reality of the women in the class. My first day there I set out to explain public radio to the inmates. But they made it clear that they knew all about public radio. They called out "I like Reggae, I like the blues show," "I like the opera," and Lori asked "Isn't this the last day of your pledge drive?" When I remarked on their familiarity with public radio, one woman joked, "We listen a lot, we're a captive audience you know."

I'm embarrassed to admit this, but I was surprised by how funny and intelligent the women were. I was also surprised that they didn't seem that different from me. I guess on some level I'd expected that there was some fundamental difference between us that I'd be able to perceive just by looking at them. But that wasn't true. Their art teacher, Sara Mast, commented that the inmates' purple uniforms were the only obvious thing that set them apart from us.

Sara Mast: What struck me after our first meeting with the women was— they're just like me—you know? If they didn't have purple on, you wouldn't be able to tell us apart.

Steve Griffin: I'm Steve Griffin, I'm from the Women's Correctional Center in Billings, Montana. I'm the volunteer coordinator.

Amy Roach: Steve explained that a lot of people on the outside have false ideas about the women inside the prison walls.

Steve Griffin: They come in and they have this stereotype of what the women should be, but once they've arrived and they come in and tour the facility and they meet the women it's really a shock to them, that they are people. And something that I like to remind people is that they are somebody's mother, they are somebody's sister, they are somebody's grandmother, and they've made wrong choices. I've had volunteers offer . . . I have several that have offered to work on literacy, but we don't have any persons that are in need of that. The book study group reads quality books; they don't read true romance or true confession type novels.

Steve. I chuckle to myself when I hear his voice. He has become such a friend over the years. He is so key to our program as our facilitator, guide, and teacher. His enthusiasm for his job and his irreverent advocacy for the women inmates has inspired us many times when the weight of confusing emotions and conflicted thoughts get us down. An example is this new expansion. Yes, we get a large grant for a public artwork on the prison grounds. Yes, it's really fantastic that our program has gotten to this point. Yes, this will be a great project for the women to create. But, no, we do not want to see the prison expand to hold more prisoners. The goal here is to see it shrink, not grow.

Every time I see an old familiar face in the class, I am both happy and sad to see her still in there. It is somewhat unsettling to be around so long that you see people serve their time and leave, or go into prerelease or parole. People you have gotten close to. People you will probably never see again. Some stay out, some come back, and some will never leave.

Amy Roach: Still this isn't day camp, the women are in there for a reason. About half the class was from the high side, which means the high-security area of the prison. These are the women who have committed serious crimes.

Celeste: My husband, I killed my husband. There were multiple stab wounds. I only remember stabbing him once.

Sara Mast: Celeste had murdered her husband, and she told us about that. You are not supposed to ask them about their life story, but if they offer you can talk to them about it. So she offered that, and she told us lots of stories about her life. She was a prostitute and has children. She's a mother.

Amy Roach: Most of the women didn't talk about their crimes, but they did talk about their kids and about the daily grind of prison life and the injustices in the system, like being required to wear bras, for example. And they talked about missing men and about art.

Terry Karson and Sara Mast taught the art class at the Women's Correctional Center in Billings. Before the class started they put a lot of thought into what they hoped to accomplish. Here's how they explained their teaching philosophy.

Sara Mast: We started out with the idea of empowerment versus top-down where we would decide what they should do. And we really had a hands-off policy about touching the artwork; we didn't get in there and try to fix their drawings or anything. We wanted them to find their own line, find their own mark, find their own personal expression, and through that we felt that would empower their environment, for one thing, because they would have an impact in their space, which they never feel that they have.

Terry Karson: Being artists and teachers we truly believe there is an artist inside of everybody, and as we grow up it's just something that we drop because we don't feel confident about it. Well, our biggest problem was how do you teach someone to draw in forty hours or less. We decided that the best way to teach people how to draw is to teach them how to see. If you can't see, then you can't draw.

It is so windy here, the truck is rolling with the gusts. But the air is winter clear. If you look closely, you can see the snow blowing off the mountaintops, slightly blurring the once sharp edges of the snowfields. Still, the dark green pines on the lower slopes are black cutout emblems against the white mountain page. Observation, we felt, was the key to unlocking the imaginations of the inmates. Seeing things anew, with an added sense of visual acuity and critical discernment, would, perhaps, even more than the art making itself, enrich the inmates' daily lives in some way.

Amy Roach: The women were surprised, and pleased, by Sara and Terry's hands-off, learn-to-see approach.

Amy: My name is Amy. I'm from Missoula.

Amy Roach: What do you think of the class? Is it what you expected it would be when you first signed up?

Amy: No. I thought it was going to be more just that they were going to get up there and teach us how to draw, you know—this is what you do and this is what you do. I'm kind of learning to be able to look at something and let it go from my mind to my heart and coming out on the paper. You just know it, it's like you're not thinking about it in the sense of words so much, it's more of just a feeling. I've already noticed like I can walk outside, and I notice the trees a lot more, and I'll notice not so much the trees but the sky, the outline of the trees, you know, the opposite type thing now. The tree is not a tree but it's a hole in the sky, kind of. I've been looking at things quite a bit differently since I've taken this class.

Candy: Okay, I'm Candy and I'm from Butte, Montana.

Amy Roach: What made you decide you wanted to do this?

Candy: They said that even if you can't draw stick people then they can teach you to draw something. So I thought I'd try it. I just think it's cool to be able to stick something, really nice . . . just to draw something that actually looks like something. Like I drew my first rose, okay, like two days ago. Okay, and I was sitting in my chemical dependency class, and I was sitting there and I was talking about something, right, and I always wanted to be able to draw one, and I just started drawing, and it was just cool. It just turned out really, really cool and I never drew one before and I never drew nothing, so like I've been like whippin' 'em out here and there, you know. I can't get the stem, and I can't quite get the leaves yet, but, you know, I got the little . . . yeah, it was cool.

Amy Roach: Prison is a busy place with lots of classes. The women take some classes because the prison requires them to. They take other classes

to make themselves more employable when they get out, or often to impress the parole board. The art class is different.

Candy: I take anger management and I take chemical dependency and I work in industries, see, and I go to AA and I go to NA and I have an accounting college course and I have a keyboarding college course and I have a WordPerfect college course. So I'm busy from 5:30 in the morning until 11 o'clock at night every night of the week. This is the only thing I'm doing for me to learn something to do for myself. Everything else, I'm doing so I can get programmed out, so I can get out of here.

We did have one strict rule, harsh and unbending as it may sound. Each participant had to attend every class from the beginning of the project to the completion of the windows. No exceptions. Continuity and commitment to not only the class but also the entire learning process was important to the overall success of the project. We started with twenty-one women and ended with four.

Amy Roach: Candy and Amy both had to quit the class because of the other demands on their time. A few others from the class were transferred to federal penitentiaries, sent to halfway houses, or paroled. One woman was diagnosed with Huntington's disease and transferred to a group home for medical care. However, she loved the class so much that she petitioned the prison to let her come back twice a week to finish it. She was disappointed when her request was denied. That's saying something. She got out of prison, and she was sad when they wouldn't let her back in to do art.

So in the end we were down to four women, which was lucky in a sense, because the class had been asked to make exactly four windows. So now, no one's design was rejected. Everyone in the class got to design a window. The four students who remained were Jan, Celeste, Rosanne, and Lori. Lori is the one who asked the Montana Arts Council for funding to make this class happen. And she took the class mostly to show support for the project. Lori didn't have much confidence in her artistic abilities, so she was surprised to discover that she had something to say as an artist.

Lori: I'm Lori, and I'm from Columbia Falls. I've never considered myself anything of an artist. I always thought when you drew something it had

to look exactly like what's in front of you, and it doesn't. It can't because we all see things differently. We don't all see things the same. And I never really realized that before. Terry and Sara, they're such outgoing people that they are a pleasure to be around, and they've just opened up a whole new world of art for me. I've always been an art appreciator but I've never considered myself much of a participant. I don't think Grandma Moses has anything to worry about; I don't think I'm in competition, but I can draw for my own pleasure now. Where before I never even thought about drawing.

Amy Roach: There was one woman in the class, Rosanne, who didn't say much, particularly when a microphone was nearby. But she put a lot of herself into her work. Here's Sara again.

Sara Mast: Rosanne, the fourth student . . . incredible work ethic. One night, I remember, she came back with homework that she had worked on for eight hours. We gave them a Charles White drawing, and we said you could work with this, copy it, and learn from it. And it was a really difficult drawing to work with. She spent all that time drawing it, like eight hours or something drawing it, and it didn't turn out. So at the very end she erased, she covered the whole paper in black and then erased out the drawing with an eraser. So she drew with her eraser. I mean that's something that in art school . . . drawing with your eraser is kind of another advanced concept, you know, working in the negative. And, I mean, she just worked so hard that she got herself to that point.

Amy Roach: All four women took pride in their drawings, and they were pleased with the way they turned out. Once the drawings were finished they were blown up on an overhead projector and traced onto rubber mats that were mounted onto the glass window panels. The women cut their designs out of the mats with X-acto blades. The parts that were cut out would be sandblasted white. The parts covered with the mat would stay black. Everyone pitched in to cut the designs out of the mats. This meant each woman had to trust the others not to ruin her design with the slip of a blade. Jan is a perfectionist, so accepting help was especially difficult for her.

Jan: Well, I think everybody cut on mine, and I can tell different people's interpretations, but I like it. I like the way it turned out. It's a little

different than if I had done it all myself. Like, well maybe I should just do the whole thing myself!

Celeste: Yeah, it's hard . . .

Jan: You had to trust people and that's a hard thing to do around here.

Amy Roach: Celeste agrees.

Celeste: Putting your artwork and your little baby in their hands, so to say, because it is your little creation, you know, and have others influence it is kind of a trust thing. And trust is really hard in here because there are so many people, you know, that have had bad lives and are in here under bad circumstances. It's hard for them to see anything positive or to let anyone else have anything positive. Not that these people in here in particular were like that, but some people are.

Jan: Working together all these weeks we have a certain amount of trust for each other that we probably didn't have before.

Celeste: Yeah, I think so.

Jan: Because we've spent a lot of time together.

Celeste: Yeah, with knives!

Jan: Yeah, with knives! And nobody got in a fight or anything!

Amy Roach: One thing the inmates enjoyed about the art project was having contact with the world outside the prison. They looked forward to seeing their teachers, Terry Karson and Sara Mast, and every week Terry and Sara brought different flowers from their garden for the women to draw. Here's Lori.

Lori: Of course our world is very limited. We sometimes forget that there is a world going on out there. That people do everyday things like shopping, dishes, and gardening.

Amy Roach: So when they bring flowers in from their garden?

Lori: Oh, that's such a treat for us.

Celeste: Bugs and all. Wildlife! Wildlife! Contraband wildlife!

Lori: We still have a ladybug flying around here somewhere that escaped last week from them.

Celeste: Yeah, it came walkin' off their flowers.

We are passing through Livingston now, about to head over Bozeman Pass. The road is nestled sweetly along the Yellowstone, surrounded on all sides by high, rugged, deep blue mountains. We love to drive through this old-time Montana town. Quaint, rough around the edges, and personable with it's precious, detailed, turn-of-the-century brick buildings.

The prison building, in contrast, is one story, lying hunched over and prone on the ground. Any ideas of uplifting architecture escaped its design long before the prison arrived. It stays hackled within its slick green plastic wire-mesh perimeter fence with its crown of gleaming razor wire, seven blocks from downtown Billings on the main drag into town, right next to the Chamber of Commerce and the main post office. The windows look out on nothing but more ugly architecture and vacant lots full of weeds. On the corner is a big blue plastic Montana Women's Prison sign where tourists stop to take pictures of each other. Beauty here is rare and invisible.

Amy Roach: What do you guys think about the idea of doing these designs about nature? What does nature mean to you or what does beauty mean to you? I mean, the nature of these designs has to do with the outside.

Celeste: It'll bring a little outdoors in, I think. There's no prejudices, you know, in different types of flowers, but they all intermingle and they are all a part of nature, you know, and beautiful in their own little right. My particular design is dandelions, and I had hoped that a lot of women in here . . . I, myself, relate to being an outcast from society like a dandelion. But we are pretty prevalent and we'll be back in at some point in time. And we're everywhere. And we're very beautiful in our own individual rights.

Amy Roach: It was no accident that Sara and Terry had the women drawing images from nature. They chose that theme with intentionality.

Sara Mast: We knew nature as our overall theme. And we chose nature because it is apolitical, areligious, universal. It doesn't really know boundaries. People all have experiences of nature that are positive. We are part of it. We wanted to bring the outside in to them. We feel nature is a healing force, and we wanted to bring that to them as well.

Terry Karson: Nature is the most healing thing that we have in our lives. And it's the thing that they have the least of. They have no nature whatsoever, and we thought, well here is a situation where these people need to be healed, and the most powerful healing force available to humankind is not available to these people who need healing. And so we wanted to bring nature in to them, and we couldn't bring in landscapes and we couldn't bring in trees or rivers or anything. We couldn't take them out. So the only thing that we really could bring in to them were flowers. And certainly, they were the most security-free thing that we could bring in because you can't hurt anyone with a flower.

Amy Roach: I asked each woman in the class to tell me what her drawing expresses about her personality. Let's start with Celeste.

Celeste: I like precision and stuff, and there's a lot of precision in it, I think. There's a lot of sexuality in it, I think. The flow of the picture is kind of sensuous. I like that. I like the harmony of it.

Amy Roach: Jan is a musician. She performed a lot at her church before she was incarcerated, and she still plays and sings at prison functions. So her drawing expresses her musicality.

Jan: It is musical. The apple blossoms are kind of maybe the slower part of the piece if you were writing a musical piece because they are smooth and flowing. And the other ones are maybe like eighth notes, or sixteenth notes, dancing around the piece and around the slower parts of the music.

Amy Roach: Lori, what does your drawing tell us about you?

Lori: Oh, I don't know. I guess femininity. The tiny, petite part of my work.

Amy Roach: What about the larger flowers, the bolder flowers?

Lori: Well, that's the part of me everyone can see every day because I can be very bold when necessary. I think there's a lot of that in all of us. We have more than one dimension.

Amy Roach: Is it hard for people to see the more delicate, feminine side?

Lori: Yes, because in here we don't show a lot of that. We can't. The bolder part comes out more than the inner petite part.

Amy Roach: Why is that true?

Lori: Well, it's a daily struggle in here just to survive and that part of you—you save for later. It has no use in here.

Amy Roach: But it's still there?

Lori: Oh yeah. Definitely. Definitely.

Amy Roach: Rosanne, the shy one, had more trouble seeing herself in her drawing, although everyone else in the class could see it.

Rosanne: Well, I just drew what I saw and that's it.

Amy Roach: There's got to be some of you in there though.

Rosanne: Well, I don't know about that. I don't recognize myself in there.

Amy Roach: Your drawing looks pretty complex.

Rosanne: Well, I care a lot about details, but I've learned other people don't, so . . .

Celeste: That doesn't mean you have to stop caring about them, Rosanne. They are important to me also.

Amy Roach: That was Celeste chiming in at the end. As we heard in the descriptions of their work, each artist created a drawing that expressed

something about her own individual personality. Lori says Terry and Sara made that possible by treating them like individuals.

Lori: They don't see us as just a crime. They see us as people, individuals, all of us with individual personalities. We're usually lumped in one group, we're all criminals, that's it. We're all four different, totally, individuals. We're all different personalities, and this is our way of expressing our personalities.

Amy Roach: Sara is proud of her students for what they accomplished.

Sara Mast: I saw the transformative power of art. I mean, I always believed in that; that's why we wanted to do this project in the beginning because I believe that art is a healing, transformative thing, but to witness it is a whole other thing, and we really witnessed that in this project. We witnessed how these women came to themselves, in a way. Through the process of discovery they learned something about themselves, they learned what was great about themselves, what was unique about themselves, what was special about themselves. We set up the environment to create it, but we couldn't go in there and do it. They had to go through the process of discovery to find out those things about themselves.

Amy Roach: Here's Jan talking about her drawing.

Jan: I know my kids were impressed because they've only seen me draw stick figures. I'm proud of it because it's something that I created and I surprised myself. So it makes me feel good. It's good for self-esteem because it's something that came out of my head, I guess, and I put it on paper and here it is and people like it. Yeah, I think it expresses a lot. I can see myself in it. A lot of different emotions I think. I see a lighter side of me maybe because things around here are real serious most of the time for me and I tend to look at the negative. And it's kind of a happy, as Terry says, "whimsical" picture, so it's the lighter, better side of myself.

Terry Karson: There were a lot of jokes in the beginning about stick figures. And one of the things we did was we brought in a lot of sticks for them to draw. That was kind of the running joke, the stick figure. And

Jan proclaimed herself to be our personal experiment. If we could teach her to draw, then we could teach a monkey to draw. And I think we're going to go out to Zoo Montana and go to business out there . . .

But I think the women actually had a period of transition where they weren't immediately comfortable with being themselves. They weren't immediately comfortable with expressing themselves because they never get that opportunity and their environment is such that they guard against self-expression because you leave yourself open to ridicule. And we set up an environment where it was safe, it was safe for them to be themselves. In fact, we wouldn't allow them to be anything else.

Amy Roach: Sara Mast gives this example.

Sara Mast: There was one woman in the class who struggled, and it was the woman who had the most art skill before she arrived. And you'd think, you would normally think, that the one who has the most art talent would be the one to really sail through this process. And actually it was hardest for her, I think. Well, she had a design that she turned into us, but we rejected it based on the fact that we knew she could do a lot more than that. Not that the first design wasn't a good design. It was a good design, but it wasn't about her. It didn't speak with her own voice like the second one did.

She had a great idea. She said . . . one day just in class she was saying, "I want you to bring in dandelions in your flowers." And I said, "Oh, well I can do that. We have hundreds in our backyard." She said, "Well, the reason I want you to bring those in is because, you know, I see us, the women inmates, I see all of us as dandelions. Dandelions are weeds, but they're everywhere, you know, and they're like a menace, you know, we even have a tool to dig them up. But they're really beautiful and they go through all these different stages of evolution. And they transform." When she said that I thought—that's a great idea! Do that for your design. So she finally did, and it's really beautiful.

Amy Roach: And they really did transform. Remember that first slide show at the beginning of the eight weeks? Terry showed black and white images to give the women ideas for their drawings. Well, the women had opinions about the slides even then, but they hadn't yet learned to see with the eyes of an artist. When Terry and Sara showed the same

slide show again toward the end of the class the reaction from the women was radically different.

Sara Mast: They looked at those slides, and they had something to say about each one. They were discriminating. They said, "Well, I don't like that." Well, then you say, "Well why don't you like that?" "Well, this is why, because of the way that's dealt with here in that space." . . . I mean, they got very specific. And Terry and I just kind of sat back and listened to them discuss the slides. We'd flip another one up, and they'd have all these things to say. It hit me at that point that they were artists. That we were their teachers, but it was like now we were just really facilitators, that we could be there to offer suggestions or feedback, but they were the artists making the decisions, not us anymore. Not that we ever were making their decisions, but that they had actually stepped into that role of artist for the first time.

Terry Karson: It was like giving birth. It was an amazing feeling that day that it shifted. To realize that they had all the information they needed to transform themselves into another human being. It was just phenomenal. It was chilling. We felt so drained that day. We went out of there that day like our souls had been ripped out of us. It was kind of what I picture birth being like. You give life to something that is really going to grow beyond anything you ever did for them.

Amy Roach: So why did it work? Where did the magic come from that transformed these four women into artists? I think that Terry and Sara's approach made all the difference in the world. They treated the women with respect and the women responded by giving themselves to the project wholeheartedly. Here's Terry.

Terry Karson: We didn't go in there to save them. We didn't go in there to preach to them. We just went in there with the idea that we wanted to draw out the best in them and I think that got us their respect because we didn't try to change them. We just tried to bring out something in them that they just don't have a chance to bring out.

I think most people would consider criminals' lives as being useless, but then when we catch them and incarcerate them we give them even a more useless life. And instead of teaching them something that they can accomplish in their life, we take everything away from them and say

we want you to improve as a human being. It just doesn't seem to work. We need to find some other way to help these people. In a lot of ways they are victims of society and the way they were raised and abusive relationships, and all the reasons people commit crimes. One woman was in there for prescription drug abuse; another woman was in there for her third DUI; they're in there for all kinds of reasons. Reasons that are just mistakes that you make. I mean, we're all just a mistake away from being in there ourselves.

I don't know anything about prison psychology, but I can say that we've seen the transformative power of art. When you give someone something that they can hold on to, that brings out their self-esteem . . . self-esteem comes from inside. It's not something you can preach at someone. It's not something you can dictate to someone. It has to be some self-motivated pride that can come from something like art.

Amy Roach: After the women finished etching [transferring] their designs onto glass, the window panels were sent to the sandblaster. The finished panels are about three and one-half feet by six and one-half feet with graphic black and white images of flowers. And they look just beautiful. The panels were installed at the end of each of the prison's four cell-blocks just in time for Volunteer Appreciation Day.

Steve Griffin (at the microphone): Okay, everybody want to take a seat? Becky, Piay, come on.

Amy Roach: Volunteer Appreciation Day is the inmates' opportunity to thank people from the community, people like Sara and Terry who give of their time and talent to enrich the lives of the women at the prison. Before the ceremony got underway, the four women from the art class hosted an art opening to unveil their glass panels. People from the Montana Arts Council, elected officials, and a number of Montana artists came to show their support for the project. It was a festive day. The four women from the class got all spruced up, and they beamed when Sara and Terry boasted about their work and their dedication. Later in the day, two of the women participated in the ceremony. Lori read a special essay describing how important volunteers are in the lives of inmates.

Lori (reading): These caring volunteers have enabled us to toss aside the stones with which we most often cast at ourselves. We are now able to

line our gardens and beautify our surroundings with these stones of sin. Because of these selfless people, we are able to accomplish positive things from our mistakes and to leave these walls with a sense of self and a sense of accomplishment previously unknown in our lives. We have come to celebrate our own humanity and have reached out to others in our times of great loneliness and separation from our own children and families. Without this devotion to understanding our plight, we would be less humane than when we walked through these locked doors. Instead, our connection with self and others has been awakened by their selflessness and by their actions.

The attending to the spirit of us who are emotionally and often physically lost in our incarceration gives us a ray of shining hope that our prison is temporary and need not be a permanent way of life. The inherent goodness in all people allows us all to be better than we thought ourselves capable of being. It is this simple practice of a simple belief which is the essence of the golden rule. Thank you all for coming.

Jan (singing): Did you ever know that you're my hero . . .

Amy Roach: Later in the program Jan sang a song expressing her gratitude to Terry, Sara, and the other volunteers.

Jan (singing): . . . I could fly higher than an eagle, because you are the wind beneath my wings . . . Did I ever tell you you're my hero . . .

Amy Roach: So what happens next? Well, the women don't want to stop. They got a second Montana Arts Council grant to continue the art class. They are hoping to find additional funding to expand the program to the men's prison in Deer Lodge. And the next step? They want to make some more etched window panels, this time for a charitable organization in Billings. Terry Karson explains.

Terry Karson: The four women that we wound up with at the end have gotten together, and they really want to write another grant to do a glass project for a charitable organization in town. They feel that they really want to be able to give something to the community and not have the community just see them as lost souls stuck away in a steel box. They want to be perceived as people, and they want to give something to their community.

Amy Roach: Let's give Lori and Jan the last word.

Lori: This artwork will be here long after we're all gone. And when the public drives by and sees the building, they'll see art and not bars. I think we're giving something to the community.

Jan: Well, I think maybe it can open up their eyes some to the fact that we're not just criminals, but we're humans and that we have feelings and emotions just like they do and what we did was, you know, a moment out of our life, not our whole life, and that we are working on making ourselves better.

Amy Roach: For Yellowstone Public Radio, I'm Amy Roach reporting from the Women's Correctional Center in Billings, Montana. My thanks to all the artists—Sara Mast, Terry Karson, Lori, Celeste, Jan, Rosanne, Amy, Candy, and Steve Griffin. I learned a lot too.

We turn off the taped broadcast as we head down into the Gallatin Valley, the valley of the flowers, on the last leg of this trip. As we make our way through the Headwaters country we are struck by the modest, narrow Missouri River, held tight by its low banks. You could almost miss it in this free, wide-open valley.

The questions come up again, only now we've heard some answers that will help guide us through this new, more complex project. Beauty is inherent. Beauty is internal. Beauty exists regardless of outside perception. Beauty is a giver and a receiver, asking only appreciation for its gifts. Beauty can be as grand as the valley before us or as humble and benign as the straggling willows along the banks of the river. Beauty is a window through which we may see ourselves. But sometimes beauty is hidden, as if behind dark glass, watching us.

Buzz Alexander

Smitty, Prayer, Astronomy, "Y2K and the Wicked Stepmother," and Asia Romero
Dimensions in the Work of the Prison Creative Arts Project

Many of us who choose to collaborate, or do service, in communities outside the confines of the university find ourselves in the presence of people who have been abandoned, damaged, and/or neglected by current economic policy. We find ourselves working with youth who are among the 20 percent of children who live in poverty. We work with the mentally ill who lost support when mental institutions were closed two and three decades ago. We work with the homeless, with those who have succumbed to substance abuse, with the survivors of domestic violence.

The Prison Creative Arts Project (PCAP) works in juvenile facilities and urban high schools that serve low-income and low-opportunity youth. But for the purpose of this essay, I wish to focus upon our presence in Michigan prisons. By writing about Smitty, prayer, astronomy, "Y2K and the Wicked Stepmother," and the death of Asia Romero, I wish to share some dimensions of our particular work, dimensions that will resonate with readers whose work takes them to similar places.

The Michigan Prison Population

When I came to Michigan in the fall of 1971, we had seven adult prisons and a camp program. We had a total of 9,547 prisoners.[1] In 2002, Michigan has forty-seven prisons, eleven prison camps, and one boot camp—a total of fifty-nine prisons.[2] We have 49,073 prisoners, and a recent prisoner popula-

tion projection for 2005 is for above 53,000 prisoners. In 2000, 54.5 percent of those prisoners were African American; at the Ionia, Alger, and Baraga high-security prisons, the percentage rises to 67, 74, and 75.[3] Draconian drug laws, mandatory minimums, truth in sentencing, fewer paroles, and parole officers more inclined to send parolees back to prison for minor infractions have contributed to these figures and ensured that prisoners serve more and more time.

Not only has the prisoner population increased, but so, of course, has the number of prison employees. In 1975 one in fourteen state employees worked in corrections. The figure is now close to one in three. Their salaries alone are $3,741,300 per day. The 2001 Michigan Department of Corrections budget of $1.7 billion consumes 17 percent of the state general fund, a figure that could reach 30 percent in the next few years. The budget for corrections is poised to pass, or has passed, the budget for higher education.

Rural and private investment has grown. Poor counties that have lost military bases, mental hospitals, logging and mining operations—and thus jobs that would keep young people at home—have been aided, perhaps saved, by the arrival of prisons. Phone companies, health maintenance organizations, construction and transportation firms, food suppliers, clothing companies, and countless other economic entities have profited from the needs of the captive community and their keepers. Everyone understands this. Prisoner, corrections officer, warden, they all tell us candidly, "It's big business."

If we consider family members—aging parents, spouses, siblings, children, extended family, people who in a better country might be drawing upon the earning and nurturing power of those we incarcerate—the growth is even more dramatic. It is especially poignant for the children involved; because they have an incarcerated parent, they are more likely to be imprisoned themselves.

Twenty-five percent of earth's prisoners are here in the United States. I have not met anyone, whatever their analysis or perspective, who thinks that the most affluent nation in history should be the most incarcerating nation in the world. It is clearly a national shame.

The Prison Creative Arts Project

The work of PCAP, a university-based organization of faculty, students, and community members, is inadequate in the face of this. But it is useful work. We began video workshops with children at the Dewey Center for

Urban Education in Detroit and a theater workshop at the Florence Crane Women's Facility in Coldwater in 1990. Since that time, the youth and adults we work with have produced 120 original, collectively created plays in seventeen Michigan prisons, sixty-nine plays in four juvenile facilities, and thirty-nine in four high schools. They have held dance concerts, produced art, photographs, videos, and murals through more than seventy workshops, and readings and anthologies through more than thirty creative writing workshops. In our Fifth Annual Exhibition of Art by Michigan Prisoners last February, 116 artists from 35 Michigan prisons exhibited 281 works of art and drew over 1,500 visitors to the Rackham Galleries. For two years now, incarcerated youth have exhibited their art and read from their writing in the Art Lounge in the Michigan Union. We have a Website (www .prisonarts.org), a Speakers' Bureau, a National Advisory Board, forty active members, workshops running throughout the year, and fledgling follow-up programs as adults and youth return to their communities.

To speak generally about the impact upon participants: the annual art exhibition is talked about and prepared for by prisoners throughout the system all year, on evaluations the artists rate every aspect of the exhibition above 9.5 on a 10-point scale, and artists testify again and again that public exposure has meant everything to them in terms of confidence, determination, and hope. Evaluations now coming in from actors in the theater workshops are similar. Prison staff who understand our work, the skills and aspirations it gives the prisoners, and its positive effect upon behavior and security solicit more workshops from us. Students often go from one of our placement/training courses to another; many of them continue afterwards as volunteers and members of PCAP, and many change career plans and end up as rural and urban teachers through Teach for America and other organizations, as counselors in juvenile facilities, as graduate students in education, social work, and public health, or in law school with, for instance, an emphasis on juvenile justice. One PCAP associate (former member) is facilitating a dance workshop in a Colorado prison, three others are starting up a prison theater workshop in New York City, and two more in Chicago are presenting their credentials to begin a prison theater workshop in Illinois.

Smitty

Smitty from the city. Dr. Smitty. Creek. Dr. Hyde. As he approaches the stage, we begin to smile. Onstage or offstage, we, the Western Wayne Play-

ers, prepare to scramble. We know what his character is *supposed* to do; we don't know yet what he *will* do. In "Willie's Corner," he is Creek, one of four street-corner youth hoping to make it as a singing group. He performs at a piano bar. Maria Stewart, playing music agent Jakki Star, turns up to persuade him to sign a corrupt contract on behalf of the four. He is supposed to turn her down. But in rehearsal and in performance, Smitty takes advantage of the occasion to sing gently seductive songs and pays no heed to Jakki's words: Maria has to achieve the content of the scene by herself. In "Seasons," when a wounded youth arrives at the hospital, Dr. Smitty, ranting with unheard-of medical analyses and cures, madly manipulating the patient's body, takes off, unstoppable. Luckily, another actor figures it out, dons a lab jacket, and announces, "Dr. Smitty, you're needed in the emergency room."

I have known Smitty since 1994 and have been fortunate enough to have shared stories with him and to have played the evil Dr. Jekyll to his naïve Dr. Hyde in our most recent play, a study of the forces that alienate neighborhood youth. I admire his imagination and the philosophical and political thought it reveals. And he is my favorite actor, because he so fully and with such verve represents the basis and challenge of our respectful strategy of improvisation.

We have good technical reasons for improvisation in prison theater. First, our actors (including most of us) are untrained, they struggle to remember written dialogue, lose their lines, have a hard time recovering. But if they know their character and the essence of a scene that they have rehearsed many times in their own varying words, the acting becomes electric, full of energy and humor.

Second, prison actors may be paroled or transferred or consigned to segregation at any time, including one hour before a performance. If we are dependent on someone knowing their lines, we are lost. If we have rehearsed again and again, know the role and the essence of scenes, anyone can, and does, step up.

Yet prison improvisation is deeper than that. To struggle collaboratively to arrive at a story and define meaningful characters and plot to bring that story home, to build a play rather than memorize and master an outside text, allows prison actors to *own* and then to *shape* their conflicts, hopes, and aspirations, their stories, their histories, their communities.

Also, as we seek together through improvised variation upon variation to locate both drama and meaning, we may become close, and qualities that are rare in prison—vulnerability, sincerity, and even friendship—may de-

velop. The plays rise out of these collaborations and almost inevitably end in families, friends, neighborhoods, and communities coming back together and into a prisoner's difficult but successful return to society. This is deeply useful for those striving to forge better lives, useful for all of us.

Improvisation works poorly if not founded in respect for the abilities, perspectives, and experiences of each actor. It works poorly if it is impatient and prescriptive. Improvisation must believe, trust, support, and celebrate. It must scramble. It must love energy and embrace chaos, and be eager to follow them.

It sounds easy. It is very difficult. Most of us at the outset don't fully believe, trust, and support. We are unnerved by chaos; we want control. We think we are supposed to "teach." We have agendas. We have attitudes. We have stereotypes.

When university students take English 319, the course that sends them into the prisons, we try to prepare them for Creek and Dr. Smitty by preparing them very little.[4] Since prisoners do not have the opportunity to study universities and university students, we do not study prisons and prisoners. We do make sure that every student knows that prison rules and regulations *must* be obeyed; we make sure that women working in men's prisons have the tools to handle challenges they might face; we imagine the first workshop session; we furnish a small stock of games, warm-ups, improvisations, and methods for discovering the play. But no more than that. Everyone is to enter the room equally and figure out together what they will do there.

I also realize that my classroom space must be like the prison theater space. I must refuse to "teach," that is, to constantly verbally impart my knowledge—in Paulo Freire's terms, to provide banking education. I must be patient and nonprescriptive; I must respect what each student brings with them; I must seek and embrace energy and chaos. We must value our stories and histories, our limitations, struggles, and aspirations, and together shape what we'll have in the end. To do this is to model the improvisation we practice in the workshops.

This works, but often it works better in the prisons. Prisoners are mostly older, have more experiences, are hungrier for creation, are more kinetic, more inventive with language, better storytellers. Students are, often despite themselves, more academic and competitive; they find it more difficult to believe that a classroom space is open and theirs, than prisoners have believing the same about a chapel, a cafeteria space, a small room. Students find it harder to improvise their class, to explore chaos, to respect their own sto-

ries, to work together, to take risks, to feel trusted and trusting. What is at stake and what is possible in both prison and the classroom is the same.

What I and my PCAP colleagues who teach this and similar courses (as well as my PCAP colleagues who continue the work) offer, to students, to new PCAP members who do not come through the courses, and to prison actors is simple and in the end reassuring. We offer our *knowledge*, both implicit and made explicit, that improvisation *can* work, our *expectation* that it *will* work, and our *recognition* that each participant, student, and prisoner, is resourceful, creative, eager, and good-willed. Our memory of the moments we have witnessed and of the euphoria of performances permeates all we do.

This is my first dimension then: that respectful, patient, believing improvisation is the key to our work in the prison community and is the way we must work with each other. At its best it brings together both Dr. Smitty and the student who has entered with good will, commitment, and old baggage.

Prayer

Since March 1999 our plays, in scenario form, have required the approval of a prison staff person (usually an assistant deputy warden), the warden, and the regional prison administrator.[5] The process normally takes a week to twenty days at the most. Yet in May 1999 we realized that the scenario for the Western Wayne Players' remarkable "The Genie and the Hood" had stalled inside the prison, where some intention or carelessness seemed determined to prevent the play from reaching performance. Within days before the scheduled performance date, we had to tell the actors. We imagined frustration, despair, resignation, some anger.

We rehearse in a small ground-floor room in the old Detroit House of Corrections building at the prison, sometimes looking around pillars to follow the action. On May 5, after the usual chatter, laughter, and excitement quieted down, I explained that despite the actors' great commitment to the play and despite the promises of the new process, we had no guarantee that the play would happen, or happen soon. It would have been inappropriate to speculate on causes for this, and I did not do so. Walker, large, good-humored, intense, a marvelous Hasan the Genie, stood near the narrow high window that looked out into the yard. He spoke immediately into the hush: "We need a prayer." The men glanced at Duffy, then moved quietly into a circle, where the fifteen of us lowered our heads and held hands. I don't remember all the words, but I know Duffy spoke to God of our work together

and the benefits it brought, spoke of the significance of the play's message, and asked Him to "touch the hearts of the administrators."

Seven years before, the Western Wayne Players decided that their second play, "Inside Out," would be directed at high-risk youth and that to be effective, the players would risk using their own hard stories of school and the street, of physical and sexual abuse, and of drugs and family. The plan was to bring in Maxey Training School youth to see the play, to participate in discussion, and to follow up with their counselors. Maxey counselors came to Western Wayne to see a nearly final version of the play and were excited, and the warden was fully supportive. However, the Michigan Department of Corrections decided they did not want youth to enter the prison. So we opted for a video version of "Inside Out" which then would be used to initiate a video dialogue between the actors and incarcerated and high school youth.[6] Fran Victor and Bill Harder, University of Michigan graduates and a professional video team, volunteered their services beyond what we could raise for them, and we went into a week of production in May of 1994.

The final morning of filming was to be close-up testimony by the two lifers and three longtimers, directly addressed to the youth. Willie, Val, Nate, Moye, and Mac agonized over their testimony. This was it: they would reflect on the play's meaning, urging the youth to let "out" what is bottled up "inside," to "tell someone, be it your mother, your brother, or a friend." Fran and Bill decided they would do just one take of each testimony. As we were about to begin, suddenly the five prison-toughened men, who had struggled, wept, and bonded with each other to make this play, disappeared into the next room. After a few minutes, I glanced in. Holding hands in a circle, they spoke in turn, said a prayer, breathed deep.

They returned, stood up before the camera one at a time. Each time, Willie, Val, Nate, Moye, Mac, Maria, Fran, Bill, and I tensed, praying that they got out what they needed to say and got it out strong, then broke into applause as they succeeded, striking high-fives speech by speech.

These moments of prayer tug my memory later that month when evening sun flooded the patio outside a residential wing at the Florence Crane Women's Facility while Jackie, Drew, Dora, Sunny, and Pilar acted out Drew's AIDS story, one autobiographical piece of "Inside and Personal," and then Shar and Sunny turned, floated, rose, came to the earth, danced solo and in sync to the haunting "Gone Too Soon," causing a hush in the audience that is echoed whenever I show the video.

All the achievement of PCAP and all the sinister, damaging backdrop of massive incarceration against which we work, comes down, for each of us,

to such moments. Who on the outside imagines prisoners circled up praying together to speak effectively to youth or praying that God will touch the hearts of those holding power over them so that a play might be approved?

Who imagines prisoners dancing with a focus and passion that causes an audience to catch its breath? Prison is many things; it is deprivation, punishment, humiliation, subtle violences to the soul, and much of what we learn there is pain. But it is also prayer and beauty and the resilience of the human spirit. This is the second dimension I offer.

Astronomy

On a spring evening in 1996, I catch up with Susie, and we walk toward rehearsal together, a patch of scraggled grass alongside the Evergreen Classroom Building on our right, on our left the rows of razor wire that enclose the Florence Crane Women's Facility. We're both actors in "Best Friends: Struggling to Succeed," and her improvisational work is exciting; nothing impedes her access to the emotions of the characters she takes on. Now she is stepping high, radiant with knowledge from her latest Western Michigan University astronomy class, exuberant over the impenetrable, intriguing, seductive, humbling mysteries that are opening to her. Nothing in her life before prison led to this class, she says; she never thought she would go to college. Her mind is swimming, challenged.

Four years later, this past spring, the last of college classes are torn away from Michigan prisoners, from the two women's prisons, and from the Egeler Correctional Facility. The lights are turned out.

This is my third dimension. Many prisoners, children of our most limiting urban and rural environments, are hungry for imagination, knowledge, and growth, and so much of prison, on the contrary, is about denial and limitation. Many prisoners are surging with *yes* only to run into the constant *no* that is at the center of prison and punishment.[7]

Y2K and the Wicked Stepmother

In September 1999 the warden and regional prison administrator notify Pilar and me that we cannot return to Florence Crane, where the Sisters Within Theatre Troupe has completed twelve plays since April 1991, unless we bring in the text that is to be performed.[8] We reply that, because we have always worked through improvisation, this would be a major change for us, that we need to discuss it with the women. Although we have traveled 180

miles round trip once a week for nine months a year since 1990 to volunteer this program at Florence Crane, now we are given permission to go in once for forty-five minutes, cramped into the tiny muster room just inside the prison. Alert and nonacquiescent, the seven Sisters present recall a plotless title that we had joked about the previous spring, then, thinking and writing rapidly, they and we brainstorm a plot and its protagonists and antagonists: No Matta, Igor, Bubbles, Sasparilla, and Esther Krasenknopf, Susie Stopall, Ann T. Dote, Y2 Krasenknopf, Helen Hapstein, Whitney Williams, the infected Benamati family. The next two evenings the women meet in the yard to develop the scenario, then send it on to us for more work. We submit it to the regional prison administrator. She turns it down. She wants a line-by-line script. We negotiate and are allowed to return to the prison through the end of January to write the script with the Sisters Within. This gives us the opportunity to improvise the play, writing the lines as they are invented in the heat of a scene, getting them as true to the life of the interactions as we can. We submit the line-by-line script of "Y2K and the Wicked Stepmother." It is approved. It has taken so long that the eager Florence Crane audience gets only one play this year, but they have a play, and on May 12 and 13, they shout astonishment at Y2K's birth, they tense as Y2K and his cousin Ann T. Dote battle out the fate of the earth in a ruined telecommunications tower, they celebrate as Igor is led away by the police, and they tremble as he and the deceased Whitney Williams erupt into the final séance.

Amid this proliferation of prisons that tells so much about the soul of our country, we are inspired by the resistant imaginations of the incarcerated. We learn from them how to work in a framework not of our choosing and how to find legitimate paths to success. This is my fourth, essential dimension.

Asia Romero

The fifth dimension is more complicated. Bear with me.

December 3, 1996. I hurry in. I have to pick up Pilar and drive to Five Mile Road for the Western Wayne workshop. I play back my answering machine. Nate Jones's voice: "Buzz, I have something to tell you. Asia . . . you remember Asia, the one who . . . Asia's been shot last night, in a parking lot. Isn't that something . . ." Then Tony's voice: "Buzz, it's urgent, something, call right back." Before I can call, he's at my door, in shock. I have to go. He

sits there with me while I wolf some old stir-fry, I say little things; he can't talk; he simply can't talk. I give him a hug.

At Western Wayne, Val has just seen it on the news. A skating rink, no weapons allowed inside, two gangs, someone trips someone else, they go outside to settle. A crowd follows, Asia's sister says "let's get out of here," but Asia objects, she wants to linger and see what happens. Someone pulls an AK-47 from his trunk and shoots, the bullet rips through Asia's head.

Seventeen, outspoken, she and Nate fought once about her uneven participation in the evening theater workshop at Henry Ford High School. Both held their own, both hurt, both learned. I sat in on the afternoon photography workshop one afternoon, Tony and Betsy's group. The youth discussed magazine photos in preparation for the writing that would accompany their own. I remarked on Asia's original, sensitive, humorous insights. Her energy. She had come to Ann Arbor to see Oyamo's play; she had told her grandmother afterwards she wanted to go on to college.

December 7. The youth have decided, in tribute to Asia's spirit, to go on with the performances, to hang their drawings on the wall. Kandy takes Asia's lead role. They had given the characters their own names. Midway through the play, another actor calls Kandy "Asia," and something freezes inside everyone there. Yet it feels right too; her presence is everywhere. The high school and university students stand together and speak of her to the audience, read poetry. The photography book, dedicated to Asia, opens with a photo of her, and another she had taken of her one-year-old son.

The night of the murder Tony, Betsy, Cassie, Jackie, Lauren, Missy, Kara, Erica, together in my tight living room, tears, long silences, a struggle for words; we watch television's bite on the crime, the nothing, the same. In their anguish two students have phoned home, needing understanding. Hearing about Asia's son, one mother cries out, "What, she had a child?! She was too young for that." It is settled. Another parent explains to her daughter that "those people live differently." It happens to *them*; they bring it on themselves. Settled.

Despite ourselves, when my students, colleagues, and I speak to our parents or others about the striving, beautiful, but endangered lives we encounter, our words often give them the opportunity to retreat, to consent to the status quo, to continue to be willing bystanders. This is agonizing. Asia and her classmates should not live in danger of stray or directed bullets. They should not have so many friends and relatives incarcerated in our juvenile facilities and prisons. Three decades ago most of those friends and relatives would not have gone to prison. And if they had, they would have done less

time and returned to their communities, most of them not to offend again. All of us who work in Michigan prisons have met longtimers and lifers who are powerful models for younger prisoners and for us as well, who should have left prison a long time ago and brought their rich spirits to Michigan workplaces and communities. How do we *speak* about this, *tell* the story or find the image or action that will engage others in the struggle against massive incarceration, against the existence of conditions that allowed Asia's child to lose his mother?

This question is central for each one of us who wishes to bear witness to what we have seen and heard and to engage others in an active struggle for change. It is a central question, therefore, for me as a teacher.

In training my students to work respectfully with prisoners and prison staff to offer positive programs, my desire is that they will make a life choice to act against the massive incarceration of their fellow citizens in some way: by choosing careers and paths that enable them to fight at their roots the causes that lead certain populations towards prison; by joining others in the corrections field who attempt to offer prisoners opportunities for growth so that they may escape the cycle of repeated imprisonment; or by finding the words, images, and actions to persuade politicians and the public that it must end.

I have long dedicated myself to courses that fill what my history department colleague Bill Rosenberg once said should be the true goal of university teaching: "the troubling of minds." I have done this by choosing texts that enable students to face what few others are placing before them—searing films, novels, poems, and memoirs from the Holocaust, from Latin America, from our war in Vietnam, the insides of high schools with shamefully inadequate facilities, salaries, safety, equipment, books, and programs, the insides of juvenile facilities and adult prisons—and then setting them loose with one another to sort out their reactions to the rich, hard, complicated, multidimensioned oppressions, to the fears and silences that allow those oppressions, and to the resistant abilities of the human spirit. I try to challenge consensual language ("It has always been this way," "I have to figure out my own life before I worry about this," "one person can't change the world," "that was my ancestors, it wasn't me"), and I seek authenticity, whatever the point of view, in all our reactions.[9]

When my students, when any of us, have placed before us the insides of juvenile facilities and adult prisons, we can see the devastating results of racism. We can see aspects of an economic policy that isolates, warehouses, and profits off of poor people and people of color and, increasingly, women;

we can see a backlash against affirmative action on the most basic level; we can see the removal of determined groups of potential voters from the electorate. We can hear the voices and stories of those affected.

Yet, for all of us, there is a difference between seeing and *seeing*, between hearing and *listening*. When I showed "Inside Out" to the Sisters Within Theatre Troupe in the fall of 1994, several were crying at the end. Jackie said, "That's my whole story there." Then she added something I needed to think about. She had herself "let what was inside out," both to counselors in a juvenile facility and to a counselor at the Scott Correctional Facility. But those counselors had heard with the ears of their own agendas and definitions and had not been able to listen. To her this was agonizing because she needed them, and they weren't there for her. Seeing and listening imply, demand, an active commitment to change. And they enable us to *speak* instead of just talking.

So how do I enable my students to *see* and *listen*, so that they choose to join others in ending the conditions that allowed Asia's child to lose his mother, so that they help end this national shame?

I owe respect to every one of my students as full and growing human beings, as learners. My pedagogy is very influenced by that of Myles Horton and the Highlander Center for Research and Education. Horton writes:

> Stretching people's minds is part of educating, but always in terms of a democratic goal. That means you have to trust people's ability to develop their capacity for working collectively to solve their own problems; if you ever lose track of where people are in the process, then you have [lost your] relationship to them and there's nothing you can do. So if you have to make a choice between moving in the direction you want to move people, and working with them where they are, you always choose to work with them where they are. That's the only way you're ever going to be able to work with people . . . because otherwise you separate yourself from them. My job is to try to provide opportunities for people to grow (not to make them grow, because no one can do that), to provide a climate which nurtures islands of decency, where people can learn in such a way that they continue to grow.[10]

I have learned over the years that I must provide opportunities for my students to grow. I have learned that I must work with them through improvisation and respect so that we can share and debate what our particular learning environment puts before us. I have learned that I must support and

celebrate their authentic confrontations with films, books, the prison, and each other. I have learned that I must encourage them as thinkers who take risks and can be troubled, and that I must value them and bless them on their way, whether it is my way or not. I know that their own needs, pressures, and aspirations are complex, and I know that they must choose their own relation to Asia's child and to the people inhabiting our spreading prison spaces.

That is the fifth dimension. It is my dimension as a teacher. It is a dimension too, a hard one, for students who collaborate or do service in communities that reveal the unnecessary poverty and pain this society allows, for students who see a bullet rip through the head of an Asia Romero. Too many student peers, too many of our fellow citizens, are indifferent to what we see and hear in the prisons and elsewhere. We owe our peers, our friends, and our family our respect and love. But we also owe it to them, and to those they deny, to keep seeking words, images, and actions that will persuade them to *see*, *listen*, and *speak*, to join us in collaborating for change with those our economy has consigned to poverty of opportunity and to prison.

Rachel Marie-Crane Williams

Learning to Teach by Traveling Inside

The Experience and Process of Mural Making in a Women's Correctional Facility

*W*hen exiles create for themselves a new world in which to live and then construct that world in language, a poet, a writer, or intellectual may emerge. When the imagined world takes physical form and comes to exist in two, three, or four dimensions, it may be represented as the work of a performer or as that of a visual artist. This work creates a demilitarized zone, a place of safety, which defies old-world colonialization and presents a distillation of all the complexities within which one lives. Or, it may present a world beyond complexity that has imagined itself into synthesis.[1]

Traveling

Each Monday, I drive ninety-six miles from the University of Iowa in Iowa City to the Iowa Correctional Institution for Women in Mitchellville to work as an artist in residence and a researcher. I usually arrive in the prison parking lot in the late afternoon and leave through the gates to go home well after dark. This drive has become part of my weekly ritual. It is three hours in which to meditate, listen to National Public Radio, make phone calls, drink coffee, and eat starlight mints.

I mark progress on the trip by mentally ticking off the mileposts and fences and tuning the radio in and out depending on static. The scenery is lackluster; towns like What Cheer, Montezuma, and Brooklyn remain hidden from interstate 80. Originally from the East Coast, where trees, small

crowded cities, and a variety of rolling hills, mountains, seaside, and farm-land make up the landscape, I am still unaccustomed to the openness of the Midwest. It seems at first that there is nothing but land and sky. The vast fields that line the highway change throughout the year from undulating stretches of green, to muddy rows accentuated by cornstalk stubble left behind by the harvest, and eventually to an endless blanket of white and gray. By early March it seems like winter will never end. The sky is low, gray, and brooding, offering threats of snow or worse. Some days in winter are particularly beautiful; the sky is clear and bright, but the air is cold and made even sharper by the wind. It is hard to strike a balance for want between the warm gray days without sunshine and the bright afternoons with bitter cold. For the most part, the landscape, unlike the weather, is extremely predictable and not what would typically be referred to as scenic. If you scan the skies and the gravel shoulder you find hawks, dried goldenrod, debris, and an occasional road kill; all can offer visual stimulation in the winter when the landscape is so sparse.

When I am only a few miles from the prison, past the truck weigh station, I spot a large yellow sign that says not to pick up hitchhikers. (I have never seen this sign anywhere else in Iowa.) After turning south off of the highway, I drive straight over a pair of railroad tracks, then I halt at a two-way stop. If I look to the west there is nothing but the horizon for miles and miles. Directly ahead is the prison surrounded by a tall chain link fence topped with rolls of razor wire; to the east lies the rest of Mitchellville, a small rural town outside of Des Moines where the population is 1,670 people. The prison holds 450 women.

Once I arrive at the control office of the prison, sign in, and get buzzed through gate five and gate six, I am locked in the yard. It looks like an institution; almost all the women are dressed in cornflower blue, and the officers wear rich brown uniforms embellished with black heavy security gear around their waists and bits of metal here and there. The exterior yard looks like the campus of an old boarding school. All of the buildings are red brick except for the latest addition, built to accommodate more inmates.

On the other side of the gate, Jane Parsons, my partner, *always* meets me smiling, with her walkie-talkie slung on a low belt around her slender waist and a cigarette in her hand. She is different from many people's idea of a stereotypical prison employee. She always wears tennis shoes, even if she is wearing a dress. Her short wavy hair is set off by two long braids, which hang over her left shoulder and are tied with colorful handmade beads and rubber bands. She has a great sense of humor and compassion.

She and I have been working together as teachers and artists with a group of twelve women since 1999. Our group fluctuates in size by one or two people each week depending on other programming opportunities, canteen, and aftercare requirements. The project that brought us together is a series of murals. These large images are based on women of strength.

On the Inside

The interior gate closes behind me with an electric click; we walk south along the sidewalk, past the laundry and small groups of women. In the winter the yard is usually empty; only women who smoke will brave the cold. Most are gathered around the short galvanized steel buckets filled with sand and cigarette butts or huddled against buildings to block the wind. If it is warm, the yard is buzzing with activity, and women gather around picnic tables. Occasionally, over the loudspeaker, you can hear an officer in the control room paging people, directing the women outside to stop whatever "mischief" they are doing, or telling units that the dining hall is open. As we walk, we pass through small clouds of cigarette smoke that mark the space where conversation has been.

We walk to the last older building on the east side of the yard; it is called unit four. Jane unlocks the double security doors. The inside of unit four is coated in cheap glossy paint that reflects the fluorescent lights and waxed terrazzo floor. In the late afternoon the air smells like microwave popcorn. Perhaps to remind people that women live here, the interiors of the neutral rooms are trimmed in a sour salmon pink. Jane opens a locked door to a small hallway, squeezing by the perpetually occupied phone where women make collect calls to people in the free world. We walk a few steps and unlock the door to the art room, formerly the chapel.

On some days women who are participating in my research will meet me in the art room to talk and share their latest creations. If no one is scheduled, then Jane and I take a brief look at the murals, make small talk with women who pop in and out, plan the evening, and chat about the previous week. At 4:30 P.M. we walk over to her office in the basement of unit two so Jane can eat her supper; usually this consists of a cup of instant soup.

How the Mural Project Began

Jane and I are always scheming for ways to get funding and paint. We decided after seeing the large, open, empty foyer in unit nine, a new unit at

the prison, that it was a perfect place for a series of murals. We wrote a small grant to the Iowa Arts Council and received 500 dollars. On the first night of class, Jane, a group of women, and I gathered together and talked about our ideas for the murals. We decided that they should show women who had done great things while living modestly. For the next few weeks we researched the lives of different women. Unit nine had four living spaces called pods. Each pod is named after a woman. The residents did not feel connected to these famous women. They complained that they did not know who the women were or what they did that made them worthwhile.

After more discussion and a trip to unit nine, we decided on our subjects: Nilak Butler, a Native American activist; Clara McBride Hale, an African American woman who adopted and cared for over 500 children; and Mother Teresa, a woman known for her faith and charitable work around the world. The fourth mural would be comprised of the faces of many women.

After we chose the people we wanted to represent, we found photographs. Next, we photocopied them onto transparencies, and then we transferred the images onto canvas by using an overhead projector. The women took turns tracing the projections on the canvas with pencils. When the entire image was transferred, we began to put down a thin layer of paint. Because we used acrylic paint, mistakes could simply be wiped off or painted over. The freedom to paint without hesitancy or consequence was at first difficult to get across to some of the women who were inexperienced. Having the freedom to make decisions and mistakes is rare in the lives of some women at the prison. They have grown used to living within the parameters of rules and routines. Many have had extremely unsuccessful educational experiences. In addition, like most people who have never painted, they were unsure about how to manipulate the paint. After Jane, a few of the experienced artists, and I made mistakes and painted over them, the more hesitant women understood that there was no pressure to get it right the first time.

Life on the Other Side of the Fence

It took us many months to finish the murals. During the cold months and the unpredictable spring and summer, we became connected not only through ideas and the act of painting but also by our interest in each other's lives. Each week we talked about what happened while we were apart. Even though the women live in a heavily regulated environment, they build rich personal lives.

In my research I have found that most women in prison, in spite of their seemingly adjusted exteriors and behaviors, are always struggling with societal, familial, or emotional issues. I choose to use the word struggle because that is what they experience. Things that would normally be minor become difficult and sometimes frustrating because they have so little control over their circumstances and choices.

Mothers oftentimes have the most difficulty. Sometimes incarcerated mothers are able to contribute to decisions concerning their children but must trust others or the state to make sure that their children are safe, nourished, educated, and loved. Studies have also shown that there is limited institutional support for women who are separated from their children.[2] Bedford Hills Correctional Facility in New York runs one of the most progressive programs for women and children in the United States.[3] Research about their motherhood program states that "women come to the group experiencing three levels of powerlessness: (1) being in prison; (2) being separated from their children; and (3) coping with legacies of powerlessness in their own lives."[4] Using peer coaches and an exploration of personal history, these three levels of powerlessness are addressed. "Only 10% of women who successfully completed the program returned to prison, in contrast to 52% of inmates overall."[5] Within these three areas, there are issues concerning mothers resuming normal relationships with their children after incarceration. Many women plan to reunite with their children once they are released. Some researchers state that this is not always best for either party and that it is important for mothers to resolve the grief of separation so the relationship between the mother and child is not in jeopardy.[6] In addition to the resolution of grief, it is also important that women deal with their anger and guilt about how their offense has impacted their children's lives. Life in prison is filled with uncertainty; many mothers state that not knowing or having control over the lives of their children is one of the most frustrating parts of being incarcerated.[7]

In spite of these statistics, many mothers in prison continue to dream of the time when they can be with their children for longer than one day; they miss the way their children smell; they proudly display pictures of their children and grandchildren whenever possible. Many women in the art room participate in the art class so they can make something beautiful to send to their sons, daughters, and loved ones to commemorate birthdays or other special occasions. They often fear that their children will forget them.

When we painted, much of our conversation was lighthearted; our banter seemed normal despite the setting. There are moments when odd snip-

pets emerged, such as when Jenny was making a joke about a lover and she ended it by saying, "Yeah, I took care of that . . . I shot him." While this was odd in the context of a lighthearted conversation, it was also true. No one batted an eye, not even myself. I have learned that in this culture there are no secrets. The women know what others have done; they read the newspaper. This knowledge is used to determine where women fit in the social hierarchy. I think that sharing their crimes with others is part of the healing process for some women. Jenny has participated in numerous victim advocacy panels and expresses deep remorse for the attempted murder of her lover, even though he stalked her. While working in prisons I have learned that one reason women choose to tell outsiders about their crimes is to establish trust and to see if they are still acceptable in the eyes of the listener. Conversely, *as an outsider*, you do not ask casually what crime they committed.

Knowledge of a woman's crime has brought me feelings of ambiguity. As a researcher, volunteer, and artist in a prison, I must wrestle with this ambiguity. It has been easy for me to become friends with the women I have encountered. Sometimes, after I know what their offense is, it is hard to imagine that I could like them, but I do. I say to myself, "It is true, you genuinely *like* a person who has perpetrated a violent crime against another human being." I also say to myself, "Who knows, if I were in their position I might have done the same thing." These two statements keep me from being repelled or becoming judgmental. In truth, I usually would rather not know what they did to end up in prison, but I realize that it is an important part of their lives. If I am to work successfully as a teacher, then I need to understand my students and treat them with respect, dignity, compassion, and empathy.

People are different in prison than they were before they became involved with the criminal justice system. They are sober, sometimes more politically aware, and usually they feel safer than they did before. This doesn't mean that prison is not a horrible place, no matter how progressive it is or how comfortable a person may become. In the long run, prison usually makes people more depressed, anxious, and angry than they were before they were incarcerated. They are in a situation of extreme deprivation, repression, and oppression. They are exiled from their communities and estranged from the lives of their families, and they live with the knowledge that there will be a perpetual aftermath of rejection from society once they are released. These facts alone produce a heavy burden that is a continuous source of stress.

To somebody who walked into the art room, the daily pressures of incarceration would not have been immediately apparent. As the women worked on the murals, the conversations that buzzed from different areas in the room made it feel like a normal community setting. This feeling of normalcy added to the positive atmosphere of Monday nights and fostered the kind of interaction that I enjoy most as a teacher. The group was loose but focused with collective purpose, and interactions between teachers and students were individualized.

Artists on the Inside

For weeks we worked on a halo of flowers around the figure of Nilak Butler. This afforded an opportunity for a large group of women to work on the same part of the mural. Tony was in her early forties with a short shaggy haircut. She had intense gray-blue eyes, and her husky voice was gentle as she spoke with a neutral Midwestern accent. She came to the mural class one night with a friend to see if she would enjoy it. It turned out that she was the first woman to paint a flower on the mural; it was beautiful and resembled a fantastic chrysanthemum. Other women watched her work and added blossoms of their own. Tony returned every Monday night and even joined Jane's painting class. The art room and the classes provided a space for Tony that was a necessary part of her preparations to return home.

Most of Tony's past struggle stemmed from her troubled relationship with her family and her addiction to cocaine. Tony's artwork outside of the mural class centered on the idea of her life after prison and the reunion she was planning to have with her teenaged children. Through her art making she examined the idea of rebuilding her family and life. This was her second time in prison for drugs; her first experience in prison had brought with it the demise of her family. She felt that the time she spent apart from her children made her bond with them weaker. Because their relationship had been altered by her incarceration, her return home after her first sentence was fraught with problems.

In the center of her new images, she painted a cross and a heart. This configuration divided the composition into four parts. In these four sections she painted things she needed, such as sobriety, to return home and be successful. She created this image in a variety of ways. It seemed to act as a way to reaffirm her ideas, calm her anxiety, and send a message to her family that things would be different. Joining the mural class gave Tony the confidence and space to extend her ideas into images during the beginning

of her transition from prison back to her community. Ellen Dissanayake, an ethnologist and philosopher, states:

> Transitions from one state to another often provoke anxiety or heightened emotion because they mark the end of something known and the beginning of something unknown. Hence they are particularly apt to call forth dromena, and the dromena themselves frequently create another transition in response, the ritualized transformation of substances and selves from one state to another. In uncertain circumstances, following the "imperative to act," things are done to convert, the cloth dyed, the flesh tattooed.[8]

Tony's images seem to be the outward manifestation of the beginning of her inward transition from offender back to mother and sober community member. The change from prison to the free world is often a time of high stress, anxiety, and the reshaping of the self.

Ruby's story is also set in the art room. Ruby had a sharp sense of self-deprecating humor. She spoke with a thick inner-city New Orleans accent, exercised feverishly, was a devout Catholic, and read ferociously. She is one of the smartest women I know. She first met Jane during a dance program. This creative movement and expression program was her initial encounter with the arts in the prison. Ruby enjoyed working with the group and having a way to escape from the tedium of prison life for a few hours. When she heard about the mural, she decided to see what the project involved. Her continued interest in the arts after her dance class ended is not surprising. According to a study on the social impact of the arts, after taking courses in the arts 37 percent of adults were inspired to take up new training or educational courses.[9]

After the dance class, she immersed herself in drawing and the mural class and has now branched out to try painting. Ruby took drawing from Jane for over six months. The focus of her exploration was portraits. Now she does intricate ink sketches with a brush. These sketches are beautiful and sensitive. Her lines vary from thick to thin and are used sparingly but with a great deal of skill. Her favorite subjects are famous people. According to Ruby, everyone in her family is a talented artist. She never felt as though she possessed any talent in art, so she never pursued it and believed that it was not a realistic goal to attempt. After a few months in Jane's drawing class, she became so confident that she sent drawings to her siblings. She told me during an interview that making drawings worthy enough to send

home was never a goal she thought she could achieve. Naturally, her family is very supportive and positive about her work. Ruby came to almost every session of the Monday night mural class. She says that it is one of the few places in the facility with a positive atmosphere.

While the prison is very progressive, the culture is oppressive. It is based on control and safety. In the art room there is some sense of these two elements, but they are not mediated by power or applied through force or domination; instead they were tied up in the destiny of four large paintings, which had no specific deadlines for completion and were not prescribed in terms of how they should appear when they were finished. In the end the final appearance was controlled by the artists.

The women were careful to protect the quality of the art room environment, perhaps because they valued the space and freedom. They were conscientious about carefully cleaning their brushes and palettes. They tried to speak positively about themselves and to others while working. Often they helped each other with imagery and ideas. At the end of each session they always made a point to thank Jane and me for our time. When Betty Ann Brown, an artist, asked Rachel Rosenthal, a performance artist, about people working collaboratively and the profound effect of the experience and the space, Rosenthal stated:

> First of all it centers you in the moment. This is one of the hardest things to do, since we live in a world that is so divisive and scattered and distracting, pulling us in every direction. I think one of the real problems for human beings right now is that we live in the past or the future—even if the past or future is just the moment before or the moment after—rather than in the now. This kind of work obliges you to surf the moment, to be in sync with the moment. And that, I think, is profoundly important for spiritual and psychological health.[10]

When I worked on Monday nights I felt centered; it was a way for me to escape the petty pressures of academia. I think that perhaps women like Ruby and Tony also felt that it was a momentary escape.

In June 2001, after many months of working, we completed three of the four panels. Inspired by Faith Ringgold, an African American painter and activist, we decided to frame the images in soft quilted fabric. We chose to use quilts as frames because they are inherently filled with nostalgia, they are soft and inviting, and they can be visually stimulating. We also chose to

quilt the murals because we felt it would grant women who had not partici-
pated in the painting a chance to contribute to the project.

Jane and I are not always the teachers. The role of teacher and student
shifts between those who have insight and those who desire clarity or ad-
vice. Sara, April, and Lilly taught us how to use the Sew-Dear Sewing Ma-
chine to make quilts. From Lilly I learned how to lay out the pattern of a
quilt, label it, and add it to the large stacks of neatly cut fabric. From Lilly I
learned how fabric must be carefully inspected and sorted according to the
fiber from which it is made.

From Sara I learned the difference between making a life and making
art. She sews all day at a machine as part of her job. There was a distinct
difference between the activity of sewing quilts for the border of the mural
and the industrial sewing that she was required to do at work. In the art
room she sews without the pressures of work because it is pleasurable and
reminds her of home.

Lilly was very excited when she learned we would quilt. She quilted
before she came to prison and looked forward to finishing the edges of the
paintings with fabric and a sewing machine. After Mother Teresa was fin-
ished, we started to design the first quilted border. Lilly and Sara started by
going through bags of fabric that Jane had brought in from her attic at
home. In the pile were various projects that were never completed and scraps
of fabric from the 1960s and 1970s. The women spent the entire night sort-
ing, laughing, and asking Jane to tell stories about the origins of the fabric.

Through a community service project in the activity room Lilly started a
quilt to donate to a battered women's shelter. She cut out the squares, but
was never able to finish the project. The activity room closed, and many of
their unused or unclaimed items were shifted to the art room. Lilly thought
that in the transition her project had been thrown away. On a Monday night
in the art room beneath the table, she found the remains of that work and
salvaged what she had done to create a border for Mother Teresa. She was
more than delighted when she told me that she felt so good about finally
being able to complete her quilt. It took two sessions for Lilly to label and
place all of the squares, and she decided to use a sewing machine to piece
them together in a series of four strips that would become a border. For the
next few weeks she spent all of her free time in the art room working on the
quilt border.

Watching her recreate her quilt and finish the project taught me a lot
about the art of quilting. It also helped me to appreciate the amount of work
that is involved in creating something so precise out of fabric. I enjoyed

watching Lilly become engrossed and excited. She seemed to feel a sense of purpose sparked by the important role she played in the completion of the mural.

The Distance Between Teaching and Traveling

I have thought lately that there is a correlation between teaching and traveling styles. These two things are important components of my life; often one conflicts with the other because of time. When I travel I prefer to take to the ground rather than the skies. New thoughts come to me out of the mental void of a long drive; my best ideas happen while in transit between places. I create grandiose paintings, ponder things I am going to write and research, and act out conversations I should have had but resisted. I never try to predict my time of arrival or the sights that I might encounter or avoid. I also rarely take the interstate. I always have a map and a pencil with which to scribble down names and thoughts on my atlas—a tattered paper book, it is covered with these doodles—they are mostly book titles or music that I hear about on National Public Radio. I am not sure why I feel compelled to record these things; I seldom return to my notes. Maybe it is to make my listening seem purposeful, or perhaps it is so I will not forget these savory tidbits later.

The way I teach is similar to the way that I travel. I have a map; I try to tune into the "airwaves" of the collective subconscious for interesting ideas and input; I rarely if ever take my students along the most direct route, and I often shift my expectations with regard to time. Usually the journey develops according to the needs of the collective. Some travelers prefer to get from point A to point B in a very prescribed manner. Just like people I have traveled with, if students are of this mentality, they will find me frustrating.

The journey of acquiring knowledge and the moment that you arrive at a destination are important. During the experience and afterward, there must be reflection and a reciprocal exchange of perspectives between those who took the trip to fully synthesize the narrative of the journey.

Teaching with Jane is like traveling with an old friend. We never plan the evening's activities; we only plan to paint. Both of us like to let things take shape without a great deal of control. We promote ownership among participants by stepping back, letting the images change from bad to good and back to bad, only to finally be reclaimed as good and celebrated, so that the natural dialogue between the painter and the painted is not interrupted. We offer advice and encouragement, and try for the most part to lead by

example and personal engagement. We have painted just like the women, made mistakes, asked for advice, and watched eagerly while our work was painted over by others who had different visions. The cultural critic and writer bell hooks would define this approach as engaged pedagogy:

> When education is the practice of freedom, students are not the only ones who are asked to share, to confess. Engaged pedagogy does not seek simply to empower students. Any classroom that employs a holistic model of learning will also be a place where teachers grow, and are empowered by the process. That empowerment cannot happen if we refuse to take risks. Professors who expect students to share confessional narratives but who are themselves unwilling to share are exercising power in a manner that could be coercive. In my classrooms, I do not expect students to take any risks that I would not take, to share in any way that I would not share.[11]

To share the experience of painting these large images with the women means that we also shared their feelings of joy and pride, and we understood their struggles with the paint. Jane and I *know* the multilayered painted faces of Nilak, Mother Teresa, and Clara; we know these images *intimately*; we know of *all* of the transformations. We participated in the process and eagerly watched the murals progress.

I have been teaching and conducting research in prisons since 1994, usually working alone or, if I am lucky, in collaboration with other teachers. These experiences have deeply affected the way that I teach not only within the prison but also at the university. It was behind bars that I first learned that teaching in a prescribed way with predetermined expectations (like everything else the women are subjected to) is least effective. Working in the prison also made me reexamine my ideas about other women and the way that I formed relationships with women. I found the community of women to be one that required trust and sharing as well as a great deal of give and take. It was a place to learn what being comfortable with values and myself really meant. The most important part of teaching in any situation is to be flexible, empathetic, honest but constructive, and above all supportive.

> I enter the classroom with the assumption that we must build "community" in order to create a climate of openness and intellectual rigor. Rather than focusing on issues of safety, I think that a feeling of community creates a sense that there is shared commitment and a common good that binds us. What we all ideally share is the desire to learn—to receive ac-

tively knowledge that enhances our intellectual development and our ca-
pacity to live more fully in the world. It has been my experience that one
way to build community in the classroom is to recognize the value of each
individual voice.[12]

When women sign up to take art class, they are usually looking for an
outlet. They are the objects of control for most of their time at the prison.
Perhaps they feel as though art class will give them a little bit of freedom to
make choices. Women in prison come from a variety of backgrounds; some
have traveled and are well educated, and others have never left their home-
towns until their incarceration. In my experience, most have had unsuccess-
ful interactions with programs that are structured or designed to produce
specific outcomes.

The profile of a *typical* female offender incarcerated in a U.S. state prison
reveals that she is probably a minority (67%), between the ages of 25 and 34
(43%), has never been married (47%), has probably graduated from high
school (39%), has at least one child (65%), was probably sexually abused
(57%), may have made less than $600.00 per month before she was incarcer-
ated (37%), and may have been under the influence of drugs or alcohol
when she committed her offense (40%). It is shocking to know that 11 out
of 1,000 women will be incarcerated at some point in their lives.[13]

Because of the variety of experience among the students with whom I
worked, I found that each one could help to shape the knowledge that was
constructed during class. Many of the students were already natural teach-
ers. They had transcended horror and sorrow, made peace with their present,
and continuously looked, with an eye toward positive goals, forward to the
future. Because of this, women who had not surmounted such hurdles
sought advice and support from these experienced women. Sadly, many of
the women who act as mentors are serving long sentences. They have re-
signed themselves to making a life within the prison. These longtermers add
stability to the environment of the prison. They are usually well respected
by the other women and the staff, and they are the most committed mem-
bers of the group.

The Return Home

At 7:20 there was usually a shift in activity in the art room on Monday
nights. Seven thirty is the last movement in the yard between buildings.
After that time the women must have special permission to be in the yard

or to walk between buildings. Jane would announce that it was time to clean up, and the women immediately began scraping precious paint back into the large plastic jugs with their fingers, washing out their brushes, and searching for bits of masking tape to seal up the small cups of new colors.

One or two always asked if I would come the following week because of my travel schedule. I tried to reassure them that I would be back. Some asked me to bring books or images that they needed. Others wished me a safe drive home; part of me was always hesitant to leave. At 7:30 the only women left were Jane, a few women who live in unit four, and myself.

Hope was almost always the last to leave. She was incarcerated as a teenager and is now in her early twenties. She talked incessantly, was extremely sensitive, and very helpful. She always asked for a hug good-bye. As a volunteer I was allowed to do this. I gave her a strong squeeze and told her to have a good week. Jane and I shut off the lights, locked the two sets of doors, and left. We almost always walked to the gate in silence. I always felt a little overwhelmed by the experience of the class. I was amazed each week at the progress we made as painters and as people. Because of the cold night air or my long drive, our good-byes were usually short. I walked through gate six and then gate five into the dark parking lot. On the way home I always stopped in Newton for a sandwich. Usually I tried to decide if I should cut through the Amana Colonies and Cedar Rapids or continue along the interstate.

Away from interstate 80, along dark narrow roads, where I can see the stars and don't have to face the headlights of passing cars, is my first choice. Usually regardless of the route, I pulled into my driveway around 10 P.M. First I would pet my three dogs, then take a bath to relax and wash away the day, crawl into bed with my warm drowsy husband, and fall asleep exhausted. I am always thankful for these small pleasures, especially after Monday night mural class at the prison.

This project has led me to conclude that art is a powerful force that pervades, informs, and is informed by culture. It can perform miracles in acts of healing, communication, meditation, ritual, and empowerment. In its original setting, divorced from the expectations provided by the art world, it is created through collaboration, cooperation, and interaction.

My work in prisons has also led me to understand the power of conversation, empathy, collaboration, and ambiguity. These forces and interactions constantly create a narrative for me to explore and analyze that speaks less of women set apart from humanity by acts of violence, poverty, destruction, defense, poor reason, and necessity, and more about women artists working

within an unusual cultural context, who are influenced by their past experiences and present conditions.

Prison is a place where deprivation, oppression, and disenfranchisement take place. Due to limited resources, there are few chances for personal renewal and transformation. Art offers one route that is productive, nonviolent, communicative, and insightful. It also offers a portal that leads to an in-depth understanding of the symbols and objects that have power within the cultural collective. These symbols and objects can help observers understand and define belief systems, social functions, as well as functions necessary for day-to-day living.[14] Art making presents a way to control and create personal connections to the universe through the manipulation of materials. Suzanne Langer, a noted philosopher, states: "It may serve somebody's need for self-expression, besides, but that is not what makes it good or bad art. In a special sense one may call a work of art a symbol for feeling, for, like a symbol, it formulates our ideas of inward experience, as discourse formulates our ideas of things and facts in the outside world."[15] This statement underscores the value of discourse as well as art making. This chapter has sought to combine both of these in an attempt to shed light on the world of women's incarceration, the experiences women have lived through, the art they produce, the daily routines and frustrations they encounter, as well as the possible positive outcomes.

Prison is an end-game strategy for deterring crime. Crime rates are falling, yet the number of people who are incarcerated continues to rise. Prison construction has become a booming industry. Private manufacturers are exploiting the availability of an inexpensive labor force within prisons to raise their profit margins. In a society that prides itself on being ethically and morally advanced, the desire to profit and punish rather than rehabilitate should not be allowed to overcome human compassion, common sense, and justice. There must be a genuine search for other alternatives to prison. Communities must attend to the needs of women who commit crimes as a reaction to poverty, victimization, and circumstance instead of warehousing them only to forget that one day they will return to their communities, interact with their children, friends, and families, and try to have a normal life.

Susan Hill

This Is for Anthony Beard

This is a true story. It's about the California Youth Authority (CYA), the government agency responsible for imprisoning and educating juvenile felons. In 1985 they asked the California Arts Council for funds and for direct assistance to begin a statewide, institutional arts program. The story is about Artsreach, a small artist-managed community service arts organization tucked into unused offices at UCLA that submitted the winning bid in the statewide competitive request for proposals to establish an arts program for the Youth Authority. And it's about Anthony Beard, a very big (in every way) seventeen-year-old. He was a badass, a loner, a deeply talented young man of no distinct racial origin, who walked into the program, stayed, changed us, was paroled, and was killed. I'm told that every two youths out of ten paroled from the Youth Authority are killed within their first year back in the city. For us—that is, the troupe of artists who were that program—ever since that day he died, our work has been dedicated to Anthony Beard.

In 1985, California's arts-in-corrections program was arousing positive attention. Arts-in-corrections, birthed as a pilot prison arts program initiated by inmates and supported by local nonprofit arts organizations, is a multidisciplinary, professionally managed fine arts program, which operates with dedicated space and a substantial budget in each state prison in California. It's recognized as an official program, mandated and funded by the Department of Corrections. In 1983, the University of Santa Cruz had published

the Brewster Report, an extensive study of arts-in-corrections, which documented significant benefits for inmates and staff alike.[1] Inmates enrolled in the program demonstrated reduced infractions, reduced racism, increased cooperation, and a reduced rate of recidivism. California's energetic arts council, established by Governor Jerry Brown a decade before, envisioned expanding arts services to the Department of Mental Health and the Youth Authority. Following the intelligently structured model that arts-in-corrections presented, the state agency (i.e., Youth Authority or Mental Health) and the California Arts Council would contribute matching funds to establish the arts program. The design, curriculum, implementation, artist selection, orientation, and evaluation was to be the primary responsibility of a highly qualified local arts organization sought by a fair competitive bidding process conducted by the state agency; these two organizations, the arts group and the Youth Authority—one small, one an enormous paramilitary bureaucracy—were equal partners with tremendously varied expertise in the care and operation of the arts program. The state agency hired qualified arts personnel to manage the programs on site while the local arts organization sought, interviewed, hired, and trained skilled professional artists who taught at the institutions on a regular basis, conducting three-hour weekly instructional workshops attended voluntarily (with regular attendance required) by the institutions' residential wards. The program design, choice of artists, selection of spaces within the institution to use as classroom sites, and recruitment of wards became collaborative tasks between the Youth Authority arts coordinators and principal staff at the community arts organization. The joke was, "I won't hire and train the guards, if you don't ask to hire and train the artists, but let's train them both to work with each other," and we knew that as long as the partnership was equal on those terms, as long as we remained in agreement to protect the standards of creative excellence, then we, as artists, could work inside places whose official mandate is punishment, and we knew that the program would remain viable. We did not expect the partnership to last.

So, in 1985, the California Youth Authority and the California Arts Council made an agreement to initiate an arts program. There was $50,000 in seed money to be spent—half in northern California, half in southern California (Fresno is the midpoint). They issued a request for proposals and encouraged the large, well-organized cultural organizations to apply: the Music Center, the LA Theatre Center, and the biggest artist-in-schools organization. From the southern California region, which contains not just Los Angeles—the City of Angels, birthplace of Crypts and Bloods—but also small

cities named in Spanish for saints and in indigenous languages to describe the earth itself, came the winning competitive bid from a quiet, artist-managed organization called Artsreach.[2]

Unlike the other bids submitted by the Goliath organizations, which promised a program of short workshops in a variety of mediums, Artsreach envisioned the creation of an improvisational theater company comprised of carefully selected, thoroughly trained actors: an improvisational, interdisciplinary, multilingual, interracial, gender-balanced ensemble that would team teach, operate on principles of cooperation and trust, and annually produce original performances for public audiences. Instinct told us that there was strength in a comprehensive, in-depth, focused program—strength in the work, strength from which to build curriculum that actually challenged the belief system held by young felons, and strength for survival in a huge, often careless incarceration system. In hindsight, the instinct has been rewarded, but that's getting ahead of the story.

It is my belief, and perhaps the point, that in addition to the intelligent structure arts-in-corrections provided (a program initiated by inmates requesting assistance to teach themselves), we intuited another critical strength. Almost *because* there were very limited funds, and certainly in spite of very limited funds, we made one, big, challenging, collaborative, interdisciplinary program with limited and specific focus. We engaged an interconnected cadre of (nine) artists, setting them to work in teams to reach a limited number of participants, who, in turn, were made responsible to an audience. It was not a limited program; it was not small or careful; we did not divide the money fairly to create a number of programs to reach as many participants as possible. We were rewarded with the contract to found the program, and we were rewarded with amazing work. Other programs follow other models—including spreading limited resources to reach as many participants as possible—experience success, know elation, and are granted longevity. In 1985, in California, we had an incredibly lucky moment when the circumstance, the place, and the people who were in the room at the time were an alchemically auspicious combination.

In 1985, Anthony Beard was probably ten years old, just at the edge of gang life. We did what we said we would: the original company of actors, who were recruited and trained within a couple of months, lasted as a company for seven years—twice as long as the California Arts Council was technically allowed to fund a project. All the members of that company, and many that came after, are still engaged in the work. We based a project on improvisational theater to elicit original work in collaboration with the

youth; we team taught (and fought) and paid attention to, paid court to (and fought) differences in perspective, for the multiplicity of reasons that these differences exist. We invested trust in ourselves and the kids, although rarely in the system of justice, and each year, brought something out of it to show to audiences.

I was there when we began. I still am. I was the one that conceived of the project, wrote the request for proposal, and I was the one that took the phone call that said we'd gotten the contract, then turned to my staff of one and said, "How do you start a theater company?" I was the one that called Laurie Meadoff and Dexter Locke of the Creative Arts Team in New York and said, "Come help us, " and called Rebecca Rice at Living Stage in Washington, D.C., and said, "Come help us, " and called John Bergman, of Geese Theatre, and said, "Come help us." They did, each at intervals of five days or more, throughout the next three years, with truly extraordinary results. We began with an eight-hour, highly competitive audition process among aspiring, accredited actors for stage, television, and film, to judge teamwork, resiliency, imagination, grace under stress. From these wonderfully playful sessions came a company: dancers Lula Washington, Flo Solder, and Myrna Gawryn; actors Christine Avila, Danny Mora, Felton Perry, and J. Ed Ariza (who in a crowded group improvisation once riffed for five minutes about being one puppy among twelve in the uterus of a dog who had only ten teats); Leah Joki and Jerome Butler, both fresh from Julliard; John Freeland Jr., as quiet and deep as J. Ed was quick; the mischievous, beautiful Violette Winge; and Peter Schreiner, who played the audition so tough and so angry that no one thought he was a candidate until he sang "Amazing Grace" so off key and so heartfelt that we had no choice but to bring him in.

An allied principle of the early organizing was a conscious placement of artists of color, with restraint in using Euro-American actors; the students were predominantly African American, then Hispanic, with a few Caucasians. We found that most of the students' only experiences with white men had been with their arresting officers. Male students had to learn that female actors were not there to be baited, dated, or categorized in a family role. They were equal in power and talent to the male actors; they were to be treated as people, trusted allies. Truly balanced teams gave students close and regular proximity to someone previously defined by stereotyped notions, and the authentic experience of building the relationship was one of the most subtle and the most profound in widening the student's sense of self.

For Anthony

Anthony Beard was probably born sometime in 1976. Even if that's not accurate, the bicentennial year, the celebration of liberty's longevity, is an apocryphal place to bring Anthony Beard into the world. Anthony was big, rangy; you knew he was powerful, and you kept the distance he required. He was quick tempered; he talked loud, and he talked anytime he wanted to, no matter what. He was troubled and troublesome, an instigator, a leader by means of his great physical presence and his tremendous will. You never could cajole and persuade Anthony Beard; he entered into respect and consideration only if you merited it. I won't say that we loved Anthony; I will say that Anthony was a most worthy student. He presented himself in all his complex truth. He educated us about what he believed to be true and why, and challenged us to tell him truth as we knew it. Anthony Beard brought out the best in us.

Anthony Beard came into the first session with his unit mates—big, testy, challenging. Anthony was taller than Peter, Violette, or Christine, the extraordinary team that took that unit. Peter and Violette are absolutely solid in their voices and in their bodies, and Christine operates from grace, from a profound respect. Peter, Christine, and Violette like each other enormously; they laugh a lot, love theater, and are determined to pass it along, determined to reach every student in the room.

We learned from our mentors—Laurie, Dexter, Rebecca, Bergman—to work in teams so as to pull on our own collective imagination and strength, to provide more direct instruction to participants, and to be a living demonstration of getting along. The team of three actors worked in a group of wards comprised of eighteen to twenty-two members from a single living unit. We have to have at least seventeen wards for a project because that is the number required to release one staff person from the unit to walk the wards in military formation to the session. They cannot walk independently, and we cannot replace a staff person for the task.

The California Youth Authority incarcerates young people in its maximum security prison system from age thirteen; any ward who is twenty-one years old is no longer considered a juvenile, but if they have time left to do, and if they are working well in their programs, they may finish their time in the Youth Authority up to the age of twenty-five. If they are not working well or have posed problems within the institution, they are transferred to the adult department of corrections to finish their sentences.

The average ages in the arts workshops seem to be sixteen and seventeen. Only one institution contains female wards, and we conduct programs with them, but the majority of the projects are designed and implemented with young males. All wards wear state-issue blue denim shirts and jeans; they may receive and wear their own shoes or sneakers, and they may wear their hair as they choose. Nearly every ward comes into the system with strong gang affiliations, which they maintain. Most are tattooed with signs of their neighborhood, their gang, their cultural symbols, and marks indicating how many times they have been to jail. Most are third- to fifth-generation gang members and prison inmates. Like residents of other institutional correctional systems, more than 80 percent have a learning disability, most have a reading level of sixth grade or lower, more than 80 percent have been subject to physical, chemical, and/or emotional abuse (less than 3% have ever been treated), and more than half come from families categorized in studies as "poverty level" and "neglectful."[3] No gang paraphernalia, gang language, or signs are allowed in the project sessions; we use their given names in the project, never street names. Security staff and some CYA counselors rarely know wards by anything but their last name, if that.

From the first it was apparent that even the guards were someplace between respectful and apprehensive of Anthony, and we knew we had someone who would be a catalyst for rebellion or for achievement. Anthony's natural enemy, an enormous, very strong boy, the little brother of a famous football player, was also in the group; James (fictitious name) was sweet natured, easy going, helpful, and Anthony's equal for size and power—a rival for respect. They were enemies by ethnic lines, and each commanded respect on the living unit and in the institution by holding himself separate, prepared for conflict. They stood in different places in the circle, and Anthony always sat his chair at the very back of any group meeting. He could be quiet when he chose to be, but he was never invisible.

The circumstances of institutional life dictate how we operate the program. Wards are assigned to a specific living unit on the grounds, with sixty to ninety wards living in one unit. A living unit is one story, usually red brick with a cinder-block interior. The building is divided: one half is a day room filled with rows of heavy, badly damaged chairs in front of one television mounted on a wall, and one half is the dormitory with one row of cells (which are either punishment units or privileged private rooms, depending on the philosophy of the staff) and an open area occupied by rows of single and bunk beds. Each bed has a simple mattress, one pillow, sheets, and a blanket.

Between these two identically shaped spaces, like a fulcrum, sits a square, airless shatter-proof glass-walled office containing the security staff, who "pop" the doors to the cells with electronic switches. Back to back with this observation station is the bathroom, fully exposed to view without doors or partitions, containing sinks, showers, urinals, and toilets. Each living unit of sixty or more wards has a staff of two to four people on duty during each shift: a uniformed "peace officer," a counselor/treatment officer (a noncredentialed job assignment), and a parole officer who facilitates the parole board process and the return to community life. The staff is responsible for moving their group of wards to the dining room and to the education area, monitoring dayroom and enclosed yard activities, conducting security checks and head counts, providing required program curriculum, and coordinating movement to optional afternoon and evening activities on and off the living unit.

All living units are independent from each other. Wards are not mixed with wards for other units except for religious services, classroom education, or truly special large group audience events. Wards within the units are mixed racially and by gang affiliation: getting along, or at least tolerance, is mandated by proximity. What we discover in the course of workshops is that they do not know each other at all.

For our program, there are two simple truths in working with individual living units. One, always work with a unit whose staff is supportive of the young people and their progress (conversely, don't attempt to run a program where a staff person is prone to sabotage the schedule and the results). Two, wards join a project voluntarily; it is never mandated. The artists for any project conduct a presentation in the dayroom when all the residents are present. We talk about the project, its goals, its schedule; we demonstrate our skills; we ask and answer questions. We invite participation, making it clear that membership in the arts project requires steady attendance, full participation, and teamwork. A primary expectation is that everyone who begins the project stays to finish it; no one is permitted to drop out after the initial trial sessions—and more importantly, no one is asked out. The sign-up list is created after the artists' presentation, and the process is managed by reliable senior staff who have agreed to in-house facilitation for the project. A primary list of twenty is generated, with a back-up list of alternates that may be called to replace anyone within the first three weeks. Wards are assigned behavioral codes from 1 to 4, the equivalent of disruptive (1) to trustworthy (4); we ask for participants at every level. It is our experience that level 1 wards progress to higher levels as a result of participation. We've

witnessed an increase in literacy skills, lowered incidence of disruptive behavior on the unit, counselors changing their perception of individual wards, parents expressing pride, and overall raised expectations for positive change—in other words—accomplishment. "I didn't know he could talk," they have said to us, "and you have him singing." The best counselors do not withhold the art project from wards who merit some disciplinary action, understanding that our high standards and insistence on teamwork are effective tools for positive change.

As the relationship of the group took shape, the actors allowed each participant genuine individuality; they encouraged contribution. In the year Anthony Beard was in the project, he found a sense of himself on the stage. He loved it. The actors fed Anthony's instincts for leadership, honored his intelligence. Anthony argued fearlessly, without regard for consequence to himself, in an environment that quickly and violently shuts down opposition; he insisted intensely on fairness and truthful information. The actors encouraged him but began to use a council circle and talking stick to provide equal room for all the participants. He wrote most of the pieces, gaining skill and respect from the group; his sheer strength had an outlet.

It was as if his innate intelligence finally had a forum, and his ideas took shape as people took on assigned roles, talked back, moved in space. Anthony began to find a better fit in the world, and he took most of the group with him. The actors brought scripted pieces—monologues, scenes from Shakespeare, Langston Hughes, Luis Valdez—mixing them with pieces out of the students' imagination, to raise the stakes. It was one of our best seasons, and by final rehearsal, excitement was high.

We trained with an emphasis on creativity, on building trust among ourselves and with the groups of students. We set high standards and worked to reach them, never patronizing a student by accepting less than he was capable of producing, never providing generic compliments. We began the first sessions with a recognition that trust needed to be built, so we never used games that required physical contact in the beginning—these came later. We began always with rhythm games, name games that were simple and that were complex, games in which we passed something real or imaginary, and relay races; often students had to walk backwards because we rarely had adequate space in which to release their tremendous storehouse of energy. We built trust slowly, introducing first contacts through the passing games, then practicing simple arm-to-arm connections and mirroring, then progressing to group sculptures, group machines, blindfolded walks, high-speed Simon Says and Red Light, Green Light. We played with improvi-

sation, handing out stage direction and voice lessons as we went, setting professional standards, encouraging ideas from all quarters. In a policy hammered out in facilitated discussions among the actors, and after a season of trial and error—with lots of error—we stopped accepting and producing gang-related ideas, including crimes gone wrong, deaths, and funerals. A highlight moment in the process came when Rebecca Rice, visiting for a training session, had a boy/robber play the part of the bullet instead of the hero/trespasser, walking in slow motion across the stage to his sleeping target, talking all the way. The "bullet" dived away from the victim at the last minute, lodging himself under the bed.

We asked for more—clearer, more universal stories—and we got brilliant games of crossing through barricades to a dream goal. We got dances in which salsa met rap; we got African shamans and courageous old men; we got kids who told the truth around neighborhood factions, and jesters with saxophones. We did dance routines with aerial, acrobatic steps that depended on teamwork and focus: they worked brilliantly. One year the wards did a skit that they had created on their own. We'd never seen it, never expected it was in construction. They wrote and rehearsed it outside our sessions and simply performed it onstage between two well-rehearsed pieces. It was a brilliant satire, profiling the warden and an unpopular current policy. We were well pleased.

Representatives of the California Arts Council called me in the early phases of implementing the arts program in the Youth Authority. The Artsreach actors were working steadily, and our projects kept full participation while the northern California project was losing artists and attendance. On an average northern California artists left the program after three sessions. How did we do it? What were our selection criteria? Were we using artists with lots of experience in school classrooms; did they have teaching credentials?

We did train the ensemble. We used the best people we could bring who were experts in high-risk youth, so we were familiar and prepared for the skillful manipulations and scarification that were the undercurrents of the group dynamic. We did role play with each other, scoping out a variety of responses to student resistance, to inappropriate improvisation suggestions, to disruptive behavior, to racism, to sexist ideas, to intolerance, to devastating personal revelations. It gave us a repertory of responses, and it got inside a kid's skin, giving us dual perspective. Although the arts council expected that our successes were accomplished because we had expert disciplinarians, model citizens—which we did not—we found that the most important attri-

bute for our successful longevity was that each artist carried some memory of being the outcast kid, and that their connection to the work and to the students came from deep empathy, from a true allegiance to inclusion and stubborn survival.

Peter had gone in early in the day to finish the stage set. Peter hated heights but had agreed to climb the ladders to set the few lights we had. He was tired when we came in after supper, and the students were restless under the tension of the long rehearsal for the pending performance. The theater tradition is that a bad dress rehearsal means a great opening night, so we didn't mind. They were all up on the stage; the group was especially loud, slow to settle down. Peter began to pull the stage curtain closed and called for the council circle to begin; to help settle them down, he posed the council question. There was a young, uniformed, armed guard, very green, who had been assigned to the auditorium that night; we didn't know him. We rarely work with staff we don't know, as it takes education and experience to form the genuine partnership required between staff and artists.

I went over to the guard, hoping to gauge his temperament, to orient him to our project. I saw that he didn't listen, that he was short-tempered and nervous. He didn't like the curtain being closed, he didn't like the informality, the actors surrounded by the wards. He bolted out of his seat and mounted the stage, yelling for the students to be quiet. Anthony, of course, loving truth, said, "Peter has asked us a question." The guard yelled for silence. Anthony said again, "Peter has asked us a question." It wasn't Anthony's old confrontational behavior, and although he knew better than to cross a guard, Anthony continued to explain, very quietly, "Peter asked us to talk." The guard lunged at Anthony in a fury and threw him face down on the stage. He was much smaller than Anthony, so he used force; he twisted Anthony's arm high behind his back, put his knee in Anthony's back, and yelled again for silence. Anthony picked up his head, and before he could form the words for whatever it was he wanted to say, the guard hit him. Then, with tension and rage loosed in the room, the guard jerked Anthony up and out of the hall. We were stunned. No one moved. In the next beat, the students, shaken and furious, began to quit in solidarity with Anthony. In that moment, two different uniformed guards came through the back doors of the auditorium to replace the man who had taken Anthony to the "hole." Without thinking it through, I put myself between the assembled group of kids and the exit, and from some place outside logic, turning my back to the replacement guards, I began to tell the kids that these guards had come to apologize for what had happened. I said everyone knew it was

unfair, and everyone wanted Anthony back. I told them that if we quit now, silence and violence would win. Then I waited to be shot, for everyone to be ejected from the hall, but these guards let us finish the rehearsal. Then they escorted us to the superintendent's office, where we petitioned to have Anthony released. He was on stage the next night.

The auditorium is small, a 1930s California landmark building made of adobe and Mexican tile. It holds about 500 people. It has terrible acoustics and very little light, so you have to work hard to know what's happening on stage. The wards from the various living units are seated in groups, with empty rows between each group; parents, community members, and staff are seated at random throughout the auditorium. Uniformed and plainclothes staff patrol the aisles, radios on their belts alive with messages from the security post and each living unit, making distracting noises that drown out the actors' lines. Nevertheless, that night, all the attention was on the stage.

Anthony stepped out from the wings, walking slowly to the very front of the stage. The stage is about six feet above the first row, so he seemed immense, his presence radiating out into the audience. James, his enemy, came from the other side, walking just as deliberately, with the same cool elegance, to his mark, facing Anthony at the very edge of the stage. The audience, aware of the powerful history between these two, couldn't believe the image before them and waited. "To be," said Anthony, "or not to be." In beautiful, crisp diction, James answered, "That is the question." With the studied expertise of two men who know, respect, and dislike each other, they faced each other as planned, as rehearsed, as agreed, talking intently in 400-year-old sentences written by Shakespeare about the possibility of living or dying—riveting an audience that lived as they did on the edge of daily violence, on the outskirts of a culture that spends more on prisons than it does on schools. They stunned the audience with their performance, with the words that none of them had ever heard, and with the extraordinary image of two enemies operating with an honorable commitment to each other.

We promised Anthony support once he got back to the community, local programs, places where he could learn, where he would be welcome. Instead, one fine day, perhaps because he was standing two blocks over the known boundary of his "safe" territory, someone put a gun to his chest, pulled the trigger, and walked away. It might have been for an old unavenged grievance he'd committed back before he was incarcerated; it might have been for a current transgression by another member of the gang he had

belonged to; it might have been a mistake; it might have been a rite of initiation for new members of a rival gang; it might have been just for the hell of it. We don't know. It was more probable that this would happen to Anthony than that he would realize his innate potential to contribute.

California's Youth Authority is an extraordinary place to work. Its mission is education and rehabilitation, as well as public safety, unlike the adult Department of Corrections, whose mission is punishment. In 1985, out of a desire to provide effective programs for its wards and in the wake of the loss of funding for organized sports programs, the agency director sought funds from the California Arts Council. They asked for theater, and they opened their doors to strangers whom they distrusted, who talked about creativity and spontaneity in a system that requires disciplined order. They hoped for a talent show, envisioning top hats and funny songs. They got—and kept—real theater.

Anthony Beard was shot in the chest in 1997, two months after he was paroled from his twenty-nine-month term of incarceration, while he waited on the corner of 57th and Crenshaw. As I wrote earlier, I've been told, although I can't prove that it's true, that within the first year of parole following release from the California Youth Authority, 20 percent of first-year parolees are killed, most of them by someone just like themselves. That means that for every group of ten young people we teach, two will be dead within months after their release. That means that if we teach 100 a year, that 20 of them—every year—won't see their twenty-second birthday. It means that of the estimated 1,600 students we've taught directly, more than 300 are dead now. I can't tell you that any of them don't matter, nor, as I look into the group of faces each year, can I bear the thought that two will be lost before long. I only hope that by our work we have stopped some deaths, and I hope that because we don't hear who has died, that no news is good news, and that the best results of our work is no statistics at all.

We say that it is our hope to put the Youth Authority out of business: the young participants look shocked, then they get it, and their passion surfaces. If we take into account that each class of ten to fifteen students we teach returns to a living unit of sixty to eighty other kids, and if most of them teach one other young person what they just learned in class, as we ask them to do, the mathematical progression—calculated over fifteen years' time—yields a staggering number of children affected by creative education. Yet it's still not strong enough, not yet prevalent enough, not yet pervasive enough among the youth in and outside the justice system to disrupt their own cycles of violence against people pretty much just like themselves.

The most important things we did, I think, in this founding experience were to insist on the highest standards, trust the process and the students, refuse to glorify anything to do with gang life in any of the work, insist on regular attendance and never remove anyone from the project for bad behavior, hold intense annual training workshops for ourselves, team teach, read bell hooks, and insist that the work go to an audience. We came down on the side of product over process because taking work to an audience validates the story and its authors. It creates connection where, in the circumstances of Youth Authority wards, there was none. It invites them, as artists and as creative citizens, back into the fold. We believe that our students have an obligation to make amends, and we believe they are capable of using their imaginations to envision the men they are to become.

We, who were the young artists that came to the table then, know that new ways of doing the work are required now. It's tougher in the Youth Authority now than it was then. There's been damage to the once equal partnership; there's been a loss of funds—like everywhere else—and the system is tired. There are different kinds of young people coming into the system now—proud of their callousness, without knowledge or ethical codes that help maintain truces and make change.

We are in a process of redesigning ourselves and our work to meet the new challenges. In the past, at intervals, when we've wished to depart from theater works created solely by the wards, Alice Tuan has been the playwright associated with the projects, with Aaron Mendelson as the choreographer. Victoria Aguilera brings Native American dance and ceremony; Bobby Rodriguez and Byron Hester are musicians and song-writing instructors; Desire Adomou, Marcel Adjibi, and France and Omawale Awe are drummers and dancers from Africa. Spoken-word concerts come from workshop series led by Father Amde Hamilton and Richard Dedeaux, of the amazing Watts Prophets.

We partner often with ex-gang members to team teach community history and community-building skills in equal measure with the arts. We partner with ceremonial elders, teach council practices, and are developing processes by which acts of amends can be creatively accomplished. The wonderful Watts Prophets, griots, often called the grandfathers of hip hop, are partners in an extensive community project, training young hip hop and spoken-word artists to perform and to co-teach with our most experienced artists. Following their first important concert, they've been invited to teach at a university rather than being invited to conduct prison workshops (which is what we expected), challenging our own notions about education-

ally underserved environments. It's a piece of the new work—work with its roots deep in the early CYA theater project—that has just begun.

For Anthony, the foundation of every project has to challenge the sources and the use of violence. Because of Anthony, we will continue to ask students to talk back and will argue fearlessly with kids who believe that "not to be" is the only choice.

Rachel Marie-Crane Williams

Evaluating Your Arts-in-corrections Program

lthough this chapter simply scratches the surface of program evaluation, I hope it provides some insights into why evaluation is important, how to plan for an evaluation, what to look for when hiring an external evaluator, what to expect in a final report, and one way that you can do your own evaluation.

Why should you conduct a program evaluation?

There are many successful arts-in-corrections programs across the United States and elsewhere. Many of these programs have never been evaluated, their outcomes have never been measured, and their history has never been documented. Organizations, artists, and institutions may feel that conducting an assessment would be overwhelming or that the cost of an evaluation would be better spent hiring more artists or buying more materials. Nevertheless, there are numerous reasons why every program should incorporate *some* evaluative component. Some of the most compelling are as follows.

- *Evaluation offers participants a confidential way to give feedback about the program.* The artists can use the feedback to improve instruction or to gain insight into their experiences.
- *An evaluation can ensure and demonstrate accountability.* This accountability may be crucial to those who fund or oversee the program. It may also be important for the institutions and the artists.

- *Evaluations are helpful in measuring outcomes and documenting what resources were utilized.* A thorough evaluation can help program managers create a budget for the upcoming cycle of programming or help program developers set reasonable outcome targets.
- *Evaluations promote your program as one that could be replicated by other organizations or artists.* A well-done evaluation provides a record for others who wish to create similar programs. If a curriculum is highly successful, then having evidence to share with others may help proliferate the program.
- *Evaluations can determine whether your program is meeting the needs of participants, the correctional facility, or the community.*

What are your evaluation options?

Many different types of evaluations can be used to assess an arts-in-corrections program. Most evaluations fall into one of three categories: qualitative, quantitative, or a combination of these approaches.

Qualitative measures employ observations and unstructured interviews as primary sources. Evaluators might also use secondary sources from the program and the hosting institution such as journals, grants, newspaper articles, administrative memos, participant records, and classification folders. During interviews, researchers try to explore the experience of participants, artists, administrators, and institutional employees involved with the program. Qualitative evaluators aim to understand the context, story, and outcomes of the program. Qualitative researchers use the data to develop an explanation for what they have found using inductive logic.

Quantitative evaluations involve standardized measures and statistical data. The researcher gathers data in controlled environments and often tightly coordinates the data collection. This kind of evaluation uses deductive logic. Usually researchers set out with a hypothesis that they wish to prove or disprove.[1]

Generally, evaluation is either formative or summative. Formative evaluations are often low stakes, somewhat informal, and aimed at improving the program. Usually formative evaluations take place internally or with the assistance of a consultant. Summative evaluations are more structured and high stakes, and are often used to provide accountability and documentation. Usually they are highly structured and could be used to make decisions about funding, future programming, or individual performance. The outcomes of a summative evaluation are compared with the program's original

goals. An external evaluator usually conducts summative evaluations or works closely with an internal evaluation team.[2]

What should you evaluate?

After you decide whether you wish to have a formative or summative evaluation conducted, and whether qualitative or quantitative data could best be used to meet your program's needs, you must decide what you wish to have evaluated. The best time to make this decision is when you are writing your program's goals and objectives. When writing goals and objectives, it is important to use clear and precise language. Remember that goals are very general things that you hope will happen as a result of the program. They also describe the context of the program in very general terms.

Here is a sample goal written for an arts-in-corrections program:

> The goal of this program is to provide quality educational opportunities through the visual arts. A 20-week course will be offered at the Men's Correctional Facility in Anywhere, USA. Program participants will enroll in a workshop that meets once each week for three hours. Participants who successfully complete this 20-week course will be eligible to enroll in other arts courses.

Objectives are written using very specific language so that they can easily be measured. Some include a method section that describes what will be accomplished. Here is an example of an objective:

> **Objective #1: This program will reduce self-reported/institutionally recorded antisocial actions, behavior problems, and disciplinary infractions of at least 70 percent of the participants.**
>
> *Method:* This will be accomplished through individualized and group instruction in the visual arts. Written voluntary contracts will be secured from each participant stating that he or she will attend 90 percent of the art classes offered over the course of twenty weeks in addition to any classes required by the institutional treatment/education staff. Absences will only be excused based on court appearances, institutional appointments/requirements, family visits, or illness. The contract will also state that each participant will complete any homework assignments and will create a final piece for display during the final graduation exhibition.

Objective #2: This program will provide male offenders with op-
portunities for personal growth and development through self-
expression, for contributing to the community through one com-
munity arts outreach project and the graduation exhibition, and
for sharing their learning and talent with other offenders, friends,
and family.

Method: Participants in this program will be asked to explore their
ideas through a variety of media related to drawing and painting.
They will be challenged to overcome their weaknesses and build on
their strengths. They will provide gifts for the community through a
community arts outreach project for a children's shelter, and they
will invite the community to attend their graduation exhibition. Any
funds raised as a result of this exhibit will be donated toward a social
service agency for Vietnam Vets. There will be postage available for
artists to select one piece to send to someone on the outside. Prior to
this course interested applicants will be screened and recruited to act
as classroom assistants.

Objectives should be easy to measure. Thus they must be written using con-
crete language that speaks to specific outcomes.[3] Your goals and objectives
will become the standard against which your program is measured. Evalua-
tion might also assess instructional performance, the institutional impact of
the program, or even the cost versus the benefits of the program. What you
decide to evaluate is often based on who will read the final evaluation report.
In other words, who is the audience for the evaluation? A funding agency,
the institution, other arts-in-corrections organizations? When deciding what
to evaluate, determine what the audience needs to know. Then you can tailor
your evaluation to their concerns.

What if you hire an external evaluator?

If you decide to hire an external evaluator to help assess your program,
make sure they have experience, some training in program evaluation, an
understanding of the context of your program and of correctional facilities,
and good communication skills. It might be helpful to interview a few differ-
ent people or evaluation firms.

The evaluator should be aware of the resources you have available and
have an understanding of both qualitative and quantitative methods. You
must clearly communicate how much you can pay for their services. In turn,

the evaluator should have enough time to do the evaluation and be available at different points in your program for consultation and data collection.

Evaluators must have a good grasp of language and should be capable of producing a document that is easy to interpret and useful to you and your program. If possible, ask them to provide writing samples and references for their past work.

In correctional settings, particular issues need to be addressed when hiring someone. These issues are usually the same whether you are hiring an artist or an evaluator. You must find out if they have any past history that might impede them from entering a correctional institution. You must be sure they are aware that incarcerated individuals are very vulnerable; they should be sensitive to the needs of people from different cultures, classes, and races. The evaluator must understand the importance of confidentiality, trust, and honesty. Correctional facilities are full of people with intriguing, horrible, and sad stories; obviously, the evaluator must not jeopardize an evaluation participant through gossip or unprofessional behavior. He or she must be willing to adhere to the rules and regulations of the correctional institution. You should feel confident that they are ethical and will work well with members of your organization, program/institutional staff, and participants. In working with correctional facilities, patience and flexibility are extremely important, as is a willingness to jump through administrative hoops and fill out mountains of paperwork. Although it may be difficult, make sure the evaluator you hire understands these circumstances and has the right attitude to complete the job without causing problems.

After you have found someone with whom you feel comfortable, the next step is to create a contract between your program and the evaluator. This contract will specify a timeline, a salary or fee, ownership of the final evaluation data, the necessary steps that must be taken in order to publish the data, and what expectations are to be upheld. These expectations might include interim reports, monthly meetings, or weekly contact.

After you have decided what it is you want to evaluate, you must create a timeline with the evaluation team and/or external evaluator. This timeline will be based on when data collection begins and ends and when the final report will be due. It is crucial for evaluators to get a sense of your program before it begins so that they can decide how and when they are going to collect data. For example, if you have decided to use a quantitative approach, it may be necessary for the evaluator to create two control groups before the program begins; one group will participate in the program and one may not. It might also be necessary for an evaluator to interview participants before

they experience the program, or for the evaluator to develop and use pre and post measures. Usually the evaluator will write an evaluation proposal. This proposal will detail the specifics of data collection. They will also need to clearly define how they will ensure that the information collected is valid and collected using proper protocol.

What are other things you need to know to ensure a successful evaluation?

Institutional administrators and even artists usually see evaluations as extra work. It is important for *everyone* involved in the program to be aware that it will be evaluated and that this process will require their input, cooperation, time, and understanding. Sometimes the evaluator will need to train artists or administrators to collect data as the program progresses.

Program participants should be aware that they will be asked to participate in the evaluation. It might even be helpful to have the evaluator there to answer questions on the first day of class. All participants should have the right to refuse to be involved or to withdraw from the data collection at any time. Informing participants will make them less nervous and suspicious if they are observed or interviewed. In my experience, most participants enjoy the process and contribute a great deal to its success.

Institutional approval and cooperation ahead of time is crucial. Often it is important for an external evaluator to meet administrators at the correctional facility. They might have to get clearance to enter the facility or even to collect data from the department of corrections. If you are working with juveniles, there are often many institutional barriers for an external evaluator to overcome before data collection can start. If they need access to participant records, evaluators will make sure they have signed appropriate paperwork and submitted preevaluation proposals to an internal institutional review board for approval.

External evaluators will probably require participants in the evaluation to sign consent forms before data collection can begin. These forms ensure that participants understand why the evaluator is collecting data, what kind of data will be collected, what the data will be used for, and that responses will be confidential. It is also important for participants to know what will happen to the raw data; this includes interview tapes, the evaluator's notes, tests that people might have taken, photographs, and/or videotapes. Sometimes institutions will also require consent forms before participants can be part of an evaluation that might be published. Here is a sample consent form.

INFORMED CONSENT DOCUMENT

Project Title: Heartland Collaborations
Investigator(s): Dr. Rachel Williams

Purpose

The purpose of this research is to implement and develop an evaluation model for Heartland Collaborations. Women are invited to participate in this research because they are involved in arts programming and are incarcerated at Mitchellville Correctional Institution. This project will last for the duration of Heartland Collaborations' arts program and up to six months after the program has been completed starting in April of 2002.

Procedures

The procedures for this project involve institutional observation of daily routines, archival historical document examination to gather the history of the program, small inmate focus groups, in-depth interviews with inmates and selected staff, and a case study construction of the overall program. Art, arts programming, and art making will be discussed in the focus groups as well as the interviews. Participants will be invited to bring and share their art at the focus groups or during interviews. In addition to gathering data from these sources, I will also observe and collect data about the art education program sponsored by Heartland Collaborations and the Iowa Arts Council. This research will involve the examination of inmate records related to discipline, health, and programming. The information obtained from official inmate records will be obtained and reported in group form by the D.O.C. In order to maintain confidentiality, inmates' names and individual histories will not be released or connected to this information. The information gathered through this research will be disseminated through scholarly writing, an evaluation report, and presentations at various conferences. Those agreeing to participate can expect the following to occur: in-depth interviews, participation in focus groups, and observation. The interviews will take place during the program and will last for less than forty-five minutes. The focus groups of twelve or fewer inmates will meet for approximately an hour during the program and an hour after the program to discuss ways to improve the experience and to discuss the impact of the experience. Prison officials will not participate in these groups, but the institution might require the presence of a guard. This presence will be noted, and care will be taken not to jeopardize the inmates by initiating discussions that could implicate them in rule-breaking activity or illegal events. Topics of the focus groups will include instructional competence, the arts program, the experience provided by Heartland Collaborations, and the personal relevance/impact of this experience. These focus groups will be led by the researcher and will not be recorded. The purpose of the focus groups is to gain a general understanding based on collective and collaborative conversation of the culture, experience, art, and art-making activities within the prison. In addition, the

researcher will also ask if photographs can be taken of the art/performance that is produced and shared.

Risks

Participation in this research does pose risks to the participants. Participants will be informed that the investigator's records could be obtained by the institution and that inmates could incriminate themselves by providing information that implicates them in illegal or rule-breaking activity. Participants will be informed that the researcher will not record information of this nature in order to protect the integrity of the study and the participants. A final report of general findings and conclusions will be given to the institution, Heartland Collaborations, and the Iowa Department of Corrections. The topics that will be discussed revolve around culture, values, art, art making, and the experience of participating in arts programming. Topics that will not be discussed include illegal activities within the prison and illegal activities that do not pertain to the current sentences of the participants.

Benefits

There will be no personal benefit for participating in this study. However, it is hoped that in the future society could benefit from this study by understanding the needs, arts programming, arts evaluation methodology, experiences, culture, and art making of incarcerated women.

Costs and Compensation

Subjects will not be compensated for the time and inconvenience involved in participating in this research.

Confidentiality

Records of participation in this research project will be maintained and kept confidential to the extent permitted by law. However, federal government regulatory agencies may inspect and copy a subject's records pertaining to the research and these records may contain personal identifiers. The methods that will be used to ensure confidentiality include coded names, removal of all identifying information, and the storage of data and consent forms in a secure filing cabinet that only the researcher can access. In the event of any report or publication from this study, the identity of subjects will not be disclosed. Results will be reported in a summarized manner in such a way that subjects cannot be identified.

Audio Taping

By initialing in the space provided, subjects verify that they have been told that audio materials and photographs of the images, performance, and objects that inmates consider art will be generated during the course of this study. The recordings will be used for publication and evaluation purposes and could be obtained by the institution if so requested.

_____ Subject's initials

Voluntary Participation

All participation is voluntary. There is no penalty to anyone who decides not to participate. Nor will anyone be penalized if he or she decides to stop participation at any time during the research project.

Studies Involving Prisoners as Subjects

Participation does not affect or influence the duration of the sentence, parole, or any other aspects of incarceration for any prisoners who choose to take part in this study. In the event that a prisoner completes his/her sentence, the study will continue to be available.

_____ Subject's initials

Questions

Questions are encouraged. If there are any questions about this research project, please contact: Rachel Williams at 555-1212 or 100 any street, any town, any state, 55555.

Subject's Name (printed): _____

_____ _____

(Signature of Subject) (Date)

Investigator's Statement

I have discussed the above points with the subject or his/her legally authorized representative, using a translator when necessary. It is my opinion that the subject understands the risks, benefits, and obligations involved in participation in this project.

_____ _____

(Signature of Investigator) (Date)

What will the final report look like and how can it be used?

Usually the main goal of an evaluation is to see if the program met its original goals and objectives. In order to conduct a program evaluation, evaluators learn about the program, document the outcomes, responses, experiences, process, and products that resulted from participation, and list the required resources necessary to implement a program. In the process the evaluation team collects data and creates a final document that acts as a record of the program's history, artist selection and experience, performances, and participant and institutional response. They might also uncover and specify what parts of the program could be generalized and replicated

for implementation elsewhere. The final report could be used to satisfy the funding agencies, general public, administrators, artists, and program coordinators that the program did operate as planned and met all or most of its original objectives. If this did not occur, then the evaluation could be used to determine why the program was unsuccessful. The report might also provide materials to support decisions about the future of the program in terms of funding, space, and continuation.

Here is a sample outline for a final report

Title page
Who wrote the evaluation and who it was written for
What (title of the program and evaluation)
Where
When

Executive summary (500 words or less)
What was evaluated? (You would write the evaluation goals and objectives; these may be written in response to the original program goals and objectives.)
Why was it evaluated? (Who is the evaluation audience and what was the purpose of the evaluation?)
Recommendations and conclusions (This portion would be a short summary of the findings.)

Background information
Origin of the program (How did it begin?)
Goals and objectives of the program
Population description (Who does your program serve?)
Program materials (What resources, funds, curricula did the program use?)
Activities' scope and sequence (What was the actual daily history of the program or what did a typical program session involve?)
Bios/job descriptions/qualifications of the administrative/artistic/institutional staff involved with the program

Description of the evaluation
Purpose (What was evaluated and why?)
Design and procedure (What methods were used—qualitative, quantitative, mixed—and why? How did the evaluator or evaluation team make sure

that the data they collected was valid and confidential? What was the time line for data collection? How was the data analyzed?)

Outcome measures

Sample questions related to outcomes: Does exposure to arts programming reduce self-reported/institutionally recorded antisocial actions, behavior problems, and disciplinary infractions, improve participants' attitudes related to their self-image, reduce self-reported mental and physical health problems, and improve self-reported/quantitatively measured cognitive and psychomotor skills and attitudes?

Instruments (Interview scripts, surveys, standardized measures)

Data collection procedures (How was this data collected?)

Implementation measures

Sample questions related to implementation measures: What resources, materials, actions, and personnel are necessary to create and implement a program, which can be reproduced with similar results and relative ease in similar settings?

What took place during the planning and creation of the arts program?

Did the programming meet the original goals and objectives outlined by the artists, institution, and funding agency?

Instruments (Interview scripts, focus group questions, surveys, standardized measures)

Data collection procedures (How was this data collected?)

Results

Outcomes/supporting data

Implementation/supporting data

Discussion of results

Can the evaluation team be sure that the outcomes are related to the program? Can the evaluation team be sure that the implementation measures are accurate and were collected in a valid manner? How good were the results?

Costs and benefits (Optional)

This could be a cost analysis of the program which might include a summation of the money that your program saved taxpayers or the institution in terms of violence, health care, therapy, crime reduction, recidivism,

and so on. (The cost of art instruction, documentation, and outreach, etc., would be listed under implementation measures.) Benefits of the program would be those things that fall outside of the outcome measures and were perhaps unexpected or unaccounted for in the program's original goals and objectives.

Conclusions, recommendations, and options for further evaluations and implementations

This outline is useful for understanding what a final report will entail, what will be evaluated, and what kind of data might be collected for the purpose of an evaluation. The external evaluator or the evaluation team usually writes the final report. However, it may be that you write the final report based on the data that the evaluator collected and analyzed. This should be specified in the evaluation contract.

Conducting an evaluation is a great deal of work. Sometimes the task can be daunting, especially if you have not given yourself or the evaluator/ evaluation team enough time. In spite of this, you should try to incorporate some element of evaluation in every program that you or your organization conducts. This might be as simple as creating a series of questions for participants to answer after the program has been completed, or it may be as complicated as hiring an external evaluation fund to develop instruments to fit your program's objectives, create in-depth case studies, and chart recidivism rates for participants of your program for five years. It is always better to have some data and documentation about your program rather than none. A final report, if it is positive, can be sent to potential granting agencies, the correctional facility, organizational board members, artists, and people in the community with whom you wish to share your program. If the final report is negative, it can be used to help you improve your program or seek necessary additional resources.

How can I do a small evaluation without an external evaluator?

If you have never collected any data about your program and your budget will not allow for a full-scale formal evaluation, then you might start simply with a questionnaire or individual interviews with artists and participants. If you do interviews, it is easiest to record the responses and transcribe them later. Below I have listed questions that I ask participants, artists, and institutional staff when I do an evaluation.

The questions for each interview with participants could be as follows:

Why did you wish to participate?

What did you feel were the most rewarding aspects of your participation?

Which aspects were the least rewarding and/or helpful?

What did you learn about yourself through your participation?

Are there any additional benefits that you perceived as a result of your participation?

Have you participated in similar programs in the past?

Do you feel that this was a worthwhile thing to do?

Do you feel that this program should be continued?

How can its continuation benefit the institution as a whole?

How would its continuation benefit individuals that might participate?

What would you change about this program?

Do you feel that this program met, did not meet, or went beyond your initial expectations?

Did this experience change your outlook on life? If so, how?

Do you have anything you wish to add to this discussion regarding this experience?

The questions for each exit interview with artists who conduct the programs could be as follows:

Describe the program.

What did you hope to accomplish?

How did you determine the content of the program?

Did it naturally unfold, or did you find that it was more productive to stick to a predetermined curriculum?

What are your professional qualifications?

What other skills did you find necessary to utilize in your teaching and production?

Why did you want to conduct this workshop?

What did you find to be the most challenging aspect of this opportunity?

What would you tell other artists who wish to conduct similar programs in similar settings?

What would you do if you were given this opportunity again?

Would you change anything about the participants, the program, the facility, the materials, your philosophy, or the actual implementation and approach?

Do you feel that this was a successful endeavor? Why or why not?

What personal challenges, theories, expectations, or ideas, if any, did you have to overcome in order to conduct this program?

Did you feel that there were any challenges in terms of your initial expectations and the final outcome of the program?

Did you feel sufficiently supported by the arts administrator of your program? By the facility? By the participants?

Questions for other institutional staff involved in the program could be as follows:

Do you feel that this program was a positive addition to the institution? Why or why not?

Do you feel that the initial goals and objectives of the program were clearly described and implemented?

Have you noticed any positive or negative consequences of this program at the institution?

Has the program made this institution rethink any policy issues?

How would you describe the artist's relationship with the institution and the participants?

Would you host a similar program in the future?

Did you feel that the arts organization/artist was a productive and supportive partner?

What recommendations would you make for future programming?

With these questions in hand you should be able to gain some insight into your program. If you are the artist and you wish to evaluate your program, it is best to have confidential questionnaires so that participants feel as though they can be honest. If you have concerns over literacy, it might be advisable to ask a person in the institution such as the chaplain or another artist that works in the correctional facility to ask inmates about your program for the purpose of your evaluation. If you still need help, there are lots of books and Websites about program evaluation that can help you create a plan and implement it.[4]

Notes

Foreword. Buzz Alexander

1. In the film "Sentencing Circles—Traditional Justice Reborn," by Doug Cuthard and Vicki Covington.

Introduction. Rachel Marie-Crane Williams

1. Marian Liebmann, *Art Therapy with Offenders* (London: Jessica Kingsley Publishers, 1994).

2. Allen Beck and Paige Harrison, "Prisoners in 2000" (Washington, D.C.: United States Department of Justice, August 2001).

3. Allen Beck and Jennifer Karberg, "Prison and Jail Inmates at Midyear 2000" (Washington, D.C.: United States Department of Justice, March 2001), 4.

4. *Criminal Offender Statistics (online)*, February 28, 2002, Bureau of Justice Statistics, http://www.ojp.usdoj.gov/bjs/crimoff/htm.

5. *Incarcerated Parents and Their Children*, September 22, 2000, Bureau of Justice Statistics, http://www.ojp.usdoj.gov/bjs/abstract/iptc.htm.

6. Jan Gibbons, "Struggle and Catharsis: Art in Women's Prisons," *The Journal of Arts Management, Law, and Society* 27, no. 1 (1997): 72–80.

7. Eric Schlosser, "The Prison Industrial Complex," *The Atlantic Monthly,* no. 282 (1998): 51–77.

8. Beck and Harrison, "Prisoners in 2000," 1.

9. Ibid.

10. Schlosser, "The Prison Industrial Complex," 73.

11. Lawrence Brewster, "An Evaluation of the Arts-in-corrections Program of the California Department of Corrections" (Santa Cruz: William James Association and the California Department of Corrections, 1983).

12. Steve Durland, "Maintaining Humanity," *High Performance* (spring 1996). See also William Cleveland, *Art in Other Places* (Westport, Conn.: Praeger, 1992).

13. Ibid., 11.

14. Rachel Marie-Crane Williams, "The Art of Incarcerated Women: Its Functions and Consequences in the Culture of Taycheedah Correctional Institution," Ph.D. diss., Florida State University, 2000.

15. Cleveland, *Art in Other Places,* 85.

16. Phyllis Kornfeld, *Cell Block Visions* (Princeton, N.J.: Princeton University, 1997), xiii.

17. Marian Liebmann, *Art Therapy with Offenders* (London: Jessica Kingsley, 1994). See also Durland, "Maintaining Humanity," 10–12.

18. Ibid.

19. Gyles Brandreth, *Created in Captivity* (London: Hodder and Stoughton, 1972).

20. C. L. Harrington, "Time to Piddle: Death Row Incarceration, Crafts Work, and the Meaning of Time," *Journal of Arts Management, Law, and Society* 27, no. 1 (1997): 51–70.

21. Ibid., 61.

22. Williams, "The Art of Incarcerated Women," 2000.

23. Brandreth, *Created in Captivity*.

24. Liebmann, *Art Therapy with Offenders*.

25. Brandreth, *Created in Captivity*.

26. Ibid.

27. Ibid., 29.

Chapter 1. Grady Hillman

1. Inmates everywhere refer to people in the free world outside of prison as "freeworld." Locked-ups is my term to avoid the convict/inmate/prisoner semantics.

2. Eric Schlosser, "The Prison Industrial Complex," *Atlantic Monthly*, no. 282 (1998): 51–77.

3. Ledbelly was convicted of murder in both Texas and Louisiana and sang his way out of both systems owing to his discovery by a Louisiana governor and the folklorists, the Lomax brothers. He was the author of many classic songs such as "Goodnight Irene" and "The Midnight Special," and he hosted a New York City radio program at the height of his career.

4. The anthology was published over eighteen years ago and so consequently is out of print. However, the film was produced with funding from the Texas Council on the Humanities, and it can be borrowed from their archives for viewing.

5. These are a series of well-known and well-published inmate writers from the early 1980s. Eldridge Cleaver wrote *Soul on Ice*; Malcolm Braley wrote many books, but his *Autobiography from San Quentin* is the most famous. Michael Hogan is a poet from Arizona who was discovered by a well-known American poet who was working in the prisons. Ricardo Sanchez was one of the earliest Chicano poets who did time in both California and Texas and got his Ph.D. while behind bars. Etheridge Knight was a Korean veteran who came back from the experience addicted to morphine in the 1950s. He was imprisoned in Illinois.

6. Lawrence Brewster, "An Evaluation of the Arts-in-corrections Program of the California Department of Corrections" (Santa Cruz: William James Association and the California Department of Corrections, 1983).

7. I read Dickens's "American Notes" in an archive in Massachusetts. These are also available on the World Wide Web at several sites.

Chapter 2. William Cleveland

1. William Cleveland, *Art in Other Places* (Westport, Conn.: Praeger, 1992).

2. The Center for the Study of Art and Community is an association of community leaders and artists who believe the arts are America's most underutilized natural resource.

The center conducts research and consults with arts and community institutions seeking innovative creative partnerships. Please write to CSA&C, 7561 Park Drive, Suite 101, Citrus Heights, CA 95610, or phone 916-726-1720 for information about the center or to get a copy of *A Manual for Artists Working in Community and Social Institutions* or *Art in Other Places*.

Chapter 3. James Thompson

1. James Thompson, *Drama Workshops for Anger Management and Offending Behavior* (London: Jessica Kingsley, 1999).

2. Tragically, after writing the first draft of this chapter, the camp was attacked by local people and twenty-nine of the young men were killed. The young men have therefore not gone home, and the questions raised about the project there have become even more acute.

Chapter 4. Pat MacEnulty

1. Louis Slobodkin and James Thurber, *Many Moons* (New York: Harcourt Brace, 1944).

2. Lawrence Brewster, "An Evaluation of the Arts-in-corrections Program of the California Department of Corrections" (Santa Cruz: William James Association and the California Department of Corrections, 1983).

3. Dave Hickey, "A World Like Santa Barbara," *Harper's Magazine*, September (2000): 11–16.

Chapter 8. Terry Karson

1. "Glass Walls," narrated by Amy Roach, Yellow Stone Public Radio, 1997.

Chapter 9. Buzz Alexander

1. *Michigan Department of Corrections Annual Report*, 1971.

2. From the Michigan Department of Corrections Website (http://www.state.mi.us/mdoc).

3. 49,073: Michigan Department of Corrections, "Corrections Data Fact Sheet for February, 2000." Projection: Barbara Levine of Citizens Alliance on Prisons and Public Safety, e-mail communication, May 15, 2002. 54.5 percent African American: *Michigan Department of Corrections Annual Report*, 2000.

4. Most students who become members of PCAP have been trained through English 310, English 319, or Art and Design 454. Members who make major contributions to PCAP become PCAP Associates when they leave Ann Arbor.

5. Michigan Department of Corrections operations are divided into three administrative regions. Each regional prison administrator has established a different method of approving our plays. The method here is that established in Region III, where we have most of our workshops.

6. Buzz Alexander, "Inside Out: From Inside Prison Out to Youth," *Drama Review* (winter 1996): 85–93.

7. My sense is that most of those who study prisons in this country and most of those

who work in them would agree to this characterization of prison as a place that sets limits and says "no." But they would also agree that such a characterization does not represent the full purpose of every person who administers or works in a prison, which is an extremely difficult place to work. We work with remarkable wardens, deputy wardens, assistant deputy wardens, special activities and recreation staff, and corrections officers who believe in the right of prisoners to grow and take positive charge of their lives and who do what they can to enable this to happen.

8. Florence Crane is in Administrative Region II. We submit our plays directly to the regional prison administrator.

9. I understand consensual language to be language that is on the surface clearly "true" (one person can't change the world) *and* that serves the speaker's purpose of remaining inactive or consenting to the status quo.

10. Myles Horton, *The Long Haul: An Autobiography* (New York: Teachers College Press, 1998), 132–33.

Chapter 10. Rachel Marie-Crane Williams

1. Carol Becker, *Zones of Contention: Essays on Art, Institutions, Gender, and Anxiety* (Albany: State University of New York Press, 1996), 113.

2. See Kathy Boudin, "Lessons from a Mother's Program in Prison: A Psychosocial Approach Supports Women and Their Children," *Women and Therapy* 20, no. 4 (1998): 103–25. Also see Kathryn Watterson, *Women in Prison* (Boston: Northeastern University Press, 1996).

3. See Phyllis Baunach, *Mothers in Prison* (New Brunswick: Transaction Books, 1985), 75–119. Also see Tammerlin Drummond, "Mothers in Prison," *Time Magazine*, 6 November 2000: 156(19): 106–9.

4. See Boudin, "Lessons from a Mother's Program in Prison," 106.

5. Drummond, "Mothers in Prison."

6. Baunach, *Mothers in Prison*.

7. Watterson, *Women in Prison*.

8. Ellen Dissanayake, *Homoaestheticus* (New York: Free Press, 1992), 69.

9. Francois Matarasso, *Use or Ornament: The Social Impact of the Arts* (London: Comedia, 1997), 22.

10. Betty Ann Brown, *Expanding Circles, Women, Art, and Community* (New York: Midmarch Press, 1996), 291.

11. bell hooks, *Teaching to Transgress* (New York: Routledge, 1994), 21.

12. Ibid., 40.

13. Lawrence Greenfeld and Tracy Snell, *Women Offenders* (Washington, D.C.: Bureau of Justice Statistics, December 1999).

14. Tom Anderson, "Toward a Cross-Cultural Approach to Art Criticism," *Studies in Art Education Journal of Issues and Research* 36, no. 4 (1995): 198–209.

15. Suzanne Langer, *Philosophical Sketches* (Baltimore, Md.: Johns Hopkins Press, 1962), 90.

Chapter 11. Susan Hill

1. Lawrence Brewster, "An Evaluation of the Arts-in-corrections Program of the California Department of Corrections" (Santa Cruz: William James Association and the California Department of Corrections, 1983).

2. Artsreach is not affiliated with the large nationwide network of organizations with the same name.

3. This information is from the California Youth Authority.

Chapter 12. Rachel Marie-Crane Williams

1. David Krawthwohl, *Methods of Education and Social Science Research* (Longman: New York, 1998).

2. Joan Herman, Lynn Morris, and Carol Fitz-Gibbons, *Evaluator's Handbook, CSE Program Evaluation Kit,* vol. 1 (Washington, D.C.: Office of Educational Research and Improvement, 1987).

3. Mary Hall, *Getting Funded: A Complete Guide to Proposal Writing,* 3d ed. (Portland, Wash.: Portland State University Continuing Education Publications, 1988).

4. I use a variety of resources when creating a plan for evaluation. Listed are online sites I have found helpful. William B. McCurdy, *ProgramEvaluation: A Conceptual Tool Kit for Human Service Delivery Managers* [book online] (New York: Family Service Association of America, 1979), accessed June 1, 2002; available at http://programevaluation.homestead.com/. See also KRA Corporation, *A Guide to Evaluating Crime Control of Programs in Public Housing* (Washington, D.C.: U.S. Department of Housing and Urban Development Office of Policy Development and Research, 1997), accessed June 1, 2002; available at http://www.bja.evaluationweb site.org/html/documents/documentz.html. See also David C. Crawford, *Suggestions to Assess Nonformal Education Programs,* Master's thesis, Michigan State University, East Lansing, Department of Agriculture and Extension Education, 1995, accessed June 1, 2002; available at http://www.ag.ohio-state.edu/~brick/nfeeval.htm. See also Murari Suvedi, *Introduction to Program Evaluation,* Michigan State University, East Lansing, Department of Agriculture and Extension Education, 1995, accessed June 1, 2002; available at http://www.ag.ohio-state.edu/~brick/suved2.htm#What%20is%20evaluation.

Recommended Reading

Although the *useful* literature on prison and the visual arts is somewhat sparse, I have always been interested in finding resources that offer me new ways to approach my visual art and my students. I would advise anyone entering this field to seek out books related to their disciplines and sources outside of those disciplines.

The first book about arts in prisons that I read, which contained incredible imagery and was devoted specifically to the visual artwork of inmates, was Phyllis Kornfeld's *Cellblock Visions* (Princeton, N.J.: Princeton University Press, 1997). Her book offered an overview of visual art, especially painting and drawing, produced in North American prisons.

During the years, I have referred to numerous books and articles about art therapy with incarcerated populations, most notably, *Art Therapy with Offenders* (London: Jessica Kingsley, 1994) by Marian Liebmann. Colin Riches wrote a wonderful chapter in this book that describes the hidden therapeutic benefits of art in prisons. I also pored over "Struggle and Catharsis: Art in Women's Prisons," an article by Jan Gibbons (*Journal of Arts Management, Law, and Society* 27, no. 1 [1997]), an Australian art therapist, who equates the production of visual art within prison to Aristotle's concept of "Katharsis." When I first began working in prisons, these texts and articles helped me to understand why the arts have such power for inmates.

Different artists and arts administrators have also written chapters and books about working with prisoners. William Cleveland, the author of *Art in Other Places* (Westport, Conn.: Praeger, 1992), includes a chapter about working in prison. C. Lee Harrington, a university professor, wrote "Time to Piddle," an article about the visual art of inmates on Death Row that appeared in the *Journal of Arts Management, Law, and Society* (27, no. 1 [1997]). *High Performance*, an arts magazine, featured two articles, one about the work of dancer Leslie Neal in Florida (Leslie Neal, "Miles from Nowhere: Teaching Dance in Prison," 71 [1996]) and another about Grady Hillman's work as a writer in prisons (Steve Durland, "Maintaining Humanity," 71 [1996]). James Thompson, a professor at Manchester University in England, has written *Drama Workshops for Anger Management and Offending Behavior* (London: Jessica Kingsley, 1999) and *Prison Theatre* (London: Jessica Kingsley,

1998); both are about drama in prisons and his work with the Theatre in Prisons and Probation Center (TIPP). Judith Tannenbaum wrote *Disguised as a Poem: My Years Teaching Poetry at San Quentin* (Northeastern University Press, 2000). I found her account filled with advice about how to be an arts professional in a prison setting without being hardened by the system or softened by the extreme emotions that can be encountered. Rhodessa Jones, a famous dancer, performance artist, and choreographer, was recently written about in *Imagining Medea: Rhodessa Jones and Theatre for Incarcerated Women* (Chapel Hill: University of North Carolina Press, 2001). Although Gyles Brandreth's *Created in Captivity* (London: Hodder and Stoughton, 1972) was written three decades ago, it has provided me with a great deal of insight into the reasons that people in prison make art. All of these texts and articles have been essential additions to my personal library. Recently the Context Project of Books Through Bars in Philadelphia published *Insider Art* (2000). It is a catalogue of works of art sent to the Books Through Bars organization as thank-you gifts from different inmates. Like *Cellblock Visions*, it is an impressive catalogue of works filled with information about prison life. Robert Ellis recently published *Funhouse Mirror* (Pullman: Washington State University Press, 2000) about his years of teaching writing workshops in prison. Jean Trounstine published *Shakespeare Behind Bars: The Power of Drama in a Women's Prison* (New York: St. Martin's Press, 2001). Both of these books are filled with remarkable insights into the relationship between teachers and students, the challenges of working behind bars, and the grit of prison life.

Certain criminologists have also been helpful to read. I would encourage anyone who wants to work with inmates to spend some time surfing the Web and looking at what academics have written. Some information is disturbing, and some is insightful. Most of what I have read and can recommend is based primarily on female offenders. For sheer statistics, I would encourage people to look up the Bureau of Justice Statistics and the National Criminal Justice Reference Service on the World Wide Web. There are a number of sites available on the Internet related to prison and criminal justice. In terms of criminologists, James Fox ("The Study of Stigmata," dissertation, State University of New York at Albany, 1976), a noted scholar, has addressed prison cultures and has even studied tattoos in prison. His work, the writing of Barbara Owens (*In the Mix: Struggle and Survival in a Women's Prison* [Albany: State University of New York Press, 1998]), and Kathryn Watterson (*Women in Prison* [Boston: Northeastern University Press, 1996]) were also helpful in my search to understand the needs and experiences of incarcerated women. Meda Chesney-Lind's book about female offenders (*The Female Offender* [Thousand Oaks: Sage Publications, 1997]) was also helpful to read. Her text made clear the connection between cycles of abuse, drug addiction, early childhood experiences, and incarceration. Mary Bosworth's *Engendering Resistance: Agency and Power in Women's Prisons* (Brookfield: Dartmouth, 1999) has an in-depth review of literature that is relevant to the history of punishment and corrections in the

United States, two chapters about gender and the justice system, and information related to research methods in studies involving women's prisons and incarcerated women. Jeff Ferrell and Mark Hamm's writing about risky qualitative research methods and their work with juvenile graffiti artists helped me understand how I could synthesize my role as an artist with my goals as a researcher and social activist to help improve the judicial system (*Ethnography at the Edge: Crime, Deviance, and Field Research* [Boston: Northeastern University Press, 1998]). Michel Foucault's *Discipline and Punish* (New York: Vintage Books, 1975) is an academic text, but it gives the reader a unique philosophical view of corrections and punishment through the ages. Many of the artists who have contributed to this volume have also written extensively about their experiences and published their ideas on the Internet and in books, magazines, newspapers, and academic journals. Most of what I have recommended in this short literature review refers to prisons in the United States and the United Kingdom. There is a great deal of literature regarding incarceration in other countries and the plight of political prisoners that I have not mentioned.

Before entering the field of arts-in-corrections, it is important to read books related not only to arts-in-corrections, but also to the political, social, and legal ideas and the institutional policies surrounding prisons. This kind of reading creates an understanding of the culture and context, history and procedures that shape that environment. It can also be preparation for the uncommon inhumane practices and environments encountered in some settings.

Contributing Authors

BUZZ ALEXANDER is a professor of English language and literature at the University of Michigan. Author of *Film on the Left; American Documentary Film from 1931–1942* (Princeton University Press), he founded the Prison Creative Arts Project in 1990. He is a member of the Sisters Within Theater Troupe at the Western Wayne Correctional Facility and a member of the Poet's Corner at the Southern Michigan Correctional Facility, as well as co-curator of the Annual Exhibition of Art by Michigan Prisoners. He has completed a book-length manuscript on community-based theater and has written several articles on arts in corrections. He is a member of the Blue Mountain Arts Group to End Massive Incarceration.

WILLIAM CLEVELAND is the founder and director of the Center for the Study of Art and Community in Minnesota. He has pioneered numerous institutional and community arts programs including Artsreach Community Artists, California Arts-In-Corrections, and California State Summer School for the Arts. A musician and author, he has written *Art in Other Places: Artists at Work in America's Community and Social Institutions* (Praeger). He has been director of California Arts-In-Corrections and a contributing editor of *High Performance Magazine*. In addition he specialized in the development and assessment of art-based community partnerships, and training for artists and their community and institutional partners. His clients include artists and arts organizations, schools, human service and criminal justice agencies, and business and philanthropic organizations.

SUSAN HILL is the artistic director of Artsreach, an artist-managed community service organization founded by University of California, Los Angeles Extension. Artsreach specializes in artist residency projects with high-risk, immigrant, and incarcerated constituencies, with a focus on young people. Susan Hill is a visual artist who has devoted two decades to creating arts programs within California's justice system.

GRADY HILLMAN of Texas is an award-winning poet, Fulbright scholar, and community arts consultant. Hillman has worked extensively as an artist or consul-

tant for arts-in-corrections programs throughout the United States and in Peru, England, Ireland, and Northern Ireland. From 1999 to 2002 he was the Technical Assistance Provider to a federal initiative *Arts Programs for Young Offenders in Detention and Corrections* through a grant from the National Endowment for the Arts and the Office of Juvenile Justice and Delinquency Prevention. Since 1998, Hillman has published *Artists in the Community: Training Artists to Work in Alternative Settings* (Housing and Urban Development); *The Arts and Humanities as Agents for Social Change: Summary Report of the 4th International Congress of Educating Cities* (Housing and Urban Development); and *Arts Programs for Juvenile Offenders in Detention and Corrections: A Guide to Promising Practices* (Office of Juvenile Justice and Delinquency Prevention).

JANE ELLEN IBUR is a writer/teacher living in St. Louis, Missouri, who helps people find their voices through creative writing. She currently teaches male Class A felons at the St. Louis County Department of Justice Services. She also teaches at homeless shelters, at a housing project, and at a facility/school where abused adolescent girls reside. Her work appears nationally in anthologies and literary magazines. She is on the board of *River Styx* magazine and she co-hosts a literary talk show on local community radio called Literature for the Halibut.

TERRY KARSON is an artist, writer, and curator who received his B.F.A. from the Kansas City Art Institute and his M.F.A. from Montana State University. His work is exhibited nationally and is included in numerous public and private collections. He has also written many curatorial publications and articles on contemporary art. In 1996, with his wife, artist Sara Mast, he established the first art program in the Montana Women's Prison, where they are currently working with the Montana Arts Council on a percent-for-art project.

PAT MACENULTY is the author of the novel, *Sweet Fire* (Serpent's Tail Press). She has a Ph.D. from the writing program at Florida State University, where she was the recipient of a University Dissertation Fellowship. She has designed and delivered arts programs for the Florida Department of Corrections, the Mecklenburg County Jail, and Transition House, a residential facility for at-risk youth. She was a Kingsbury Fellow and in 1996 received the Florida Arts Council Individual Artists Fellowship. She is currently working on a nonfiction book with her brother, David MacEnulty, about his experiences teaching chess to inner-city school children.

LESLIE NEAL has been an active member of the Miami dance community since 1981. Ms. Neal is an Associate Professor of Dance at Florida International University and served as the Director of the Dance Program from 1995 to 1997. She is the Artistic Director of ArtSpring, Inc., a not-for-profit arts organization based in South Florida that provides community exposure to the arts through live perfor-

mance, as well as specifically designed outreach workshops and educational arts programs. In 1997, Ms. Neal served as an artist-in-residence for the National Endowment of the Arts at the Federal Correctional Institution for women in Tallahassee, Florida. ArtSpring's Inside Out program, begun in 1994, is the longest ongoing prison arts program in Florida and has been featured in several publications of nationally recognized community arts programs including *Art Works!* by the Dade County Coalition, *ac3 = infinity User's Guide on Arts in Community Service* by the Corporation for National Service, and *Teaching Dance in Prisons* by *High Performance* magazine. Ms. Neal was a featured artist in two recently published books, *Twelve Secrets of Highly Creative Women—A Portable Memoir* by Gail McKeegin and *The Performer's Guide to the Creative Process* by Sheila Kerrigan.

JUDITH TANNENBAUM taught poetry at San Quentin for four years, and her memoir *Disguised as a Poem: My Years Teaching Poetry at San Quentin* was published by Northeastern University Press in 2000. She taught poetry in California prisons for many years in addition to the years at San Quentin; she also created, wrote, edited, and distributed the newsletter for Arts-in-Corrections from 1989 to 1995. Author of the "Manual for Artists Working in Prison" and "Handbook for Arts in the Youth Authority Program" created for the California Youth Authority, she has also completed a feasibility study for arts programming in Minnesota prisons.

JAMES THOMPSON is a senior lecturer in Applied Theatre in the Manchester University Drama Department, co-founder of the Theatre in Prisons and Probation (TIPP) Centre, and Director of the Center for Applied Theatre Research. He has devised applied theater programs in Brazil, Burkina Faso, Sri Lanka, the United States, and the UK. His research interests include theater and offender rehabilitation programs, theater and development, and Sri Lankan theater. His publications include: *Prison Theatre: Perspectives & Practices*, ed. (1998), *Drama Workshops for Anger Management and Offending Behaviour* (1999), and *Applied Theatre: Bewilderment and Beyond* (2002).

RACHEL MARIE-CRANE WILLIAMS is an assistant professor of Art Education at the University of Iowa. She received her B.F.A. in Painting and Drawing from East Carolina University and her M.F.A. in Studio Art and her Ph.D. in Art Education from Florida State University. She has worked as an artist and researcher with incarcerated populations in Wisconsin, Iowa, Rhode Island, South Dakota, and Florida, and as a guest designer for Inside Job Theatre troupe at HMP Holloway in London, England. In 2001 she was awarded a major grant from Humanities Iowa to facilitate a long-term project focusing on nonfiction, bookmaking, and narrative storytelling with the women at the Iowa Correctional Institution for Women. She has also received a research grant from the National Art Education Foundation. Her writing has appeared in the *Journal of Arts Management, Law, and Society*, *Art Papers*, *Ceramics Monthly*, *Visual Arts Research*, *Reflections*, and the *Journal of Poetry Therapy*.